The Social Turn in Second Language Acquisition

The Social Turn in Second Language Acquisition

David Block

Georgetown University Press
Washington, D.C.

For Vicky and Adrià

© David Block, 2003

Georgetown University Press
Washington, D.C.

10 9 8 7 6 5 4 3 2 1 2003

This volume is printed on acid-free offset book paper.

First published in the United Kingdom by Edinburgh University
Press.

Typeset in Garamond
by Norman Tilley Graphics, Northampton,
and printed and bound in Great Britain.

Library of Congress Cataloging-in-Publication Data

Block, David, 1956-
 The social turn in second language acquisition / David Block.
 p. cm.
Includes bibliographical references and index.
 ISBN 0-87840-144-X (pbk. : alk. paper)
 1. Second language acquisition. 2. Sociolinguistics. I. Title.
P118.2.B58 2003
 418–dc21

 2003000712

Contents

Preface

This book is about the prospect of a social turn in the field of second language acquisition (SLA) and in particular that part of SLA which is devoted to the Input-Interaction-Output model. The overall aim of the book is to examine critically some of the basic notions and assumptions that underpin this model and to suggest a more interdisciplinary and socially informed approach to SLA research.

In order to achieve this aim, I subject the elements making up the acronym SLA to close scrutiny, analysing what mainstream SLA researchers understand by 'second', 'language' and 'acquisition'. Drawing on recent work in sociolinguistics, as well as SLA research influenced by sociolinguistic and sociohistorical approaches to language and language learning, I argue that there is a need for a less partial view of what SLA is about and a broadening of horizons to take on board this work.

The book begins with an introductory chapter in which I argue that SLA should follow the lead of sociolinguistics and applied linguistics, where in recent years researchers have begun to work in a more socially informed and interdisciplinary manner. This chapter is followed by a short history of SLA in which I make the case that SLA has come together as a field of academic endeavour over the past forty years and that the Input-Interaction-Output model is by far the most ambitious, well developed and productive area of research in SLA today. Then, in Chapters 3–5, I discuss in detail and analyse what is generally meant by the 'S', the 'L' and the 'A' in SLA, with a specific focus on the Input-Interaction-Output model. Along the way, I make suggestions for how these concepts might be examined in a more socially informed and interdisciplinary fashion. I end the book with some speculations about the future of SLA research.

Acknowledgements

This book is the product of a decade of reading and thinking about second language acquisition (SLA). During this time I have benefited from the different contacts I have had with fellow academics and MA and PhD students. Knowingly and unknowingly, they have helped me refine my ideas and thoughts about SLA. Space does not allow me to cite each and every person who falls into this category, but I would like to mention one person in particular, my friend and colleague Debbie Cameron. Debbie not only helped me to clarify and put some shape to my thoughts, but also gave me a crucial and well timed push to write the book I had had in mind for some time.

I have been fortunate over the past year and a half to find people willing to read and comment on draft chapters. I would like to thank (in alphabetical order) Rob Batstone, Martin Bygate, Debbie Cameron, Guy Cook, Jane Davies, Amos Paran, Ben Rampton, Merrill Swain and Cathie Wallace for their perceptive feedback.

My place of work, the Institute of Education, University of London, deserves both a mention and thanks. Apart from providing a stimulating environment, the Institute also granted me a study leave for the summer term of 2002. It was during this time that I put the finishing touches to the book.

I would like to thank the Edinburgh Textbooks in Applied Linguistics series editors, Alan Davies and Keith Mitchell, for their continued support. Thanks also go to Commissioning Editor Sarah Edwards and other members of the editorial team at Edinburgh University Press for their editorial assistance.

Last, but certainly not least, I thank Victòria Castillo Austrich, and Adrià Block Castillo, for leaving me alone when I was in book-writing mode and for providing me with more support than they realise during the entire process. This book is for them.

Chapter 1

Introduction

As the title suggests, this book is about the prospect of a social turn in the field of second language acquisition (hereafter SLA), in particular that part of SLA which is devoted to the Input-Interaction-Output (IIO) model, as elaborated by researchers such as Susan Gass (1997; Gass and Selinker 1994/2001) and Michael Long (1996). The overall aim of the book is to examine critically some of the basic notions and assumptions which underpin this model and to suggest a more interdisciplinary and socially informed approach to SLA research. In subsequent chapters, I attempt to achieve this aim by first situating this model historically and then by unpacking what is meant by the 'S', the 'L' and the 'A' in SLA.

Before undertaking that ambitious task, I would like to use this introduction to provide some necessary background for this book. First, I attempt to situate discussions about basic ontological and epistemological issues in SLA in the more general context of changes taking place in sociolinguistics and debates about the future of applied linguistics. I then go on to examine briefly some of the recent discussions about SLA, in particular how some authors have challenged the more orthodox psycholinguistic bias of the field, suggesting that a more socially informed approach would be preferable. The final section of the introduction provides the reader with a brief overview of the content of Chapters 2–6, before ending with some caveats which I think are in order.

1.1 THE SOCIAL TURN IN APPLIED LINGUISTICS: FOLLOWING THE LEAD OF SOCIOLINGUISTICS

As I stated above, the chief aim of this book is to explore the extent to which SLA researchers, in particular those working according to the Input-Interaction-Output (IIO) model, might adopt a more interdisciplinary and socially informed approach to their research. Such a shift in approach would require SLA researchers to take a cue from recent debate about the present and future of applied linguistics (hereafter AL). This debate has focused on whether or not a more socially informed framework is needed by researchers exploring language-related puzzles in the real world and whether or not a more interdisciplinary AL is feasible. Perhaps the best example of such debate in recent years is the special issue of the *International Journal of Applied*

Linguistics (*IJAL*) published in 1997. The issue begins with a programmatic article by Ben Rampton (1997a), where he makes the point that AL is not just about language teaching in general; rather, it is, as Chris Brumfit has argued, '[t]he theoretical and empirical investigation of real-world problems in which language is the central issue' (Brumfit 1991: 46).

Rampton provides a list of several active research areas that he would qualify as AL. These are: interactional sociolinguistics and the micro ethnography of institutional settings; ethnographic studies of socialisation, education and literacy; systemic linguistics and genre theory; critical discourse analysis; the social psychology of language and speech accommodation theory; and institutionally oriented conversation analysis. To this list, I would add, as Alan Davies (1999) suggests, foreign language teaching and SLA (likely subsumed under 'education and literacy' and 'the social psychology of language' respectively in Rampton's model), as well as translation (e.g. Campbell 1998) and language play (Crystal 1998; Cook 2000). Drawing on the work of Hymes (e.g. 1971, 1974) and Bernstein (e.g. 1975), Rampton (1997a) proposes what he calls a 'socially constituted' linguistics. Here the starting point is the study of culture and social organisation, and the view is that language plays an integral part in the enactment of social action and communication. In this case, linguistics, and any study associated with language, serves social analysis.

What Rampton proposes is a change in AL similar to one that has occurred in sociolinguistics over the past twenty years. During this time an increasing number of sociolinguists have come to share an interest in relating social theory to the language and society puzzles that they set out to explore and understand. This is not to say that, as an academic field, sociolinguistics has abandoned its foundational and traditional links with linguistics and structuralist approaches to language in use (e.g. Labov 1972; Trudgill 1983), or that the act of borrowing constructs from other social science disciplines is necessarily a recent trend. Indeed, publications such as Labov (1994) and Eckert (2000) attest to the continued vitality of structuralist approaches to language use (although Eckert is more social-theoretical in her approach) and, as Nikolas Coupland (2001a) points out, sociolinguistics has always drawn on a variety of disciplines, from social psychology to anthropology, for ideas. However, what is new in recent years is a big increase in the amount of work that draws directly and explicitly on social theory. For example, recent collections edited by Justine Coupland (2000a), Sarangi and Coulthard (2000), Barron, Bruce and Nunan (2002) and, in particular, Nikolas Coupland, Sarangi and Candlin (2001) contain, for the most part, contributions based on the efforts of sociolinguists to relate social theory to traditional sociolinguistic interests. Meanwhile, the programme of the Sociolinguistics Symposium, held biannually since 1977, is dominated by contributions that either refer to or are driven by social theory.

Not surprisingly, Rampton's call for a more socially informed and inter-disciplinary AL has not gone unchallenged. Henry Widdowson (1998a, 1998b) is not convinced by Rampton's arguments and he questions whether AL as an interdisciplinary academic endeavour can actually work. For Widdowson, an AL organised around a group of individuals trying to incorporate theoretical and

analytic frameworks from a variety of neighbouring disciplines would lack integrity. Quoting Yeats, he argues that '[t]hings fall apart ... [as] the centre cannot hold' (Widdowson 1998a: 151). This view is echoed by Davies and Brumfit, who fear that following Rampton's suggestions would mean that 'we have to give up on the coherence of applied linguistics' (Davies 1999: 141) and that AL would 'fragment into separate groupings' (Brumfit 1997: 91).

I do not believe that Rampton's proposals are so radical and would even maintain that his suggestions are becoming a reality. Examining applied linguistics publications over the past five years, we see greater interdisciplinarity in connections between critical theory and language teaching manifested above all in journals such as *TESOL Quarterly* and books such as Pennycook (1994, 1998) and Canagarajah (1999). In addition, as we observed above, recent publications, such as Coupland (2000a), Sarangi and Coulthard (2000), Coupland, Sarangi and Candlin (2001) and Barron, Bruce and Nunan (2002), are representative of a broad trend in sociolinguistics for researchers to base their work on social theory. But what about SLA, the part of AL which is the focus of this book? Is there any indication that, as a discipline, it too is moving in a more interdisciplinary and socially informed direction?

1.2 A SOCIAL TURN FOR SLA?

Until the mid-1990s, explicit calls for an interdisciplinary, socially informed SLA were notable by their absence. Early articles commenting on the state of SLA tended to focus on the relationship between SLA and language teaching (e.g. Hatch 1978; Lightbown 1985), normally commenting on the degree to which language teachers could or should take on board the findings of SLA researchers. More recent publications have continued to focus on the relationship between language teaching and SLA (e.g. Pica 1994, 1997; Lightbown 2000), but there has also been increasing discussion about the nature of what the field actually studies, an ontological issue, and how researchers might best go about studying it, an epistemological issue (e.g. Beretta 1991; Crookes 1992; the special issue of *Applied Linguistics* entitled 'Theory Construction in Language Acquisition' and published in 1993; van Lier 1994; Block 1996a; Lantolf 1996; Gregg et al. 1997; the special issue of *Modern Language Journal* devoted to a debate about making SLA more sociolinguistically informed, published in 1997; Gass 1998; Long 1998; Gregg 2000). In these different publications, a general division of opinion has arisen between those who see SLA primarily in psycholinguistic terms (e.g. Beretta, Gass, Gregg, Long) and those who see it as both psycholinguistic and social in nature (Block, Lantolf, van Lier). Unfortunately, discussions carried out at these extremes have, in general, been neither as productive nor as thought-provoking as those about AL. Indeed, when scholars have published critical programmatic articles in major journals – the cases of van Lier (1994), Block (1996a) and Lantolf (1996) – the responses have largely been dismissive (Beretta et al. 1994, responding to van Lier et al. 1997, responding to Block; Gregg 2000, responding to Lantolf).

An exception to the pattern of relatively unproductive debate about the nature of SLA is the special issue of *Modern Language Journal*, published in 1997. The issue opens with a thought-provoking article by Firth and Wagner (1997), in which the authors state that their overall aim is to 'examine ... critically the predominant view of discourse analysis and communication within second language acquisition (SLA) research'. They argue that 'this view is individualistic and mechanistic, and that it fails to account in a satisfactory way for interactional and sociolinguistic dimensions of language' (285). After this introduction, Firth and Wagner go on to make several important points. First, they denounce a strong tendency in SLA to conceptualise language as a cognitive phenomenon as opposed to a social one, and acquisition as an individual accomplishment as opposed to a social one. For Firth and Wagner, there has been 'the imposition of an orthodox social psychological hegemony in SLA' (285) which has led to: (1) the reduction of complex and nuanced social beings to the status of 'subjects'; (2) a priming of the transactional view of language over other possible views (e.g. interactional); (3) an interest in *etic* (relevant to the research community) constructions of events and phenomena as opposed to *emic* (relevant to the researched) constructions; (4) a search for the universal as opposed to the particular; and (5) a preference for inquiry which is quantitative, replicatory and experimental in nature as opposed to qualitative, exploratory and naturalistic. Ultimately, what Firth and Wagner propose is a rejection of a narrowly framed SLA whereby an overly technical model of interaction predominates (one with essentialised interlocutors, with essentialised identities, who speak essentialised language) in favour of a broader frame that integrates this narrow approach into a broader sociolinguistically driven model which can account for some of the less easily defined characteristics of communication.

Firth and Wagner's piece provoked three responses that were more or less sympathetic to their views (Hall 1997; Liddicoat 1997; Rampton 1997b) and three that, for the most part, were not (Kasper 1997; Long 1997; Poulisse 1997). In a later issue of the same journal, Gass (1998) was critical of Firth and Wagner's stance, and the authors replied to her (Firth and Wagner 1998). Further discussions by Long and Gass have appeared in other publications (Long 1998; Gass 2000). In this book I aim to expand on some of the ideas flowing from the debate inspired by Firth and Wagner. I make the case for a broader, socially informed and more sociolinguistically oriented SLA that does not exclude the more mainstream psycholinguistic one, but instead takes on board the complexity of context, the multi-layered nature of language and an expanded view of what acquisition entails.

1.3 THIS BOOK

In addition to this introduction, this book consists of five substantial chapters. In Chapter 2, I provide the reader with what I call the 'official history' of SLA. This official history covers the past forty years, during which time SLA has become a major field of research in applied linguistics. At the end of the chapter, I make clear to the reader that in my discussion and analysis of SLA, I focus primarily on work

done around the theoretical framework that sees input, interaction and output at the heart of SLA, a framework which I refer to as the IIO model. I have chosen to focus on this model and not others because I think that it is linked to the most ambitious, well developed and productive area of research in SLA.

What is actually meant by 'focus on' will become clear in Chapters 3–5 of the book where I elaborate detailed critiques of how 'second', 'language' and 'acquisition' are conceptualised in SLA in general and the IIO model in particular. In Chapter 3, I problematise two uses of 'second' in SLA. First, I examine the monolingual bias which dominates so much research, before going on to suggest that 'second' cannot adequately capture the experiences of multilinguals who have had contact with three or more languages in their lifetimes. This done, I make the point that while it is right to distinguish between classroom and naturalistic contexts, and foreign and second contexts, it should also be recognised that none of these contexts provides learning opportunities in a predictable manner. Thus, 'second' does not represent very well the language acquisition contexts and experiences of many individuals, and perhaps terms like 'other' or 'additional' would be more appropriate.

In Chapter 4, I focus on 'language' in SLA. During the period 1966–80, SLA researchers moved from viewing language as linguistic competence to viewing language as communicative competence, as suggested by Dell Hymes (1971, 1974). However, SLA researchers fell short of taking on Hymes's social view of language, the socially realistic study of language and a socially constituted applied linguistics. The result has been a relatively partial view of language, and this partial view has become foundational to the IIO model where two concepts, 'task' and 'negotiation for meaning', are fundamental. In the main body of this chapter, I critique these two concepts and propose a more socially sensitive view of language, one which can take on concepts such as negotiation of face and identity. In order to make this point, I analyse a recent IIO-based article (Mackey et al. 2000), with suggestions for how it might be made more socially sensitive.

In Chapter 5, I focus on 'acquisition' in SLA. I first examine how, after a period of hegemonic bliss in SLA in the 1970s, Stephen Krashen's dominant acquisition/learning dichotomy gave way to a conceptualisation of acquisition grounded in the information processing model of human cognition. This information processing-influenced conceptualisation of cognition has become dominant among researchers following different versions of the IIO model. However, within cognitive psychology not everyone accepts the information processing paradigm as the definitive model of cognition. Many researchers, such as Ulrich Neisser (1967, 1976, 1997), would like to see more socially sensitive (or 'ecological') models of cognition. The views expressed by these critics need at least to be acknowledged by SLA researchers. I then move on to Firth and Wagner's suggestion that SLA needs a more socially sensitive conceptual framework. This leads to a discussion of what, in recent years, has become the biggest rival to an information processing approach to acquisition in SLA, namely that which is embodied in various proposals revolving around Sociocultural Theory and Activity Theory. Proponents of such proposals believe that mental processes are as social as they are individual and as external as they are

internal, a view quite different from that traditionally envisaged by IIO researchers. After devoting considerable space to the many constructs associated with Sociocultural/Activity Theory, I explore how one might integrate information processing and sociocultural approaches to mental processes to form a new model of acquisition in SLA.

Following the discussion of the 'second', language' and 'acquisition' of SLA in Chapters 3–5, Chapter 6 considers the future of the IIO and SLA. I begin by noting how most authors of SLA surveys have avoided making predictions and only a few have laid out detailed calls for research of a particular kind. An example of the latter is Michael Breen's (2001a) learner contributions to language learning framework, and Chapter 6 examines this framework, as well as Breen's call for greater attention to the role of culture and identity in language learning. I also examine two areas of SLA where researchers are doing work consistent with his suggestions, namely interlanguage pragmatics and narrative accounts of language learning experiences. A discussion of these two areas of SLA leads me to a detailed examination of two examples of research (Tarone and Liu 1995; Teutsch-Dwyer 2002), which I think have the virtue of socially situating learning while not losing sight of language as a formal system. The chapter (and the book) ends with some speculative comments about the future.

1.4 SOME CAVEATS

Before proceeding to these chapters, several caveats are necessary. First, this book is part of a series of 'advanced introductions' to applied linguistics. I have taken the term 'advanced' seriously in writing it, and I assume that readers have some background in SLA and have read at least one of the many general texts published over the past twenty years. The book is therefore for the informed student of SLA, from language education practitioners to applied linguists who focus specifically on SLA in their work. I have made this assumption because I did not want to write a text book (there are already plenty of good ones around) and because I knew that it would be impossible to introduce readers to SLA and still have enough space to set up and sustain the arguments I present here.

The second caveat has to do with the organisation of content. As I stated above, I began writing this book with the desire to discuss particular issues revolving around the general idea of making the IIO model more interdisciplinary and socially informed. I decided that the best way to organise my discussions was to use the acronym of SLA as a guide. I am aware that adopting the acronym as a guide has led me to a rather unconventional presentation of what constitutes 'second', 'language' and 'acquisition' in the IIO model. However, I hope that the flow of argument in each chapter will convince the reader of my decision to deal with particular concepts and issues in particular chapters. In any case, one of my aims in writing this book is to stretch the boundaries of SLA, persuading the reader to look beyond more traditional views of what is, and what is not, second, language and acquisition.

The third and final caveat concerns the nature of criticism and possible responses

to it. Throughout the book I am critical of much current work in SLA. However, my criticism is intended to be constructive, as opposed to destructive, and supportive rather than dismissive. I say this because, as we observed above, some authors have tended to take criticism about SLA far too personally, seeing it as 'attacks' and even arguing that SLA is 'under siege' (Long 1998). The two most common responses to criticisms have been, on the one hand, that critics should put up or shut up and, on the other hand, that they are talking about a different research paradigm. An example of the former type of response is provided by Long (1998):

> Instead of dismissing all past work as 'narrow' and 'flawed', and simply asserting that SLA researchers should therefore change their data base and analyses to take new elements into account, [critics] should offer at least some evidence that, e.g., a richer understanding of alternate social identities of people currently treated as 'learners', or a broader view of social context, makes a difference, and a difference not just to the way this or that tiny stretch of discourse is interpretable, but to our understanding of acquisition.
>
> (Long 1998: 92)

An example of the view that those who critique are talking about a different research paradigm is Gass's reference (2000) to the same piece by Firth and Wagner, in particular where these authors suggest that language learners have other identities besides 'learner' that might be significant in the SLA process:

> in trying to capture the more complete picture of an individual's persona, they have failed to understand the nature of an empirical paradigm; they do not understand that these categories are not included because they are not deemed to be relevant to the question at hand, which is: How are second languages acquired and what is the nature of learner systems?
>
> (Gass 2000: 61)

In this book I aim to follow Long's suggestion that critics of current mainstream SLA should provide some support for the claim that a more socially sensitive approach to research would enrich our understanding of the language learning process. In doing so, I aim to convince the reader that a more interdisciplinary and socially informed SLA is both possible and desirable.

I believe that challenges to established or self-proclaimed authorities/gatekeepers of SLA should not be dismissed as being outside the remit of SLA, and that they can be nothing but positive for SLA. This being the case, I aim to circumvent exclusionary stances, where the boundaries of SLA are clearly drawn both by and for scholars who are not easily impressed by attempts to broaden horizons (e.g. Gass 1998, 2000) and who seem, in Firth and Wagner's (1998) words, to be erecting a 'No Trespassing' sign. This book is about recognising no such boundaries.

Chapter 2

A short history of second language acquisition

2.1 INTRODUCTION

The term 'second-language acquisition research' refers to studies which are designed to investigate questions about learners' use of their second language and the processes which underlie second-language acquisition and use.

(Lightbown 1985: 173)

[SLA] is concerned with what is acquired of a second language, what is not acquired of a second language, what the mechanisms are which bring that knowledge (or lack thereof) about and ultimately, an explanation of the process of acquisition in terms of both successes and failures.

(Gass 1993: 103)

SLA is thought of as a discipline devoted to discovering and characterizing how it is that a human being is able to learn a second language: what preknowledge does he or she bring to the task, what set of learning procedures does he or she use, what strategies are appropriate for certain phenomena and not others, etc.

(Schachter 1993: 173)

By SLA we mean the acquisition of a language after the native language has already become established in the individual.

(Ritchie and Bhatia 1996: 1)

These definitions of SLA have been taken somewhat randomly from four publications devoted to taking stock of the field. They have a dual purpose. First, they show a certain consensus about what the field of SLA is about: there seems to be agreement that the goals of SLA are to study, discover and characterise the what and how of any language acquired to any degree after the putative first language. More importantly, these quotes act as a way into this chapter, which aims to provide the reader with a brief history of SLA. Such an historical survey is necessary because it will allow me to show how over a period of some thirty years, a loose collection of researchers interested in language teaching developed into a considerably larger group of researchers interested in language learning, not only in formal contexts but in naturalistic contexts as well. In other words, it allows me to show how SLA

researchers moved from a rather underdeveloped and rudimentary conceptualisation of what they were doing, to an affinity with definitions, outlined above, which are sufficiently broad to permit the variety of research which characterises the field today. Despite any broad-church images which might arise from these definitions, I make the case here that over the past twenty-five years we have witnessed the development of what I call the Input-Interaction-Output (IIO) model, as broad and detailed a model of SLA as there has ever been in the short history of SLA.

In making this case, I do not wish to obscure the fact that other researchers have taken different perspectives. Notably absent from my discussion are references to variants of SLA which have arisen in European countries such as France, Germany, the Netherlands or Spain (see Fisiak 1981; Klein 1986; Dechert 1990; Sierra Martínez, Pujol Berché and den Boer 1994; Pujol Berché and Sierra Martínez 1996),[1] to say nothing of traditions which might exist in other parts of the world. Elsewhere (Block 1996a, 1997), I have lamented the fact that major international journals tend to exclude researchers who do not write in English and thereby give preferential treatment to those from English-speaking countries (or those who have done PhDs in English-speaking countries). Here, however, I am offering coverage almost exclusively to the latter. I am aware that in adopting this tack, I am vulnerable to the same charges of academic imperialism that I levelled against journal editors (perhaps unfairly in some cases). However, I have decided to focus almost exclusively on publications in English and to limit myself in relation to different theoretical perspectives because I am primarily interested in the IIO model, and this model, as we shall see below, has its origins in North American/British circles from the late 1970s onwards.

Also missing in my discussion is research for which the starting and ending points are Universal Grammar (Cook and Newson 1996; Archibald 2000). In relation to this work, my point is that, as we see below, that its approach to SLA can be subsumed under the IIO model, as outlined by scholars such as Michael Long (1996) and Susan Gass (1988, 1997). In saying this, I do not wish to suggest that the research is unimportant or even peripheral; rather that it is simply not deemed central to the IIO model which primes input, interaction, information processing and output. Equally missing in Chapters 3–5 are many direct references to work done on the role of culture in SLA (e.g. Kramsch 1993, 1998; Hinkel 1999; Byram and Tost 2001) and interlanguage pragmatics (e.g. Kasper and Blum-Kulka 1993; Rose and Kasper 2001); however, I do come back to these two important areas of research in SLA in Chapter 6. To sum up, although there are many interesting areas of research in SLA at present, this book focuses on the IIO model which has been developed over the past two decades primarily by researchers working in North America and the UK. The admittedly partial history of SLA that I present in this chapter is therefore the one which culminates in this model.

2.2 FOUNDATIONS

According to Michael Long (1998),

[a]s shown by coverage in textbooks, ... SLA as a modern field of study is generally accepted as dating from the late 1960's, meaning that the field as we know it today is still relatively young by the standards of the social sciences.

(Long 1998: 80)

The general textbooks that Long refers to quite likely include a number published during the 1990s such as Larsen-Freeman and Long (1991), Lightbown and Spada (1993), Cook (1993), Ellis (1994a), Gass and Selinker (1994), Sharwood Smith (1994), Towell and Hawkins (1994), Ritchie and Bhatia (1996). Since Long's article, there have been more texts such as Mitchell and Myles (1998), second editions of Lightbown and Spada (1999) and Gass and Selinker (2001) as well as Doughty and Long (forthcoming). In most of these books there is some reference to the history of SLA, albeit a brief reference in some cases and an indirect one in others. An example of the former is Ellis (1994a) who devotes only a couple of pages to a general survey of how SLA arrived at the point where he was able to write over 700 pages about it. Examples of indirect histories include Larsen-Freeman and Long (1991), Gass and Selinker (1994/2001) and Sharwood Smith (1994). Larsen-Freeman and Long usefully cover the history of various strands of SLA research, such as types of data analysis and the study of interlanguage, on a chapter-by-chapter basis. Elsewhere, Gass and Selinker (1994/2001) provide an elegant introduction to the history of the field through their coverage of the move from Contrastive Analysis in the 1950s and 1960s (e.g. Lado 1957) to Error Analysis in the 1960s and 1970s (e.g. Corder 1967, 1981) to the importance of interlanguage from the 1970s onwards (e.g. Selinker 1972). Finally, Sharwood Smith (1994) elaborates a history dating from the early 1970s by weaving together his personal experience with some of the key issues in SLA, such as the systematicity of learner language, creative construction, and the role of Universal Grammar in the language-learning process.

Apart from these brief and indirect references to the history of SLA, there have also been cases where authors have clearly marked their territory by explicitly setting out to write a chapter or a substantial parts of a chapter on the history of SLA. The best example of this tack is perhaps Selinker's *Rediscovering Interlanguage* where the author engages in the 'purposeful misreading of founding texts' (Selinker 1992: 3) as he offers exhaustive coverage of the work of Weinreich (1953), Corder (1967), Nemser (1971) and himself (Selinker 1972). Selinker's book is not presented to the reader as a general SLA textbook; however, it is probably the best, and certainly the most thorough, introduction to the foundational years. As regards what are more properly SLA texts, Cook (1993), Ritchie and Bhatia (1996) and Mitchell and Myles (1998) devote clearly delineated chapters to an outline of the history of SLA.

In addition to the texts cited above, some timely survey articles have had the function of taking stock. In this category we find Hakuta and Cancino (1977); Hatch (1978); Lightbown (1984, 1985, 2000); Newmeyer and Weinberger (1988); Larsen-Freeman (1991); Gass (1993); and Schachter (1993) to name a few, in addition to collections such as Beebe (1988) and special issues of *Language Learning* edited by Brown (1976), Guiora (1983) and Cummin (1998).

Whatever the approach or the amount of space devoted to the history of SLA in such texts, there does emerge an official story, one which, in Long's terms, 'is generally accepted', although it is debatable whether the starting point is better placed in the 1940s or, as Long suggests, the late 1960s. In citing the latter, Long more than likely refers not so much to the intellectual and research beginnings, but the moment in which a critical mass was reached, whereby one could begin to speak of SLA as a respectable area of research in its own right. If we compare the number of SLA publications and conference papers in the 1960s with those of 1970s, we can readily see Long's point. However, authors such as Selinker (1992) explicitly cite what he calls 'founding texts' and these precede the watershed of the late 1960s. In the official history which I now present, I have chosen to follow Selinker and therefore begin in the 1940s.[2]

2.3 PROGRAMMATIC AHISTORICITY?

Before proceeding, it should be acknowledged that although SLA is so often presented as a relatively recent academic discipline, there is not a total consensus on this matter. Margaret Thomas (1998) laments that SLA texts make few references to the learning of second languages before the mid-twentieth century and calls these omissions 'programmatic ahistoricity'. Thomas is careful to point out that she is not particularly interested in the kind of programmatic ahistoricity which takes the view that agreement about what the key questions are and how they are to be explored is only relatively recent. Nor is she concerned with ahistoricity as it relates to the view that only recently has SLA taken on the institutional features necessary to warrant the label of 'field' (that is, publications and academic programmes of study). What does concern Thomas is ahistoricity on the conceptual and notional level, in short an ignorance of how present ideas evolved from ideas first formulated centuries ago. As an example of an early reference to SLA, she cites a thirteenth-century 'exposition' by Roger Bacon on 'three degrees of knowledge of a foreign language' (Thomas 1998: 392); Augustine's fourth-century references to his own language-learning experiences; and books by various linguists which contain suggestions that many notions and concepts date back longer than many authors suggest.

It is Thomas's belief that an over-reliance on Chomskyan linguistics as a point of reference (and beginning) for analytical tools and theoretical assumptions, coupled with a sneaking tendency in the field to disengage from practical teaching matters, have together created the atmosphere where conceptual ahistoricity is accepted. According to Thomas, the link with Chomskyan linguistics is important because those working within this paradigm tend to see the beginning of linguistic history in the 1950s (although, as Thomas points out, this is not a view held by Chomsky himself). The tendency towards disengaging from practical teaching matters is important because those who work in language teaching have tended to acknowledge a history that goes back centuries. As the work of Titone (1968), Kelly (1969), Howatt (1984) and Musumeci (1997) demonstrates, moving away from language teaching means moving away from historical consciousness.

In a reply article, Gass, Fleck, Leder and Svetics (1998) contest Thomas's version of events. First, they suggest that a major reason why SLA researchers and authors of texts do not spend much time discussing the centuries-old past of SLA is the lack of any clear continuous line between the concepts and notions raised in the work of scholars such as Bacon and Augustine and those that have become prevalent over the past forty to sixty years. The support for this argument is convincing if we are to judge by the lack of any tangible link across the centuries such as citations in books; however, we might still contest that to some extent it seems to ignore how ideas from the past subtly creep into our collective consciousness and do have an effect on how we conceive of phenomena in the present.

A second and more important reason for not taking on board Thomas's arguments about ahistoricity is the way in which Thomas apparently plays down the importance of ahistoricity in the areas of key questions and epistemology, on the one hand, and the institutional trappings of a field, on the other hand. If we examine any of the texts cited above which present histories of SLA, we see that these two aspects of the field of study are of primary concern. Indeed, in some cases, the authors seem preoccupied with SLA becoming a field when there was first agreement about key questions and how to answer them, and with the development of an institutional infrastructure of conferences, publications and academic existence. Thus, to varying degrees in all of the textbooks cited above as well as in articles such as Long (1990, 1993), Larsen-Freeman (1991), Pica (1994, 1996) and Lightbown (2000), we find references to agreed-upon questions, research procedures and what Long (1990) has termed 'accepted findings'.

Although there is obviously room for disagreement with the exact positions taken by many scholars vis à vis issues of this type, there does seem to be some justification for setting the history of SLA as a field, particularly as regards these issues, in the second half of the twentieth century. This is not to deny that as soon as people started thinking about teaching languages long ago, they may have had working theories of how people learn languages; however, if we accept that a field only becomes a field when it is recognised as such by a critical mass of people (be they from within or without), then we can accept the argument that the field of SLA has developed relatively recently.

2.4 BEGINNINGS

The beginnings of SLA are to be found in the 1940s and 1950s when three different phenomena coincided. The first of these was a sudden increase in interest in foreign language teaching and learning, which took place, particularly in the United States, during and after World War II (Allwright 1988). This increase in interest was brought about by the need for effective language skills both for communication with allies and for intelligence and counterintelligence work against enemies (ibid.). It led government officials in the US to request the services of prominent linguists such as Leonard Bloomfield and Charles Fries in the development of specialised language courses (Howatt 1984).

The second phenomenon was the development of a strong theory of language, which has come be known as American structuralist linguistics. According to this school of linguistics, the linguist first gathered language data in naturalistic settings and then, working inductively, wrote the rules of the language. The goal, as Hakuta and Cancino put it, 'was to characterize the syntactic structure of sentences in terms of their grammatical categories and surface arrangements' (Hakuta and Cancino 1977: 295). There was no attempt to provide explanations as to why languages worked as they did (this was considered to be outside the remit of the linguist, whose job it was to describe, not explain), although there was a theory of how languages were learned. This brings us to the third phenomenon that contributed to the early development SLA as a field of research: behaviourism.

Behaviourism is based on the belief that all human behaviour is the product of conditioning. Conditioning excludes any consideration of thoughts, feelings, intentions, in short mental processes in general, and is concerned exclusively with observable, mind-external causes of behaviour. These strong beliefs led early behaviourists such as John B. Watson (1919) to argue that a complex and thorough understanding of human behaviour could be reached if psychologists modelled their research methodology on that of animal psychologists studying the behaviour of rats in laboratory experiences. However, despite the association of human beings with rats in laboratories (which is perhaps the most famous legacy of this branch of psychology), it was not Watson's stated intention to confine psychology to the laboratory. Indeed, he explicitly stated in his 1919 book *Psychology from the Standpoint of a Behaviorist*, that psychology should have practical application for day-to-day activities, such as work, leisure and sex.

One application of Watson's ideas to the real world occurs in the work of Bloomfield. In 1933, Bloomfield published his classic *Language* which, according to Gass and Selinker, 'provides the most elaborate description of the behaviourist position with regard to language' (Gass and Selinker 1994: 56). In this book, Bloomfield argues that children learn their first language via a sequence of events that involves the association of uttered sounds with positive and negative responses which lead to reinforcement or a change in behaviour. Loyal to his structuralist linguistic roots, Bloomfield believed the study of language and language learning to be exclusively about observable behaviour.

The result of these three phenomena coming together (i.e. the sudden increase in interest in foreign language teaching and learning, structuralist linguistics and behaviourism) was not the beginning of SLA as we know it today, but it did lay its foundations. There certainly was a clear idea of what the three words, 'second', 'language' and 'acquisition', meant: there was a theory of language, there was a theory of learning or acquisition and there was an idea that the 'second' in the formula referred to language learning in a formal (classroom) context.[2] There was also a tangible result of this new interest in how individuals learned second languages. First, there was the publication in 1945 of Charles Fries's *Teaching and Learning English as a Foreign Language*, in which the author laid out a research programme which consisted of (1) the detailed description of the morphology, phonology and syntax of

languages, and (2) the comparison of languages so described. The goal was to demarcate common ground and differences so that predictions might be made about language-learning behaviour, in particular difficulties that learners would experience when learning a particular language as well as the areas which they would find easy as a result of similarities with their mother tongue. The second tangible result of the new interest in language learning was the founding, in 1948, of the first international journal to publish articles which were expositions of early SLA theory, *Language Learning*. The journal was published at Fries's research centre at the University of Michigan, the English Language Institute, itself founded several years earlier, in 1941.[3]

During the 1950s, three more texts, often cited as 'classic' or 'foundational' to SLA, appeared and all three marked definitive changes and advances in the nascent field of SLA. The first of these texts was Uriel Weinreich's *Languages in Contact* (1953), of which the contribution to the foundations of SLA is covered in detail by Selinker (1992). Weinreich discussed how two language systems developed and were maintained in the minds of bilinguals, introducing all-important concepts of transfer and interference. Interference applied to bilinguals who manifested confusion and overlap between their languages. For Weinreich, such interference existed at the level of underlying knowledge of the two languages in question as well as at the surface level of ongoing speech. It existed at different levels of language: phonologically, morphologically, syntactically and lexically. Finally, interference for Weinreich was bi-directional, not just working from the primary language to the secondary one, but also from the secondary one to the primary one. For Selinker, Weinreich's importance lies first of all in the way that he provided a pillar for the first elaborated theory of SLA that language learners might be seen, for all intents and purposes, as bilinguals, and second, in his formulation of the concepts of transfer and interference.

In 1957, Robert Lado published the now classic *Linguistics Across Cultures*, a book which brought together structuralist linguistics and behaviourist psychology in the development of contrastive analysis (CA) as a rigorous means of deciding what to teach, when to teach it and how to teach it. The result was a theory combining findings from linguistics and psychology, engendering key concepts such as 'positive transfer' and 'negative transfer'. One major reason for the success of CA and its methodological outgrowth, audiolingualism, was that it was systematic, coherent and indeed, as presented by Lado, even elegant. It manifested the logical progression from a theory of language and theory of learning to a theory of language learning which led to syllabus-design guidelines and materials development and onto recommendations about methodology. It was therefore also significant because it represented the first scientific attempt at understanding language learning with a view to improving teaching practice, taking over from more philological approaches to language teaching which emphasised culture transmission and literary tradition, with little or nothing to say about how learning took place. A current parallel to this progression is the tendency among many researchers working on different versions of the IIO model (e.g. Gass 1997; Skehan 1998; Long forthcoming) to make recom-

mendations about methodology, materials and syllabus design based on SLA research (there is more about the IIO model later in this chapter).

In time, however, CA came to be challenged and it was eventually cast aside. First, it did not pass the empirical test of actually working in practice. As Newmeyer and Weinberger (1988) put it, 'not only did learners fail to exhibit the errors predicted by negative transfer, but many cases of positive transfer did not materialize' (Newmeyer and Weinberger 1988: 35). As regards negative transfer, it was predicted that a L1 speaker of Spanish, a language with preverbal pronouns ('el gato los comió.'), would produce utterances such as 'the cat them ate' instead of 'the cat ate them'. However, Spanish speakers do not normally produce such utterances. As regards positive transfer, an L1 Spanish speaker would be expected to have no problem producing simple utterances such as 'John is not here' in English; yet Spanish-speaking students are often observed to produce copula-dropping utterances such as 'John not here'. The explanation cannot be one of transfer, and surely has more to do with real-time processing or even universal acquisition order constraints than differences and similarities between English and Spanish.

A second and much more important reason for abandoning CA is directly related to changes taking place in linguistics and cognitive psychology in the late 1950s. In the same year as Lado published *Linguistics Across Cultures*, the behaviourist psychologist B. F. Skinner published *Verbal Behavior*, his personal foray into language (1957). Perhaps the best known behaviourist of all time, Skinner began his career in the laboratory but later branched out, putting into practice Watson's suggestion that behaviourism should be relevant to real life. Skinner was not content with the rather simplistic notion of reflex, the most rudimentary version of stimulus-response psychology, and he developed a theory called 'operant conditioning'. This invested the individual with the capacity not only to respond to stimuli but also to act on the environment. Human beings were thus seen to actively take those actions which led to positive reinforcement in the past and to avoid those actions which led to negative reinforcement. Connected to the theory of operant conditioning is the notion of shaping: Skinner thought that by controlled reward and punishments in response to particular behaviours, an individual can manipulate and ultimately predict and control the behaviour of others. Following Bloomfield's attempt to fuse structuralist linguistics and behaviourist psychology, Skinner published what many believe to be the definitive behaviourist statement on language and how it is acquired.

Unfortunately for Skinner and his followers, two sets of events taking place in the 1950s were to convert his book into a classic target for anyone wishing to point to misguided science in action. The first of these was the pioneering work in cognitive psychology by researchers such as George Miller. In 1956, Miller published his classic article, 'The magic number seven, plus or minus two'. In this article, Miller made the point that human beings are limited-capacity information processors: like computers, they can administer, organise and store incoming data, but unlike computers, they cannot take on too many tasks at once and there is a limit on how much data they can be attentive to and process at any given time. Miller's ideas

opened the door for researchers interested in strategies employed by individuals in the face of information overloads. Notions such as 'capacity constraints' and 'processing strategies' made behaviourist psychology, with its rudimentary view of cognition, seem inadequate. The field of psychology was ripe for a major paradigm shift and this came in the form of the information processing model of cognition which has dominated to this day (see Lachman et al. 1979; Baars 1986 and Mandler 1985, for surveys of such developments, and Chapter 5 for further discussion).

The other set of events running counter to Skinner's views of language and language learning came from theoretical linguistics. In the 1950s Noam Chomsky appeared on the scene. In 1957, he published his classic *Syntactic Structures* and in 1959 a review article of Skinner's book which many cite as pivotal in the development of linguistics and psychology. Ellis (1994a) sums up the effect of Chomsky's review as follows:

> Chomsky's review of Skinner's *Verbal Behaviour* set in motion a re-evaluation of many of the central claims. The dangers of extrapolating from laboratory studies of animal behaviour to the language behaviour of humans were pointed out. The terms 'stimulus' and 'response' were exposed as vacuous where language behaviour was concerned. 'Analogy' could not account for the language user's ability to generate totally novel utterances. Furthermore, studies of children acquiring their L1 showed that parents rarely corrected their children's linguistic errors, thus casting doubt on the importance of 'reinforcement' in language learning ... the demise of behaviourist accounts of language learning led to a reconsideration of the role of the L1 in L2 learning.
>
> (Ellis 1994a: 300)

In addition, Chomskyan linguistics was an overwhelming challenge to many of the basic tenets of structuralist linguistics. Above all, as Newmeyer and Weinberger (1988: 36) point out, it meant a break with the relativistic notion that all languages could be studied 'on their *own* terms' (1988: 36). Chomskyan linguists made the convincing case for a universalist model, one which established that at a deep level all languages shared the same properties. In addition, Chomskyan linguistics introduced the notion that the developing grammar of the child is systematic from the start and not just a reflection of what he or she has been exposed to in the way of linguistic input. The upshot of these changing views of language and linguistics was that errors came to be considered as evidence of development as opposed to the product of undesirable habit formation. The author most associated with introducing this new concept of error to those interested in SLA was Pit Corder. Corder is for many authors the beginning of SLA, what Long means when he writes that 'SLA as a modern field of study is generally accepted as dating from the late 1960s'.

2.5 THE 1960s AND 1970s

Michael Sharwood Smith (1994) describes in some detail what he sees as the two

basic developmental phases in SLA during the decade spanning the late 1960s and the mid-to-late 1970s. These two phases are dominated by two key concepts: the first by the concept of 'interlanguage' and the second by the concept of 'creative construction'. In this section I follow Sharwood Smith closely in highlighting the key features of these two phases. This discussion takes us to the next sections of this chapter, which describe the phase of SLA history that is still with us today, namely consolidation around agreed questions, agreed-upon research agendas and sufficient institutional development to merit the qualification of field.

2.5.1 Interlanguage

In 1967 Stephen Pit Corder published his seminal paper 'The significance of learners' errors' (see also Corder 1981 for a classic collection of his work on error analysis and Davies et al. 1984, for a tribute to the concept), which Selinker calls '*the paper that began current interest in SLA and IL [interlanguage] studies*' (Selinker 1992: 149). In this paper, Corder made the point that learner errors should be seen not as proof of incomplete learning, but as proof that learners at any given point in their L2 development possess some form of linguistic competence which is systematic.

Corder is the pivotal reference in so many texts about SLA because of that (at-that-tme) revolutionary idea and also because, as Sharwood Smith points out, he introduced several key notions which are still with us to this day. One key notion is what Corder called the 'inbuilt syllabus' which went hand in hand with the idea that learners will not learn what they are not ready to learn. Here Corder introduced a psycholinguistic constraint on learning, suggesting that learners are hardwired in such a way that they will learn linguistic items in an internally determined order as opposed to one determined externally by a syllabus writer or a teacher. A second key notion introduced by Corder was the distinction between *input* and *intake*, the former seen as what the learner is exposed to, the latter as what he or she actually takes in. A third key notion is that of 'transitional competence' or the learner's 'knowledge of the language to date' (Corder 1981: 10). A fourth key notion is the distinction between *errors* and *mistakes*, with the former seen as representative of the learner's present transitional system and the latter seen as a product of performance and hence unsystematic. Finally, a fifth key notion is that of 'idiolect': Corder saw the learner's interlanguage system as a variant somewhere between the L1 and the target language, which, in contrast to a dialect shared by many individuals, is possessed by the individual and the individual only. William Nemser (1971) and Larry Selinker (1972) are generally identified as the researchers who extended many of the Corder's key notions. Nemser, for example, coined the term, 'approximative systems' as an extension of Corder's references to transition systems, while Selinker coined what to this day is one of the most frequently used terms in the field: 'interlanguage'. As Sharwood Smith points out, along with Corder, these researchers took on three basic assumptions: (1) that language learners are in possession of a complex and creative learning device; (2) that the learner's language competence at

any given time is internally coherent and systematic; and (3) that the learner's transitional competence or interlanguage is an idiolect, held by the individual in a unique way.[4] In doing so, they (and others) were laying the groundwork and foundation for what we know today as SLA.

During the Corder-led era, researchers were working bottom up, so to speak, from the practical day-to-day puzzle of how people learn languages. They were not seeking a justification for any theory from linguistics or psychology by using language-learning data. SLA was therefore one of the first breaks with the notion of linguistics applied, whereby linguistics provides theories which are then used in attempts to understand and explain events and phenomena in the real world of language teaching and learning. Instead, the field became a branch of applied linguistics (Widdowson 1990), a discipline inside which problems and research agenda are created. Selinker (1992) puts the Corder era in perspective when he makes the case for three epistemological data bases available to SLA researchers. These data bases are: (1) experiential evidence, 'derived from an individual experience with language learning'; (2) observational evidence, 'derived from observing learners in action'; and (3) empirical evidence, 'derived from carefully planned and well executed study' (Selinker 1992: 234). SLA began as a field when individuals who had language-learning experiences themselves and whose work as language teachers had led them to observe language learning in action, came also to adopt an empirical stance which allowed them to study language learning systematically.

Since Corder, the tendency in SLA has been to work from puzzle to refined questions to conceptual models to research methodology, and so on. This is an important point to make since it goes a long way towards understanding the apparent ahistoricity criticised by Thomas (see discussion above). SLA was born in the later 1960s because that was when individuals brought together experiential, observed and empirical knowledge. The interest in second language acquisition was their starting point; it was not an appendage to an interest in linguistics, psychology or language-teaching pedagogy.

2.5.2 Creative construction

The second primary developmental phase described by Sharwood Smith, this one taking place primarily in the 1970s, was creative construction. For Sharwood Smith, creative construction refers to 'a school of thought which maintained the view that L1 and L2 acquisition were similar and were driven by the same subconscious learning mechanisms unaffected by conscious intervention and crosslinguistic influence' (Sharwood Smith 1994: 197). An oft-cited precursor of this view is to be found in Roger Brown's (1973) classic work on L1 acquisition (see also Klima and Bellugi 1966; Slobin 1970; and de Villiers and de Villiers 1973). Studying the order of acquisition of fourteen morphemes by three children, Brown introduced the idea of staged development that has stayed with language acquisition researchers (both L1 and L2) to this day. He also reiterated the idea, already pretty much accepted in linguistics and only recently put forward by Corder in the context of SLA, that

grammars at any given point in development are systematic and not just arbitrary collections of linguistic phenomena.

The work of Brown and others allowed for comparisons between L1 and L2 acquisition, and soon this idea was taken up by researchers such as Heidi Dulay and Marina Burt (1973), who collected spoken data from Spanish-speaking children learning English in California. Burt and Dulay used an elicitation device consisting of picture sequences and probing questions designed to elicit certain morphological and syntactic items (the interestingly named 'Bilingual Syntax Measure'). They found that the order of morpheme acquisition among these children was similar to the orders found in previous studies such as Brown (1973) and de Villiers and de Villiers (1973). They also made what, for that time, were astonishing claims about learner errors, namely that L1 interference errors, which were morphological or syntactic calques from the L1, were far less prevalent than natural developmental errors (intralingual) errors, which were either overgeneralisations or simplifications, nearly identical to those documented in monolingual L1 children's speech. Dulay and Burt felt justified in making this claim because when they analysed 513 unambiguous errors culled from the 179 speech samples they had gathered, they classified just 5 per cent as attributable to L1 interference, while 87 per cent were classified as intralingual and 8 per cent were classified as unique. It should be pointed out that Dulay and Burt did not use the same criteria used previously to decide that an error was a product of L1 interference. For example, they argued that a Spanish-speaking child's utterance in English, 'he no wanna go', normally taken as a transfer error from L1 Spanish (where the negative 'no' is simply slotted in ahead of the negated verb), was in fact a general developmental error. They based this claim on the fact that a similar construction had been produced in other researchers' work on L1 English acquisition and was therefore an intralingual error. Later, Dulay and Burt (1974, 1975) examined examples from L1 speakers of other languages such as Mandarin. These studies produced similar results, leading them and others (e.g. Krashen) to make the case for universal orders in both L1 and L2 acquisition and the relative insignificance of L1 interference in the language acquisition process established facts. While a few voices contested these results at the time,[5] for the most part there was excitement and a belief that Dulay, Burt and many others soon to follow were on to something significant.

The combined claims of fixed morpheme acquisition orders, the similarity of these orders in both adults and children and the predominance of intralingual over interlingual errors, laid the groundwork for much research in the 1970s. The individual who did the most with these notions was Stephen Krashen, an early collaborator of Dulay and Burt, who appropriated these claims and concepts along with findings from neurology (Lenneberg's 1967 work on brain lateralisation) and sociolinguistics (Labov's 1970 discussion of 'monitoring'). What Krashen put together, for all its faults (about which I have more to say below), was the first broad-scope theory of SLA. This theory, or model as it was known for some many years, was and still is made up of five inter-related hypotheses (see Krashen 1976, for an early formulation of this theory). These are:

Natural Order Hypothesis: The order of morpheme acquisition is fixed and predictable. It is independent of the perceived difficulty of morphology and independent of how and in what order rules are taught in a formal context.

Acquisition/Learning Dichotomy: There are two ways of developing knowledge of a second language. The first, language acquisition, is a subconscious and incidental process leading to the development of tacit linguistic knowledge. The second, language learning, is a conscious and intentional process leading to the development of explicit linguistic knowledge.

Monitor Hypothesis: Utterances made are a product of the acquisition process. Learned knowledge can only be used as a monitor or check on production. In order for the monitor to be in action, the speaker must have time, a conscious knowledge of the rules necessary to check an utterance, and he or she must be concerned about correct form.

Input Hypothesis: Language is acquired via exposure to comprehensible input, that is linguistic input which is finely tuned so that it is either at or just beyond the speaker/hearer's current state of linguistic development (what Krashen termed *i+1*).

Affective Filter Hypothesis: Factors such as motivation, self-confidence and anxiety may be a factor in SLA but only in the sense that they may cause a speaker/hearer to raise the affective filter and in turn block out comprehensible input.

Beginning in the late 1970s and continuing throughout the 1980s there were numerous critiques of Krashen, most of which Krashen himself did not respond to, prompting Beretta (1991: 508) to comment that he had gone 'AWOL'! One of the best known of these critiques is to be found in the work of Barry McLaughlin. McLaughlin (1987) evaluates Krashen's theory according to parameters which he sets out in his textbook, *Theories of Second Language Learning*. According to McLaughlin, any SLA theory worth its salt must 'have definitional precision and explanatory power, ... be consistent with what is currently known, ... be heuristically rich in its predictions, ... and ... be falsifiable' (McLaughlin 1987: 55). In McLaughlin's view, 'Krashen's theory does not score well against any such criteria' (ibid.). For example, in relation to the acquisition-learning distinction, it is not altogether clear where one begins and the other ends, and for McLaughlin this means that it cannot be empirically tested in an effective manner. In addition, and this point was developed by McLaughlin in detail elsewhere (McLaughlin 1978 and McLaughlin et al. 1983), the acquisition-learning distinction was at odds with then-prevailing views in cognitive psychology which, although since refined, have not altered in substance to this day. McLaughlin makes reference to the distinction between automatic and controlled processing, articulated in detail in two classic articles by Schneider and Shiffrin in the mid-1970s (Schneider and Shiffrin 1977; Shiffrin and Schneider 1977). Stated succinctly, these researchers and just about anyone calling him/herself a cognitive psychologist at the time, took as axiomatic that learning proceeded from conscious, attention-focused activity to subconscious, automatic processing

(see Lachman et al. 1979, for a summary of such developments in cognitive psychology). Examples ranged from learning to drive a car to reciting a telephone number. It is a mystery to many scholars to this day why Krashen, given his background in psychology (albeit neurolinguistics), rarely referred to any of this work when presenting his theory and that he has stubbornly stuck to what is known as the non-interface position, according to which acquisition and learning are totally separate processes. I return to Krashen's views on acquisition and learning in Chapter 5.

In relation to the Natural Order Hypothesis, it has been pointed out by McLaughlin and others that the research methodology used, namely the use of the Bilingual Syntax Measure, was possibly more responsible for producing the orders discovered by researchers than the learners' Language Acquisition Devices. For example, the pictures shown were about certain events which would, it was thought, have to be talked about in a certain way. If this is the case, then one cannot be surprised at the particular morphemes produced; they are in essence an artefact of the data collection device. There is also a problem in the way that the Natural Order Hypothesis conflates production accuracy with acquisition. Clearly, just because one produces a correct morpheme when shown a picture does not mean necessarily that he or she has acquired it once and for all. In addition, there is a problem when Krashen makes claims about acquisition because most of the studies cited in support of his theory over the years have been cross-sectional (that is, one-time contacts) and not longitudinal (contacts over time). The studies therefore have not credibly been about acquisition as a developmental process at all. Finally, there is a problem with labelling individuals as Spanish speakers or Chinese speakers, ignoring their past history and whether, for example, they were knowledgeable of more than one dialect or language besides their putative L1s. I return to this point in Chapter 3.

The other three hypotheses, concerning the Monitor, Input and the Affective Filter, are also deemed by McLaughlin and others to be insufficiently defined as hypothetical constructs and imminently unobservable and hence unfalsifiable. In particular, McLaughlin takes Krashen to task for the concept of $i + 1$ as being unobservable and hence immeasurable (especially a problem as it is defined in quantitative terms). Elsewhere, Gregg has on several occasions (e.g. 1984, 1986) focused on many of the same issues as McLaughlin, but above all, he has questioned Krashen's apparent appropriation of Chomskyan assumptions (e.g. that there is an LAD) without fully explicating what he means. Takala (1984) is a particularly damning review of *Language Two* (Dulay, Burt and Krashen 1982) and convincingly challenges the suggestion that adults are inferior to children as language learners. Finally, Larsen-Freeman and Long (1991), in a particularly well articulated presentation and critique, point out other problems in the theory, such as the fact that it provides no explanation of the effects of age on acquisition or how the affective filter and the monitor function in adults but not children.

Despite all of the criticisms of Krashen's work, there are at least two ways in which it has been both exemplary in SLA and useful as regards the advancement of researchable questions. First, Krashen advanced the legacy of Corder by tying

together what Selinker sees as the three epistemological databases available to SLA researchers: the experiential, the observational and the empirical. Whatever its faults, the Monitor Model was based on: (1) the personal language-learning experiences of the researchers involved (Krashen often cited his language-learning experiences during talks); (2) these researchers' experience of having observed language learning in action (Krashen had worked as an ESL instructor); and (3) carefully planned and structured research (the morphology order studies). Krashen therefore strengthened a tradition begun by Corder and to this day the goal of carrying all three epistemological data bases, in particular the latter two, remains.

According to Lightbown (1984) and Long (1985), Krashen is also significant because his work advanced research questions by creating a model which was broad and, at the same time seemed all-encompassing, although for Long (1985), there was a need to break it down into sub-theories in order to get at these researchable questions. For Lightbown (1984), there were five source disciplines, at the time she was writing, for those researchers 'whose aim was to develop a scientific theory of SLA' (Lightbown 1984: 242). These were:

1. Linguistics: understood as exploring to what extent the Language Acquisition Device functions in SLA
2. Social psychology: understood as the study of learner differences such as aptitude and motivation
3. Sociolinguistics: understood as the study of variability in individual learner language as well as discourse analysis
4. Neurolinguistics: understood as the study of the brain
5. Psychological theory: understood as cognitive psychology, that is the study of memory and information processing.

In Lightbown's view,

One of the things which has made [Krashen's Monitor Model] interesting and intriguing is that it reflects the complex nature of SLA, taking into account concerns of linguistic theory (through its 'natural order' hypothesis), social psychology theory (through its 'affective filter' hypothesis), psychological learning theory (through its acquisition learning hypothesis) discourse analysis and sociolinguistic theory (through both the comprehensible input hypothesis and the 'monitor' hypothesis).

(Lightbown 1984: 245–6)

In addition, Krashen's theory was embraced by teachers and educational authorities alike in many parts of the world and to this day his name is one of the few from SLA which students already know when they first begin an MA programme focusing on language education (e.g. MA TESOL; MA Modern Languages). In a review of Krashen's 1985 book, *The Input Hypothesis: Issues and Implications*, Gregg (1986) states that he finds the positive reception of Krashen's theory 'disturbing' and then goes on to make the case that Krashen has been better received among American teachers working in 'elementary and adult education' than European teachers

working in the same sectors and university teachers in general. In support of this argument, Gregg claims that university teachers 'are better educated in the relevant areas and also have a good deal more leisure to study Krashen's writing critically' (Gregg 1986: 121) and that there is a stronger tradition of anti-intellectualism in the US than in Europe. In addition, Gregg states that Krashen has been popular among teachers because 'the fundamental message of Krashen's theory is that you do not have to know very much to be a good teacher' (ibid.).

A more charitable explanation for Krashen's success would recognise his communication skills (he is an effective public speaker and for many years travelled widely, giving talks to large audiences around the world) and the fact that his theory resonated with the needs and interests of language teachers working at the chalkface. Sharwood-Smith makes the point that the creative construction approach, set in motion by Dulay and Burt but refined by Krashen, downplays interlanguage and references to the L1, emphasising instead native/target norms which were said to be acquired incrementally in a definable order. While the order suggested by these researchers was contrary to that found traditionally in language textbooks, it was still an order and, more importantly, the belief in language learning as incremental and accretive resonated with teachers accustomed to working to targets with itemisable objectives. Interlanguage, by comparison, was perhaps over-analytic, too nuanced in its form and even intuitions to be of interest to teachers. Another concept from Krashen's theory that resonated with teachers was the acquisition-learning distinction. Again, what Krashen had to say was a radical departure from previous learning theories, such as behaviourism; however, it connected with what practising teachers often observed in students, namely that they can seemingly grasp (or learn) a rule, but they do not acquire it because when they are later required to produce it in a natural way (as part of an informal conversation), they cannot.

Thus, for reasons relating to his impact on SLA researchers as well as language teachers, Krashen is a pivotal figure in the official history of SLA. His theory may have been much maligned since it was first put forward in the late 1970s, but his work did set the agenda for many researchers who have gone on to become major figures in the field during the past two decades.

2.6 THE 1980s AND ONWARDS

Most authors of SLA textbooks present the official history of SLA until the 1980s in their introductions, before making a statement along the lines of the following one from Mitchell and Myles (1998: 40): 'We will not review this period [1980 onwards] in detail here, as the rest of the book is devoted to outlining the different approaches and empirical work attached to them which followed in the 1980s and 1990s.'

What has become the norm for such authors is to devote at least part of their introductions to an outline of the fundamental concepts and issues which have driven research over the past twenty years. Thus, whereas Ellis proposes what he calls 'a model for investigating L2 acquisition' (Ellis 1994a: 18; see Table 2.1 below), Towell and Hawkins provide the reader with 'five observations that can be made

Table 2.1 A model for investigating L2 acquisition (based on Ellis 1994a: 18)

Focus on learning			*Focus on the learner*
Description		*Explanation*	
Area 1	*Area 2*	*Area 3*	*Area 4*
• Characteristics of learner language	• Learner-external factors	• Learner-internal mechanisms	• Individual learner differences
• Errors	• Social context	• L1 transfer	• Learner strategies
• Acquisition orders and developmental sequences	• Input and interaction	• Learning processes	
• Variability		• Communication strategies	
• Pragmatic features		• Knowledge of linguistic universals	

about SLA ...' which '[a]ny serious approach to the construction of a theory of SLA ... would (minimally) need to offer some plausible account for ...' (Towell and Hawkins 1994: 7). These five observations are:

1. There is the transfer of phonological, syntactical, morphological, and lexical and discourse elements and aspects from the learners L1 to the target language.
2. There is staged development, from initial-state grammars heavily influenced by language transfer onto various interlanguage stages.
3. There is systematicity in learners' interlanguages at any stage in their development.
4. There is both inter-learner and intra-learner variability whereby, depending on the social or linguistic context in which they are operating, learners have more than one way of expressing an idea or carrying out a function.
5. Beyond a certain age (variously fixed somewhere between six and fifteen), there are few L2 learners who will acquire native-like competence (based on Towell and Hawkins 1994: 7–16).

In a survey article which serves as an introduction to a collection of state-of-the-art articles on SLA, Ritchie and Bhatia (1996) see three main questions that drive the study of SLA:

1. What cognitive structures sand abilities underlie the L2 learner's *use* of his or her L2?
2. What properties of the *linguistic input* to the L2 learner are relevant to acquisition?
3. What is the nature of the L2 learner's capacity for attaining the cognitive structures and abilities referred to in (1.)? Here we may distinguish the following two sub questions:
 a. What is the nature of the L2 learner's *overall capacity* for language acquisition?
 b. How is that capacity deployed in real time to determine the *course* of SLA? (Ritchie and Bhatia 1996: 19)

Finally, Mitchell and Myles make the case for four fundamental issues that have driven the SLA research agenda since the late 1970s:

1. The role of internal mechanisms.
 a. Language specific: how similar are the first and second language acquisition processes, and how far are the similarities due to language specific mechanisms still being activated? If language-specific mechanisms are important, how can they best be modelled? How relevant is the current Chomskyan conception of universal grammar?
 b. Cognitive: in what respects are second language learning and processing similar to the learning and processing of any complex skill?
2. The role of the first language. It is clear that cross-linguistic influences from the first and other languages are operating in second language acquisition, but it is also clear that such language transfer is selective: some L1 properties transfer and others do not. An important aspect of today's research agenda is still to understand better the phenomenon of transfer.
3. The role of psychological variables. How do individual characteristics of the learner, such as motivation, personality, language aptitude, etc. affect the learning process?
4. The role of social and environmental factors. How similar is the learning of a second language to the creation of pidgins and creoles? How does the overall socialisation of the second language learner relate to the language learning process?
(Mitchell and Myles 1998: 40–1)

The interest in and research on the variety of issues cited by Ellis, Towell and Hawkins, Ritchie and Bhatia, and Mitchell and Myles, has led to what authors such as Beretta (1991) and Long (1993) have lamented as an over-proliferation of theories. However, it is notoriously difficult to establish exactly how many theories there are at present. Over the years different numbers have been cited by Long (see Long 1985, 1993 and Larsen-Freeman and Long 1991). In 1985, he estimated the number to be fifteen to twenty. In 1991, along with Larsen-Freeman, he put the figure at over forty. And finally, in 1993, he wrote that '[b]y a recent count, there are between 40 and 60 theories of SLA', adding nonetheless that '[s]ome might prefer "theories", since the list includes theories, hypotheses, models, metaphors, models, perspectives, theoretical claims, theoretical models, theoretical models, and theoretical perspectives' (Long 1993: 225).

Elsewhere, McLaughlin (1987) and Mitchell and Myles (1998) are both textbooks about SLA 'theories' (as their titles would suggest). While McLaughlin analyses five theories (which he calls 'The Monitor Model', 'Interlanguage Theory', 'Linguistic Universals', 'Acculturation/Pidginization Theory' and 'Cognitive Theory'), Mitchell and Myles offer chapters on six general 'approaches' which normally contain reference to more than one theory. The approaches covered by these authors are listed as 'the Universal Grammar approach', 'Cognitive approaches', 'Functional/pragmatic perspectives', 'Input and interaction', 'Sociocultural perspectives'

and 'Sociolinguistic perspectives'. Examination of these books as well as of the others mentioned at the beginning of this chapter shows us what the key issues in SLA are. We see that the Krashen legacy remains in the form of a continued emphasis on input as essential to the process; however, to input has been added a thorough treatment of interaction and output along with a recognition of the prominent roles for both Universal Grammar and cognitive psychology. While many researchers concentrate on one particular issue in SLA, others try to construct a theory which takes into account as many findings as possible from across SLA. In the former category are researchers such as Jacquelyn Schachter (1996) and Lydia White (1996) who take a Universal Grammar perspective, or Manfred Pienemann (1998) who has developed his 'Processability Theory' around the concepts of developmental stages and learnability. In the latter group are researchers such as Gass, Long, Skehan and others who have attempted to construct a big theory under the loose rubric of the IIO model. This model, probably best articulated by Gass (1988, 1997; Gass and Selinker 1994/2001), combines the chain of input-interaction-output with findings from cognitive psychology, without losing sight of Universal Grammar as a constraint on the SLA process. To my mind, the IIO model is the closest thing to the 'big' theory which Long (1990, 1993) has often suggested that SLA should move towards. It seems that enough SLA researchers have chosen the IIO line over the past ten years in particular to make it the biggest player on the SLA scene. It is to the IIO model which we turn in the next section.

2.7 THE INPUT-INTERACTION-OUTPUT (IIO) MODEL

The IIO model has developed and become prominent in SLA over the past two decades for two key reasons. First, there was the perceived need to work from Krashen's Comprehensible Input Hypothesis towards something more complete and empirically more verified and verifiable. There was at this time a growing belief that while comprehensible input was a necessary condition for language acquisition to take place, it is not on its own sufficient. What was needed was an account of SLA that took into account, first, interaction (e.g. Long 1981) and, later, output (e.g. Swain 1985). At the same time, there was a growing need to address some of the issues outlined above, progressively coming to be considered essential features of the language acquisition process. Thus, there was an interest in developing a theory that took into account language transfer, staged L2 grammatical development, the systematicity of interlanguage, variability and the effects of age, to say nothing of the relative roles of Universal Grammar and general cognition or the various individual psychological variables which might have an effect on the process.

There are several versions of this model, most notably those put forward by Long (1996), Gass (1988, 1997) and to some extent, Skehan (1998).[6] It is Gass who has provided the most comprehensive model along these lines and it is therefore Gass who will serve as the model for what is meant by the IIO model in this book.

2.7.1 Gass's version of the IIO model of SLA

Gass's model of second language acquisition was first elaborated in Gass (1988) and updated only slightly several years later (Gass 1997; Gass and Selinker 1994), before becoming the focal point of her 1997 book, *Input, Interaction, and the Second Language Learner*, and finally being included in Gass and Selinker (2001). In Figure 2.1, I present a graphic representation of this model, based on Gass (1997: 3). In order to describe what this graphic representation means, we must explain, above all, the five primary stages as represented in the square boxes along with the mediating factors which precede each of these stages, represented by the circles (see Figure 2.1). At the top of the figure there is the INPUT, which is what sets the entire model in motion. For Gass, the first and absolutely necessary condition for any learning to take place is the provision of some form of input in the learning environment. However, she professes herself agnostic as regards the exact nature of this input (for example, whether it is elaborated or simplified) or where it should come from (teacher or fellow students in a formal setting). Nevertheless, the claim is that it is necessary.

2.7.1.1 Apperception

The apperception stage is the priming stage during which the learner notices incoming data, relating them to past experience and then parsing them into meaningful units for further analysis. Gass poses the following questions about these data: Why are some aspects of language noticed by the learners and others not? What factors mediate the process of apperception?

The answers to these questions are to be found in the first circle in Figure 2.1 which is, in effect, a filter between the input and the apperception stage, containing features such as frequency/infrequency (multiple instances or one unique, salient occurrence), affect (including social distance, status, motivation, attitude and presumably other features such as anxiety, fatigue and degree of comfort), prior knowledge (be it linguistic or more general in nature) and attention (which is said to determine the mismatch between the learner's knowledge prior to the apperception of input and the learner's knowledge after). Gass points out that these different features do not work in isolation; rather they often combine, such as when attitudes towards the L2 culture might lead to reduced attention or when a learner's beliefs about the relative merit of a particular type of language-learning activity might lead him/her to ignore input. She says that these features may determine why some input is noticed by the learner and some is not; yet, she does not address in any detail the relative importance that they have in the overall second language-learning process. Gass concludes by pointing out that the type of interaction in which the learner is engaged can determine whether or not input is apperceived. Here she makes reference to work on discourse negotiation and modification (see Long 1996 for an exhaustive summary), but relates these phenomena to their role in increasing the amount of input and hence availability of input as opposed to actually causing apperception to happen.

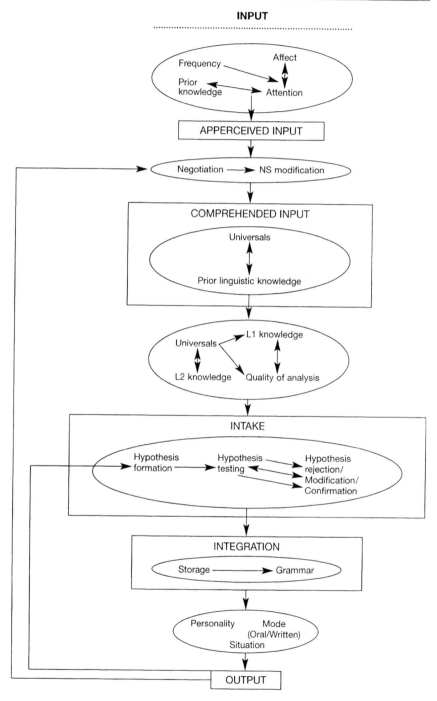

Figure 2.1 The IIO model of SLA (based on Gass, 1997: 3)

2.7.1.2 Comprehended input

Comprehended input results from apperception and represents the beginning of analysis in Gass's model. It is at this stage that the learner moves from merely noticing part of the input to which he or she is exposed to actually analysing what has been parsed for attention. Gass points out that input may be comprehended for the immediate purposes of ongoing conversation or it may be comprehended as a first step towards learning. At the same time, comprehension may be seen to occur at two distinct levels. At the more superficial and ephemeral level, there is comprehension of meaning for immediate communicative purposes. At the deeper and more elaborate level, there is comprehension of syntax for longer-term learning. Determining what apperceived input will be comprehended are aspects of prior linguistic knowledge such as the L1, the L2 being studied, other L2s which have been studied and Universal Grammar. Gass explains the redundancy inherent in reproducing prior knowledge in both circle 1 and circle 2 by pointing out that one needs a knowledge base to which incoming data can be attached, as well as a base on which to elaborate an analysis of that incoming data.

2.7.1.3 Intake

For Gass, intake 'is the processing of assimilating linguistic material' (Gass 1997: 5). It is the pivotal stage between input and grammar, the first stage during which structures internal to the learner begin to be altered in some way. Intake means the assimilation of new language features on the part of the learner. However, this assimilation is not automatic and is not determined solely by the fact that input has been apperceived and comprehended. Mediating throughout the process are prior knowledge structures such as Universal Grammar and procedural memory as well as learnability. In essence, if the learner is ready to assimilate new language features either because Universal Grammar allows it or because he or she has proceduralised a linguistic base broad and strong enough, the process of hypothesis formation, testing, modification and confirmation will commence. This process will lead to the fourth stage: integration.

2.7.1.4 Integration

Integration means the development and storage of changes that have occurred in the learner's grammar as a result of accommodation or restructuring. Gass sees the integration stage proceeding in three possible ways. First, integration will result when hypothesis confirmation or rejection occurs, that is when input serves to either confirm or disconfirm a learner's guess about how the language works. Second, integration might mean strengthening a rule already known by the learner rather than the addition of new knowledge. This strengthening in turn might mean greater proceduralisation of knowledge. Third and finally, intaken language might be stored for later use but not actually integrated into the present system.

2.7.1.5 Output

Output can serve as part of a feedback loop to the intake stage. In this case the learner tests hypothesis by producing spoken language which in turn takes the learner back to the process of assimilating changes to his or her grammar system. In addition, output can force syntactic rather than semantic analysis. In this case, it feeds back into the comprehended input stage and the beginnings of analysis. Above all, as Gass points out, output should not be viewed as an endpoint in this model; rather it is a potential catalyst for starting up the entire process again. Mediating prior to the output stage are factors such as the learner's personality, whether or not the mode of expression is written or spoken, or the actual task in which the learner is engaged. Thus, a shy learner who is not predisposed to express him/herself verbally and who is not particularly interested in the task being done because it is perhaps too demanding, is not going to participate fully at this stage which Gass considers to be not just 'the product of language knowledge ... [but] an active part of the entire learning process' (Gass and Selinker 1994: 307).

2.7.2 Conclusion

As stated above, Gass's model deals directly with (or at least acknowledges) what Ellis, Towell and Hawkins, Mitchell and Myles, and Gass and Selinker have identified as the key issues in SLA. It is a powerful model which can accommodate other well-known recent theoretical proposals such as:

1. Ellis's theory of instructed SLA (Ellis 1994b, 1997), where the focus is on how explicit knowledge becomes implicit knowledge and controlled processing becomes automatic processing.
2. McLaughlin's information processing model (McLaughlin 1990; McLaughlin and Heredia 1996) with its emphasis on restructuring.
3. Pienemann's (1998) Processability Theory, where the basic premise is that processing complexity determines the order of the acquisition of syntax and other grammatical features, and learners can only learn a feature of an L2 if they have passed through preceding developmental stages.
4. Towell and Hawkins's (1994) fusion of the principles and parameters model of Universal Grammar with work from cognitive psychology (e.g. Anderson 1983, 1995) which charts how declarative knowledge becomes procedural knowledge and how different types of memory interrelate.

The IIO model is in essence the most tangible result of over thirty years of increasingly more intensive research into how individuals learn second languages. Nevertheless, despite its many virtues, a close examination of the IIO and the field of SLA in general reveals what to my mind are two unresolved big issues. These are: (1) what exactly is meant by the 'S', the 'L' and the 'A' of SLA, in particular for IIO researchers? and (2) is there another way to conceptualise 'second', 'language' and 'acquisition'? Answers to these questions are forthcoming in the next three chapters.

NOTES

1. However, I should point out here that in Chapter 3 I discuss the work of Bremer et al. (1996), which is derived from the European Science Foundation (ESF) Project in Second Language Acquisition, carried out in the mid-1980s (see Perdue 1993a, 1993b, for a thorough survey).

2. Two caveats are in order here. First, the interest in formal language teaching and learning was not completely new. Surely there was already a long history in linguistics of references to less formal contexts of language learning such as the situations of immigrants immersed in a language. In addition, as Howatt (1984) makes clear in his historical survey of English language teaching, there has always been a theory of language-learning implicit in the different changes which have taken place in language-teaching practice. However, following the point made above in relation to Thomas's view that SLA authors act in a programmatically ahistorical manner, there is a real sense that what happened from 1945 onwards in the US and Britain was, for all practical purposes, new.

3. In Catford (1998), we find a short discussion of the evolution of what was actually published in *Language Learning* from 1948 to 1998.

4. However, as Selinker points out, interlanguage is not synonymous with Corder's 'transitional competence' or Nemser's 'approximative systems'. For Selinker, a strong form of Corder's term means that learner languages are always in a state of change and transformation. Meanwhile, a strong form of Nemser's term means that learner language is always moving in the direction of the target language and that it does so in discrete steps. Selinker rejects that learner language is always changing and for this reason he introduced the term 'fossilization' to account for the phenomenon whereby learner languages actually stabilise and do not develop at all. He also rejects Nemser's idea that learner language develops as movement away from a putative L1 towards an L2, allowing, as I read things, for backsliding and language loss. Finally, Selinker rejects the idea (also from Nemser) of development in discrete steps, preferring to see language development as proceeding from plateau to plateau, an advance on what Krashen and others were later to discover in morphological development.

5. For example, Duskova (1969) analysed a sample of English compositions written by L1 Czech speakers and found that she could attribute some 30 per cent of all errors to L1 interference. However, the most common L1 interference error in Duskova's study was the omission of articles. The Czech and English article systems are quite different, so it is easy to see how one might come to Duskova's conclusion. However, Hakuta and Cancino (1977) make the point that Dulay and Burt would have classified most of these errors as intralingual and therefore Duskova's analysis would have yielded similar results if it had been done in the same way as that of Dulay and Burt.

6. Although Skehan is primarily concerned with cognition, his model of SLA cannot function without input, interaction and output. In addition, his information processing approach to cognition is indistinguishable from that adopted by Long, Gass and others. I therefore group him at times with Long, Gass and others as an IIO researcher in this book.

Chapter 3

What does the 'S' in SLA stand for?

3.1 INTRODUCTION

Second Language Acquisition (SLA) … is the common term used for the name of the discipline. In general, SLA refers to the learning of another language after the native language has been learned. Sometimes the term refers to the learning of a third or fourth language. The important aspect is that SLA refers to the learning of a nonnative language *after* the learning of the native language. … By this term, we mean both the acquisition of a second language in a classroom situation, as well as in more 'natural' exposure situations.

<div align="right">(Gass and Selinker 2001: 5)</div>

For us, therefore, 'second languages' are any languages other than the learner's 'native language' or 'mother tongue'. They encompass both languages of wider communication encountered within the local region or community (for example, at the workplace, or in the media), and truly foreign languages, which have no immediately local uses or speakers. They may indeed be the second language the learner is working with, in a literal sense, or they may be their third, fourth, fifth language … We believe it is sensible to include 'foreign' languages under our more general term of 'second' languages, because we believe that the underlying learning processes are essentially the same for more local and for more remote target languages, despite differing learning purposes and circumstances.

<div align="right">(Mitchell and Myles 1998: 1–2)</div>

Thus is explained the meaning of 'second' in SLA by the authors of two of the better known surveys of the field. There is a lot going on in these definitions and above all, there are two general angles on 'second'. First, there is reference to a putative 'L1', 'native language' or 'mother tongue'. The latter two terms are put in inverted commas by Mitchell and Myles to indicate, I assume, that they are not accepted unproblematically by everyone, although the authors do not actually say why they themselves might consider them problematic. Meanwhile, Gass and Selinker seem to accept as relatively unproblematic the terms 'L1' and 'native language'. They define the latter term in a succinct and no-nonsense manner as 'the first language a child learns' (Gass and Selinker 2001: 5) and leave to the side situations where two or more

languages are learned from birth or where this first language is supplanted later in childhood by another language which becomes the individual's primary language. In addition, they are consistent with a certain monolinguistic bias that pervades the field. This monolingual bias involves not only an assumption of a single L1, but also the belief that the L1 remains completely intact despite contact with a second language.

In both definitions, there is also mention of a second important point, which is the possibility that a learner may be learning her/his third, fourth or even fifth language. This possibility, in fact far more common in the world than is normally entertained by SLA researchers, suggests that the term 'second' itself might not even be appropriate; however, this point is not pursued by Gass and Selinker or Mitchell and Myles as they move from preliminary definitions to the presentation of their surveys of SLA.

A second angle on 'second' in these definitions has to do with the context of learning. Gass and Selinker make a distinction between classroom and naturalistic settings, although it should be pointed out that on the same page they also, in line with Mitchell and Myles, contrast two types of classroom language learning, that is, what is understood in language-teaching literature as X (the to-be-learned language) as a foreign language, and X as a second language. In the former case, X is not the language (or one of the languages) of the community where the learning is taking place and in the latter case, X is a community language. Or, as Gass and Selinker put it,

> [X as a foreign language] refers to the learning of a nonnative language in the environment of one's native language (e.g. French speakers learning English in France or Spanish speakers learning French in Spain, Argentina, or Mexico) This is most commonly done within the context of the classroom ... [X as a second language] refer[s] to the learning of a nonnative language in the environment in which that language is spoken (e.g. German speakers learning Japanese in Japan or Punjabi speakers learning English in the U.K.). This may or may not take place in a classroom setting. The important point is that learning in a second language environment takes place with considerable access to speakers of the language being learned, whereas learning in a foreign language environment usually does not.
>
> (Gass and Selinker 2001: 5)

Thus, as regards context, 'second' is seen to be three distinct general scenarios organised along two axes: +/– classroom and +/– language in the community. These three scenarios are represented in quadrants 1, 2 and 4 in Figure 3.1. Quadrant 3, self-directed foreign language learning, has not, to my knowledge, been explored in much detail in SLA (but see Umino 2002 for an interesting survey of learners following a televised Japanese as a foreign language course).[1]

The definitions reproduced at the beginning of this chapter are fairly typical in SLA. In slightly different terms or in abbreviated fashion, they are the standard view of 'second', found not only in SLA textbooks but also in articles published about SLA

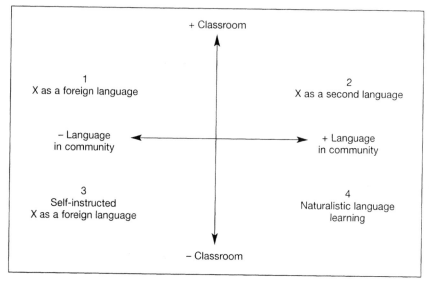

Figure 3.1 'Second' context scenarios

studies, where they are the default response to the question, 'What do we mean by "second language" in this study?' They apply to and are accepted by researchers working in a variety of sub-areas of SLA from linguistic universalists to those interested in cognitive processes, and from those who adopt a sociocultural view of SLA to those who work within the IIO model. However, despite the consensus on what we mean by 'second' in SLA, it is my view that we need to unpack some of the assumptions behind these definitions, that to present 'second' in the above manner is too partial and overly streamlined. Thus, this chapter is about problematising the two angles on 'second' set forth above. In the first section, I examine the monolingual bias, first from a linguistic standpoint and, second, from a sociolinguistic standpoint, before going on to discuss how 'second' is in fact a misnomer when it is used to refer to the experiences of individuals who have had contact with three, four, five or more languages in their lifetimes. In the second section, I make the point that while it is right for SLA scholars to distinguish between classroom/naturalistic and foreign/second contexts, they should also bear in mind that none of these contexts provides learning opportunities in anything like a predictable manner.

3.2 MONOLINGUALISM IN SLA RESEARCH

3.2.1 The monolingual bias

There is a monolingual bias inherent in use of the word 'second' in SLA, as 'second' implies a unitary and singular 'first' as a predecessor. However, as has often been pointed out by sociolinguists such as Edwards (1994) and Romaine (1995), mono-

lingualism is certainly not the norm in the world; rather, bi- and multilingualism are. In countries that traditionally have 'monolingualised' immigrants (e.g. the US and the UK), recent changes in the nature of immigration (for example, the growth of communities which retain a large proportion of their home culture such as Mexican Americans and British Sikhs) have meant that in schools in many urban areas, a high proportion of students are multilingual, often having variable competence in two, three or four languages, as they take up the formal study of secondary school French or Japanese. In addition, even in contexts that are identified as monolingual, either without or before any exposure to another language via formal education or migration, it is quite likely that individuals are, in any case, multi-dialectal. By multi-dialectal, I mean that they will have a command of two or more variants of the language of which they are said to be monolingual speakers. Thus, in my early years, I would have been classified as a monolingual speaker of Standard American English, despite the fact that I had at least one other code as part of my repertoire: African American Vernacular English.

On the subject of language unity and integrity, so fundamental to L1-L2 discussions, a half century ago, Martinet (1953) put matters into perspective for linguistics:

> There was a time when the progress of research required that each community should be considered linguistically self-contained and homogenous ... Linguists will always have to revert at times to this pragmatic assumption. But we shall now have to stress the fact that a linguistic community is *never* homogeneous and hardly self-contained ... linguistic diversity begins next door, nay, at home, and within one and the same man.
>
> (Martinet 1953: vii)

In studies of bilingualism, it is not necessarily the case that this message has been embraced fully. For example, Romaine begins a definition of bilingualism as follows:

> Bilingualism has often been defined in terms of categories, scales, and dichotomies, such as ideal versus partial bilingual, coordinate versus compound bilingual, and so on. These notions are generally related to such factors as proficiency, function and others.
>
> (Romaine 1996: 571)

Romaine goes on to make the point that views on bilingualism have varied over the years, from Bloomfield's (1933) view of full command of two separate languages to Haugen's (1953) more modest standard of the ability to produce complete and meaningful utterances in more than one language. Edwards (1994) begins his discussion of bilingualism by making the point that '[e]veryone is bilingual', justifying this seemingly audacious statement by explaining that there is no one in the world (no adult, anyway) who does not know at least a few words in languages other than the maternal variety' (Edwards 1994: 55).

In SLA, we find some reference to the question of multilingualism. The following is from Ellis (1994a: 11):

Many learners are multilingual in the sense that in addition to their first language they have acquired some competence in more than one non-primary language. *Multilingualism* is the norm in many African and Asian countries. Sometimes a distinction is made between a 'second' and 'third' or even 'fourth' language. However, the term 'second' is generally used to refer to any language other than the first language. In one respect this is unfortunate, as the term 'second' when applied to some learning settings, such as those in South Africa involving black learners of English, may be perceived as opprobrious. In such settings, the term 'additional language' may be both more appropriate and more acceptable.

Nevertheless, such words of caution are pushed into the background as researchers get on with research based on the assumption, contained in the first line of this quotation, that there is always a dominant L1. And yet if we look around us, we see that Martinet, writing half a decade ago, quite likely got it right, and that in SLA this means that talk about putative L1s and L2s is on the whole misguided and misleading. I say this in particular if we examine two separate but equally interesting lines of enquiry that have called the monolingual bias into question, one linguistically based and the other sociolinguistically based.

3.2.2 Cook's multi-competence model

One problem with the monolingual bias in SLA is the way in which it essentialises linguistic competence. As Cook (1992, 1996, 2002) points out, there is an assumed complete competence which the learner possesses in her/his L1 and an assumed complete linguistic competence in the target language which is possessed by L1 speakers of that language. Complete linguistic competence in the target language is generally considered to be out of reach for 99 per cent of the individuals who begin learning the L2 in adulthood and the concept of interlanguage is brought in to account for states of competence lying somewhere on a continuum with the L1 at one end and the L2 at the other. In short, L2 learners are seen to possess complete linguistic competence in their L1 and incomplete competence in their L2.

Cook does not deny that complete L2 competence is out of the reach of adult L2 learners; however, he does suggest a shift in emphasis away from this focus, suggesting that '[t]he starting point should be what L2 learners are like in their own right rather than how they fail to reach standards set by people that they are not by definition' (Cook 1996: 64). The 'people that they are not by definition' refers to SLA researchers, linguistically competent in the L2 in question who pass judgement on the L2 learner. Cook goes on to propose that '[m]ulticompetence is then a necessary basis for second language acquisition research' as 'L2 learners are not failed monolinguals but people in their own right' (ibid.). This multicompetence is defined simply and uncontroversially as 'the knowledge of more than one language in the same mind' (ibid.: 65).

For Cook, adopting this model means that the totality of an L2 learner's linguistic competence at any one time is not just the sum of her/his complete linguistic

competence in the L1 and her/his incomplete competence in the L2; rather it is a system which contains both the L1 and the L2. As evidence for this contention, Cook cites research that he has carried out using a variation on grammaticality judgements in the form of what he calls a MUG test (the Multi-parameter Universal Grammar test), which aims to test a language learner's knowledge of several aspects of UG (e.g. structure dependency and pro-drop) at the same time and to compare the results across a range of L2 learners with different L1s. These L2 learners are asked to accept or reject sentences along the lines of the following: 'Is Sam is the cat that brown?' (for structure dependency) or 'Is French' (for pro-drop). Cook found that when he compared learners from four L1 backgrounds – Finnish, Japanese, Chinese [sic] and English – they all scored highly on structure dependency (although Japanese and Chinese speakers scored lower than the Finnish and English speakers) but showed greater variation for the pro-drop sentences: the Japanese and Chinese speakers scored 64.2 per cent and 73.3 per cent, respectively, while their Finnish and English counterparts scored 92.8 per cent and 90 per cent respectively. Cook concludes that the Japanese and Chinese speakers' competence in an L1 that allows pro-drop was crucial in this result.

Another source of evidence focuses on the same aspects of UG, but compares two groups of English speakers: 'English people who know French' and 'English people who do not know French' (ibid.: 65). Cook notes that despite the fact that neither English nor French are pro-drop languages, the English speakers who know French show a higher tolerance for sentences where pronouns have been omitted (e.g. 'Is French'). If the research described in the previous paragraph suggests that there is influence from the L1 to the L2, in terms of parameter setting, this research suggests that exposure to an L2 destabilises, or in any case changes, knowledge in the L1, but not always in the most obvious way. It would be one thing for the English + French individuals to show a change in their judgement where particularly French parameter settings are in order (e.g. with adverb placement in sentences such as 'I like very much to play'). However, it is altogether another matter for these individuals to manifest tolerance for a parameter that does not exist in either language. Cooks sees such results as evidence for a unified linguistic competence in which knowledge of two or more languages co-exists and overlaps.

Cook's argument is a linguistic one that challenges the notion of separate competences and hence the possible clean separation between idealised L1 and L2 that permeates SLA research. Importantly, it gains credibility from studies of three observed language phenomena: code switching, borrowing and language attrition. Although initially conceptualised in social and sociolinguistic terms – a concern with 'who uses which linguistic varieties where and when and to whom' (Meyers-Scotton 1997: 218) – code switching has in recent years also been seen in terms of linguistic features, in particular the morphosyntax of intrasentential switching. In other words, there has been a concern with answering the question: '[W]here in a sentence can a speaker change languages?' (ibid.: 219). In the following example, produced by a Catalan-speaking EFL student in Barcelona several years ago, the answer to this question is at clause boundaries:

To speak English without grammar, és molt difícil.
(To speak English without grammar, it's very difficult.)

In Cook's terms, the individual who switches languages in mid-sentence, but still respects syntactic boundaries, may be seen to be drawing on multi-competence as the process 'requires, if not a single system, tight interconnections for switching from one language to another' (Cook 1996: 65–6).

Equally, with lexical borrowing, we can see the idea of multi-competence coming to the fore. Another example from my EFL teaching experience in Barcelona was uttered by a student when she felt that it was time for us to take a break halfway through a lesson:

Quan farem un *break* [brek]? Estem molt *tireds* [taɪrɛts]
(When will we have a break? We are very tired.)

In this case, the student was functioning primarily in Catalan, while borrowing English words which were part of the procedural vocabulary of her lessons. Notably, she uses the masculine indirect article, 'un', with 'break', as the word in Catalan ('descans') is masculine. She also inflects the adjective 'tired' in the same way that she would if she used the Catalan word ('cansat' → 'cansats') in order to produce a plural form of the adjective consistent with the plural pronoun (pro-dropped in this case) 'we'. Finally, she pronounces the English words using Catalan phonology, producing /brek/ for 'break' and /taɪrɛts/ for 'tireds' [sic].

Cook's theory of multi-competence also articulates well with theories of primary language attrition. Primary language attrition (see Seliger and Vago 1991; Seliger 1996) may be defined as:

the loss of aspects of a previously fully acquired primary language resulting from the acquisition of another language ... as reflected in a speaker's performance or in his or her inability to make grammaticality judgements that would be constant with native speaker (NS) monolinguals at the same age and stage of language development.

(Seliger 1996: 605–6)

It is most common in the case of immigrants who have taken up residence in a context where their previous language(s) is/are not dominant sociolinguistically. In such situations, there is a gradual erosion of the individual's ability to recall lexical items in the attrited language and, more importantly, morphological, syntactic and phonological changes begin to take place. Thus, Spanish speakers in an English-speaking environment may begin to produce utterances such as 'te llamaré atrás' (literally, 'I'll call you back') instead of 'te volveré a llamar' and may provide more pronouns than a pro-drop language like Spanish requires. Meanwhile, English speakers in a Spanish-speaking environment may begin to manifest a marked preference for utterances such as 'It's possible he'll come' over 'He may come', and may in general use far more lexical items of Latin origin than English speakers who have always lived in English-speaking environments.

What Cook's discussion and the examples cited here point to is the idea that linguistic competence is not stored in the mind in neat compartments with clear boundaries; rather, a more appropriate image is that of a mass with no clear divisions among parts. Nor is linguistic competence in different languages stable over time as there is constant bleeding between and among languages as well as additions and losses in terms of repertoires. Apart from making sense as a means of accounting for seemingly mixed linguistic competence across two or more languages or dialects, multi-competence also articulates well with the work of sociolinguists who have challenged notions of bilingualism that are firmly entrenched in lay and academic conceptualisations of how individuals engage in communication using different repertoires. Let us see how.

3.2.3 Sociolinguistic views of multilingualism

Over the past decade, Roxy Harris, Constant Leung and Ben Rampton have individually and collectively written about multilingualism in British education (Harris 1997, 1999; Leung 2001; Rampton 1995, 1999; Leung, Harris and Rampton 1997; Harris, Leung and Rampton 2002). One area of inquiry, developed in particular by Harris, has been the notion 'romantic bilingualism':

> The term 'Romantic Bilingualism' … refer[s] to the widespread practice, in British schools and other educational contexts, based on little or no analysis or enquiry, of attributing to pupils drawn from visible ethnic minority groups an expertise in and allegiance to any community languages with which they have some acquaintance.
>
> (Harris 1997: 14)

There is also the tendency to essentialise notions of L1 and L2, seeing both as self-contained entities, thoroughly developed and working in parallel. However, the reality is a different story. In Harris, Leung and Rampton (2002) the case of T, a 15-year-old English youth of Asian background, is presented:

> T. is 15 years old and born in the UK. His mother, a Sikh, was born in India but has spent most of her life in Britain. 'When I was born my father left me and my mum', and now his father, a Muslim, lives in the United States, though he often stays with the family in the UK. T. has relatives in India and he has visited there twice. T. has strong Sikh affiliations, but doesn't display any visible signs of this. He is, however, a leading member of a Punjabi dhol drumming band [The dhol drum is a key instrument used in the production of bhangra, a traditional music of the Punjab, India] and often performs in school. Three of the seven band members wear Sikh turbans, but when asked if they ever wear traditional Punjabi dress, he is emphatic that for them this denotes the practices of an older generation: '[the] older time ones, yeh, they wear their Indian clothes, yeh? the proper bhangra so like … we're the Dholis of the new generation yeh? so we wear Ralph Lauren clothes and all that we like we got our Ralph Lauren suits … stripey trousers with blue shirts … we wear um black Kickers [shoes].' T. and the band

have played alongside well-known bhangra artists and film stars from India at major shows in London.

T. takes great pride in the Punjabi language – 'my language is very important to me' – and insists that before he first attended school, he mainly spoke Punjabi, with little exposure to English. To develop his Punjabi and to teach him more about Sikh religion, history, culture and traditions, his family sent him to a voluntary community school on Saturdays between the ages of seven to nine, but he didn't continue with this because 'I didn't like the writing part ... I thought my mum can't write it, so my grandparents can't write it. My grandad can but my grandmother can't so I thought it isn't really important.' He also finds it difficult to read Punjabi in the Gurmukhi script at the Gurdwara, though he can improvise written representations of Punjabi speech in the Roman alphabet. At Blackhill School, he has been learning to speak, read and write German for almost four years, and so now, although his written standard English is modest to weak, his literacy competence is strongest in English, with German next and Punjabi third. In terms of spoken language, T. is very aware of variation in Punjabi: 'When I am with my friends I speak slang Punjabi. When I am with my family I speak standard casual Punjabi. But when I go to India I get very weird Punjabi. In India they pronounce words differently.'

He also affiliates to Jamaican language ('rasta talk') – 'we don't say hello ... we say "wha gwan" and all that, we say it like that ... we don't talk English' – although not as strongly as some of his peers: 'They've got into the rasta man talk and all that – they can't come back to Punjabi, like now V. in our year, he's Punjabi but he speaks rasta and all that ... I don't think he knows a lot about his religion.'

Beyond its general currency, T. also picks up Jamaican language from inter-ethnic friendships outside school, and he also loves Reggae music: 'white mans ain't composed it ... it's the black people they composed it ... we like their music ... I'm not interested in anything the songs that English people sing, the ones I like Bob Marley and all that, we used to listen to that ...'

(Harris, Leung and Rampton 2002: 41–2)

It is interesting to compare T's story with how he would be classified by his school in London, that is, as a bilingual Punjabi/English speaker. Such an essentialised classification accounts neither for the different varieties of Punjabi with which he has had contact and which he has used during his lifetime, nor for the varieties of English which form part of his repertoire. It also would say nothing about other forms of symbolic behaviour associated with these different varieties, from the dress and music associated with his participation in Anglo-Punjabi cultural events to the 'rasta' talk and music associated with his forays into Anglo-Jamaican culture. Finally, the classification seems odd in the light of the estimation that his written Punjabi is actually worse than his written German, a language he has studied formally under far-from-ideal circumstances at the secondary school level.

Elsewhere, Benjamin Bailey (2000) comes to similar conclusions about the difficulty of qualifying and categorising bilingualism as he explores the language

use of first and second-generation immigrants from the Dominican Republic in Providence, Rhode Island in the US. Bailey is interested in how adolescents attending a secondary school negotiate multiple identities via heteroglossic practices. In particular, he focuses on how one student, Winston, who is phenotypically of African descent, moves in and among at least six different language varieties on a day-to-day and even moment-to-moment basis. These varieties are Spanish (presumably meaning some type of idealised standard general Spanish), distinctively Dominican Spanish, African American Vernacular English, Dominican English, American English (Providence sociolect) and Hispanicised English (the English spoken by recent immigrants to US). The following example shows how in the space of a short exchange of one minute and thirty-six seconds in length, Wilson and his interlocutor, JB, use five varieties: distinctively Dominican Spanish (DS), American English (AE), Hispanicised English (HE), Dominican English (DE) and African American Vernacular English (AAVE):

[Notes on transcription: Italics = said in Spanish; [XXX] = Translation of Spanish into English; /buklin/ = Phonetic representation; (five) = Uncertainty about accuracy of transcription.]

Wilson (DS):	*Qué tú vas (a) hacer hoy en tu casa loco?* ['What are you going to do at your house today, man?']
JB (DS):	*Puede ser que vaya a jugar pelota con Tito* ['I'll probably go play ball with Tito']
Wilson (DS):	*Con?* ['With?']
JB (DS):	*Con Tito.* ['With Tito.']
Wilson (AE):	Oh.
JB (DS):	*Que si no ibas para* /buklin/? ['Weren't you going to /buklin/?']
Wilson (DS):	*Donde?* ['Where?']
JB (HE):	/buklin/
Wilson (AE/DE):	Oh. /bʌklən/. At what time?
JB (HE):	(five)
Wilson (AAVE):	Oh wor(d)! I'm gonna break you up.
JB (DS):	*No me hagas reir.* ['Don't make me laugh.']

(Bailey 2000: 563–4)

In this excerpt, Wilson and JB initially speak in Dominican Spanish, but Wilson then switches in his third turn to American English. JB moves the conversation back to Dominican Spanish, but the confusion over JB's pronunciation of 'Bucklin' (a park in Providence where the speakers go to play basketball) leads to a three-turn exchange involving Hispanicised English, American English and Dominican English. Wilson sticks with American English and then says 'I'm going to break you up' in African American Vernacular English, before JB closes the conversation in Dominican Spanish.

In the context of American demographics and education, Wilson might alternatively be defined as Hispanic (an ethnolinguistic category) or African American (a

racial category, although here it might be stretched to include anyone of African descent even if that African descent was originally outside the US). While both categorisations are fraught with problems both in general terms and in terms of Wilson, it is the ethnolinguistic classification that is of greatest interest here. If identified as Hispanic, Wilson is classified as an L1 speaker of Spanish who has acquired English as an L2 in the natural setting that is his home community in Providence. However, as we can see in the short excerpt reproduced above, the situation is far more nuanced. Indeed, it is easy to imagine, following Cook, that Wilson has a mass of language competence in his head that is not separable into individual languages. In this exchange his L1 Spanishes are constantly slipping into varieties of English and his L2 Englishes are alternatively used as primary and secondary voices in conversations.

Yet another interesting 'bilingual' context is discussed by Monica Heller (1999). Heller carried out a three-year ethnographic study of a monolingual French secondary school in Toronto. Among other things, she noted the tension between the monolingual policy of the school within the confines of classrooms and the multilingual reality of exchanges taking place among students outside the classroom. In the classroom, the adoption of a model of interaction which allowed the teacher to control turn-taking served as guarantee that French would almost always be spoken. However, outside the classroom, students employed a number of language varieties to serve their purposes that were dependent on the physical and social context. Thus, there were the 'perfect bilinguals' who played the game of maintaining French in the academic context while developing a social existence in English or English-influenced French. There were students who had moved to Toronto from Québec and were not interested in French-English bilingualism; rather, they would have been content to inhabit a monolingual French environment, both inside and outside the classroom (nevertheless, these students were often taken to task for their Québécois which was considered to be sub-standard French). There were L1 Francophones from other parts of the world, such as Northern Africa, for whom English might be more palatable than it was for the Québécois, for the simple reason that they were likely to stay in Anglophone Canada, not having a Québécois identity to fall back on. There were students from Somalia, who had come to Canada already proficient in French and could only communicate effectively in Somali and French. And there were primarily Anglophone students for whom French had no function whatsoever outside the classroom. In addition, these students were speakers of standard Canadian English but were influenced by African American Vernacular English. Reading Heller's account of her research, one is once again left with the impression that it is difficult to talk about bilingualism as two languages, as there seem to be several different French and English varieties which might become part of the repertoire of any student, depending on her/his social affiliation.

In this section, we have examined three cases where it is difficult to define language competence in terms of one, two or three languages, since observations of language use give the lie to the idea that a speaker speaks one language sometimes, then another at other times, and that it is a question of describing linguistic

competence in the different languages and of documenting code switching so as to establish rules. A more accurate appraisal of such situations is that, in linguistic terms, individuals are displaying multi-competence and that, in sociolinguistic and social terms, they are involved in an ongoing process of identity construction, maintenance and projection.

3.2.4 Multilingualism as multi-experiential

If 'second' does not appropriately apply to so-called bilinguals and multilinguals as they begin to learn another language, it is also misleading when it is used to refer to the experience of individuals who are learning not their first additional language, but their second, third, fourth, fifth or more additional language. On the one hand, there are many individuals who have engaged in the formal study of, or had naturalistic exposure to, three or more languages in their lifetimes. On the other hand, there are individuals who from birth have been exposed to two or more languages and later in life have been exposed to more either in formal or naturalistic contexts. Given the nature of SLA studies where, as Firth and Wagner (1997) argue, notions of L1 and L2 are essentialised and there is not adequate attention to individuals having any identity other than that of learner or non-native speaker, there has been little discussion of the problem with using 'second' as an all-purpose cover term for all language-learning experiences which are understood to be beyond the L1.

A notable exception is a recent collection edited by Jasone Cenoz and Ulrike Jessner (2000) devoted to the learning of English as a third language in different European contexts. The contributions to this volume provide the reader with a good idea of the number of different routes Europeans follow to the learning of English, either formally or naturalistically. These different routes are outlined by the editors in the Introduction and include situations such as speakers of Frisian who are proficient in the majority language of the Netherlands (Dutch) and who study English as a foreign language in school, or Turkish-speaking immigrants to Germany who are educated in German and study English as a foreign language in school. Momentarily moving beyond Europe, the authors also make the point that such trilingual combinations are also common in many parts of Africa and Central and South America. Given the pervasiveness of third language acquisition and, more importantly, the qualitative differences between such situations and the idealised situation, dominant in SLA, of the monolingual learning an L2, Cenoz and Jessner suggest that third language acquisition (TLA) 'is a more complex phenomenon than second language acquisition (SLA)' (Cenoz and Jessner 2000: ix). In her individual contribution to the volume, Cenoz (2000) seems to argue that it is perhaps neither wise nor accurate to subsume multilingual acquisition under the umbrella term of SLA. Because those who define SLA always include TLA in their definitions (see the two definitions at the beginning of this chapter), what Cenoz and Jessner suggest amounts to a secession movement: 'second' does not represent TLA (or multilingual acquisition in general); therefore, TLA is a separate field of inquiry.

Given the paucity of publications like Cenoz and Jessner (2000), some of the

most interesting accounts of multiple language-learning experiences are to be found in autobiographical accounts, such as those presented in Belcher and Connor (2001). An interesting example in this collection is Andrew Cohen's account of his contact with different languages. Cohen, who identifies English as his L1, is a remarkable case of multilingualism as he has attained a degree of functionality and literacy in no fewer than eleven languages. In order these languages are: Latin, French, Italian, Spanish, Quechua, Aymara, Portuguese, Hebrew, Arabic, German and Japanese. One interesting aspect of being a multilingual in contact with new language is the question of transfer from one language to another. Cohen describes how after learning Italian naturalistically while a university student in France, he had the opportunity to return to this language thirty years later during holidays in Italy. By this time he had studied Spanish and Portuguese. Cohen explains the ease with which he was able to pick up Italian again as follows:

> Given the solid base I had by that time in Spanish, as well as French and Portuguese, Italian did not pose major problems, at least with regard to basic conversation. And the reading of signs, menus, and the like was not particularly taxing.
>
> (Cohen 2001: 83)

In contrast to his experience with Italian was Cohen's experience with Japanese. He had identified this language as 'a special kind of challenge since it was so different from any other languages I had studied' (ibid.: 87), and he attended classes from the beginning since naturalistic learning was out of the question.

Another interesting aspect of multilingualism is the impression held by multilinguals that they think in certain languages when they are trying to communicate in another. As regards his spoken Arabic, Cohen says the following:

> When I speak Arabic today, I think partly in Hebrew (as Arabic and Hebrew share common words and grammatical structures) and partly in English. Interestingly enough, when I think in Hebrew, I think from right to left as I visualize words, and when I call up an English transliteration, it is from left to right in my mind even though I learned through Hebrew transliteration.
>
> (ibid.: 86–7)

In his account, Cohen makes clear that his accumulated experience made each exposure to a new language easier than it would have been had he truly been an L1 speaker of English trying to learn, for example, L2 Japanese.

The linguistic and sociolinguistic research discussed in this section suggests that the term 'second' in SLA may be inappropriate for many reasons. First, its built-in assumptions about monolingualism and separable L1 and L2 linguistic competences do not hold up when relevant linguistic and sociolinguistic studies are considered. Second, the term 'second' is far too modest to account for the experiences of individuals who have learned multiple languages in their lifetimes. In short, there is evidence from a variety of sources that the assumptions sustaining use of the term

'second' oversimplify matters considerably, are not warranted, and indeed might be misleading.

But how have IIO researchers dealt with some of the research summarised in this section? Have they bought into the monolingual bias and unproblematised notions of bi- and multilingualism? As Firth and Wagner (1997) point out, IIO researchers generally discuss individual learners in terms of their L1s and the target language, L2, framing both as homogeneous entities. There is little or no problematisation of these concepts or of whether or not any of the individuals involved manifest any of the variable language behaviour documented by researchers such as Harris et al., Bailey and Heller. Multilingualism and previous language-learning experiences, multiple or not, are not generally discussed either. However, in response to Firth and Wagner's arguments, Gass (1998) seems to both take their point and contest it:

> They point out, correctly, that the concept of NS can be a problematic one, because ... issues of bilingualism or multilingualism are important consider- ations. It is true that many of these issues are often glossed over in determining the nature of linguistic knowledge of potential 'participants' ... It is a simpli- fication to state that homogeneity is implied within groups inasmuch as in many studies, characteristics of the individual within the groups (e.g. exposure to the target language, age, other languages known, years of study) are provided and manipulated when they are deemed relevant.
>
> (Gass 1998: 86)

Here Gass seems to admit that there might be a problem, but then backtracks slightly by saying that the inclusion of such matters in a particular piece of research depends on the discretion of the researcher. She provides no examples of authors who made explicit in their work that they deem issues of bilingualism or multilingualism relevant to their cause, leaving the reader to wonder how this process works in practice.

In Table 3.1, I reproduce the results of an informal survey of IIO-based articles published in major applied linguistics and SLA journals over the period 1998–2001. The picture we get is one of researchers who provide a minimal amount of information about learners' backgrounds and then do not relate this information to their research. As regards the question of other language experience, the situation is even more extreme, as, with the exceptions of Swain and Lapkin (1998), Long et al. (1998) and Mackey et al. (2000), there is no mention whatsoever of this variable.

The sample is not meant to be exhaustive and I have only included studies where the focus was on learners carrying out tasks requiring conversational interaction. However, other articles which deal with different parts of the SLA puzzle, such as the acquisition of morphemes or aspects of cognition, also tend to provide biodata about participants which is subsequently not related to outcome in any specific or in-depth way.[3]

Of course, one possible explanation for the near total omission of other language experience is that, as the definitions reproduced at the beginning of this chapter suggest, 'second' is being used in a technical sense as a synonym of sorts for whatever

Table 3.1 Survey of IIO-based articles and how they deal with the
monolingual bias

In the journal column, *AL = Applied Linguistics*; *MLJ = Modern Language Journal*;
SSLA = Studies in Second Language Acquisition; *LTR = Language Teaching Research*;
LL = Language Learning; *TQ = TESOL Quarterly*.

Author(s)	Year	Journal	Main focus of research	Attention to monolingual bias
Foster	1998	*AL*	Exploration of the extent to which learners actually negotiate for meaning when engaging in two-way tasks in an ESL setting in the UK.	Mention of L1, age, level, and length of time on course and sex. No mention of other language experience.
Polio & Gass	1998	*MLJ*	Relationship between the successful completion of tasks and the relative performances of native speakers and non-native speakers working in dyads in an ESL setting in the US.	L2 level. Population said to be the same as earlier study by same authors (Polio and Gass 1994). No mention of other language experience.
Swain & Lapkin	1998	*MLJ*	Relationship between collaborative group activity and learning in a French immersion classroom in Canada.	Discussion of participants' previous contact with French but no mention of other language experience.
Mackey & Philip	1998	*MLJ*	The effect of recasts on learners' responses and their interlanguages development in an Australian ESL setting.	Mention of participants' age, L2 level, L1, sex and length of time in Australia. No mention of other language experience.
Long, Inagaki & Ortega	1998	*MLJ*	Comparison of the relative effectiveness of recasts for learners of JFL (Japanese) and Spanish (SFL) in the US.	In both studies, age, mention of L2 level, sex and year of university studies. In the Japanese study, secondary school JFL experience is mentioned and briefly related to some of the findings. Otherwise, in both studies there is no mention of other language experience.
Oliver	1998	*MLJ*	Exploration of whether or not children negotiate for meaning, the strategies they use to do so and how their negotiation patterns differ from those of adults in an Australian ESL setting.	Mention of non-native speaker participants' age, length of time in Australia, L2 level and L1. No mention of other language experience.

Table 3.1 Survey of IIO-based articles and how they deal with the
monolingual bias – *continued*

Author(s)	Year	Journal	Main focus of research	Attention to monolingual bias
Ortega	1999	SSLA	A study of the relationship between planning and a focus on form during interaction in a SFL (Spanish) context in the US.	Mention of L1, sex, age, level of university studies and experience with Spanish in naturalistic settings. No mention of other language experience.
Mackey	1999	SSLA	A study of the relationship between conversational interaction and second language acquisition in an ESL context in the US.	Mention of level, L1, age and length of residence. No mention of other language experience.
Skehan & Foster	1999	LL	A study of the relationship between the clarity of task structure and fluency, accuracy and complexified performance in an ESL setting in the UK.	Mention of sex, L1 (mentioned as various, but details not provided) and level of English. No mention of other language experience.
Bygate	1999	LTR	A study of the relationship between task design and the grammatical complexity of learner output in an EFL setting in Hungary.	Mention of age, years of EFL study and level of English. No mention of other language experience.
Foster & Skehan	1999	LTR	A study of the effect of different sources and focus of pre-task planning on learner performance in an ESL setting in the UK.	Mention of sex, L1 (mentioned as various, but details not provided) and level of English. No mention of other language experience.
Mackey, Gass & McDonough	2000	SSLA	Exploration of learners' perceptions of interactional feedback in an ESL and IFL (Italian) setting in the US.	Mention of sex, L1, years of prior study of L2 and length of stay in L2 environment. Mention of of some IFL learners' Italian language backgrounds but this is not related to performance.
Robinson	2001	AL	Exploration of the relationship between task complexity and learner performance in a Japanese EFL setting.	Mention of age, past EFL experience and L1. No mention of other language experience.
Ellis, Basturkmen & Loewen	2001	TQ	An investigation of the occurrences and effects of pre-emptive moves to focus on form by teachers and students in an ESL setting in New Zealand.	Mention of sex and nationality. No mention of other language experience.

language is being acquired, and that it is more economical to reduce learners to one language background and one target language in order to investigate more important matters for theory-building such as describing interlanguages and cognitive processes related to acquisition. Nevertheless, even if we accept such an argument in favour of keeping this term as regards talk of L1s and L2s, there is still a problem with 'second' as a term for the different contexts in which SLA takes place.

3.3 CONTEXT

As we observed in the introduction to this chapter, 'second' has a meaning in terms of the actual context where language learning take place and, in general, SLA researchers have tended to focus on three contexts: the foreign, the second and the naturalistic.

3.3.1 Foreign language context

The foreign context is the context of millions of primary school, secondary school, university and further education students around the world who rely on their time in classrooms to learn a language that is not the typical language of communication in their community. This means English for many of the world's people, as well as widely studied languages such as Spanish, Japanese and Mandarin Chinese, to say nothing of the hundreds of other languages that appear on national curricula around the world. Conditions in these contexts vary considerably in terms of teacher/ student ratios, teacher preparation, intensity (hours per week), accommodation, technological back-up, availability of teaching materials, the relative importance of learning the foreign language and so on. This means that any talk of the foreign language classroom in generic terms is problematic. Nevertheless, little such discussion has taken place over the years.

One exception is Van Patten and Lee's (1990) edited collection which directly took on the notion that 'second language acquisition' contexts, such as English as a second language in the US, are notably different in many ways from 'foreign language learning' contexts such as Spanish, French and German as foreign languages in the US. In the opening chapter of the collection, Margie Berns (1990) makes the point that even among contexts where 'foreign' clearly applies, there may be large differences as regards activities both inside and outside the confines of the classroom. She contrasts English as a foreign language (EFL) in Germany and Japan, making the point that there is perhaps more differentiating the two contexts than uniting them. Germany is portrayed as a context where the rationale for studying English is to use it as a *lingua franca* to communicate with fellow Europeans who do not speak German, as well as a tool of business both inside and beyond the frontiers of Europe. Both needs are catered to: the first in a school system that provides several hours of EFL instruction a week from the age of ten, and the second via language academies and in-house company classes. In addition, teaching methodology in Germany is a combination of practices considered to be 'traditional' in nature (see Nunan and Lamb 1996, for a discussion), such as an overt focus on formal aspects

of the language being studied, and practices considered to be more 'innovative', such as project work (Legutke and Thomas 1991). Finally, as Van Patten (1990) and Gass (1990) point out elsewhere in the collection, it is worthwhile to take into account cross-linguistic studies of the morphology, syntax, phonology and lexis of languages, in this case English and German, in order to understand how similarities might facilitate the learning process. Berns concludes that while Germany is an EFL context, it is one where English is not only valued in the abstract, but is actually used in practical terms by a large number of people, be this via tourism, cultural or business.

By contrast, the Japanese context is seen by Berns to be far less favourable and conducive to the learning of English. First, the sociohistorical context in which English is taught is very different: learning the English language is seen as part of *kokusaika* (roughly, internationalisation), as a way of communicating with the 'West' (symbolised most often by the US), and its existence in the national curriculum therefore is tied up with more abstract questions of national identity and Japan's place in the world. In addition, until recently, there has been little emphasis in language classrooms on speaking skills and this has led to millions of EFL students with a high degree of linguistic competence but lacking communication skills in English. Finally, following Van Patten (1990) again, there is also the question of linguistic proximity between English and Japanese: if German is deemed to be close to English, Japanese is certainly distant. All of these factors together mean that while Japan and Germany are broadly similar in terms of their status as EFL contexts, the situation on the ground is different enough to merit exploration of how different results in the two contexts relate to sociohistorical, geographical, mythological and linguistic factors.

3.3.2 Second language context

The second language context shares with the foreign language context the formal classroom setting. However, it is different in that the classroom is situated inside a community where the target language is spoken. This is the context of refugees, migrants and immigrants who have enrolled for language classes focusing on the language of the community where they have taken up residence. Second language contexts vary along the same lines as the foreign language contexts, that is, as regards teacher/student ratios, teacher preparation, intensity, accommodation, technological back-up, availability of teaching materials, the relative importance of learning the foreign language and so on. However, unlike foreign language contexts, they all include potential multiple opportunities of contact with the target language outside the classroom. Such contact is deemed to be important because it allows for more varied exposure to the target language, away from the confines of teacher-controlled discourse, and ultimately for natural language processing whereby the learner will work out fine linguistic distinctions. For example, in an oft-cited study, Gass (1987, 1990) found that L1 English speakers learning Italian in a foreign context had great difficulty moving from sentence-interpreting strategies based on English syntax

(where agency is attributed, above all, by position in the sentence) to strategies based on Italian syntax (where agency is attributed, above all, by verb inflection). By contrast, L1 English speakers who learned Italian in a second language context were able to make the transition to Italian strategies. Gass concludes that the second language context allows for the learning of 'an aspect [of Italian] which is not available through minimal exposure, as one gets in a classroom or from text books' (Gass 1990: 43).

However, as Gass would no doubt agree, simply being in a second language environment is no guarantee that a learner will be exposed to richer input which will then allow him/her to learn the subtleties of the language faster and more completely. Talburt and Stewart (1999) recount the story of Misheila, an African American university student on a five-week study abroad programme in Spain designed to develop her intercultural and communicative competence in Spanish. The programme, which combined language and culture classes with informal socialising, turned into a nightmare as the opportunities she had to process input were rendered useless by her affective state during the entire period. Misheila was from a middle-class background and had grown up in a predominantly European American setting. While she acknowledged that she had encountered racism during her lifetime in the US, she somehow expected her stay in Spain to be racism-free. As she put it, '"I have to deal with it in the States, I don't like to deal with it away from home"' (Talburt and Stewart 1999: 168). However, after just one week in Spain, she stated, '"I'm not in a hurry to ever get back to Spain"' (ibid.). The cause of her unhappiness was the input she was actually provided with in the streets of Madrid by men who made remarks which she believed sexualised her as an 'African' woman. As she explained during a class taking place at the end of her stay:

Mi observación es muy negativa. Para mí mientras estoy en España noto que mujer africana es un símbolo de sexualidad. Cuando camino en las calles siempre recibo comentos sobre piel y comentarios sexuales, especialmente con los viejos y adolescentes entre la edad de 15 y 20. Es muy difícil para mí y no pienso que es algo de cultura, es un mente ignorante., Cuando dicen comentarios a mí me siento que taking advantage *que soy extraño y no tengo* command *de idioma. Y no me gusta.*
(My observation is very negative. For me, while I've been in Spain, I notice that the African woman is a symbol of sexuality. When I walk in the streets I always receive comments on my skin and sexual commentaries, especially with old men and adolescents between the age of 15 and 20. It's very difficult for me and I don't think it's something cultural, it is an ignorant mind. When they make commentaries to me I feel that they're taking advantage of me being different and not having command of the language. And I don't like it.)

(Talburt and Stewart 1999: 168–9)
[emphasis in original; translation provided by the authors]

Clearly, for Misheila the exposure to naturalistic input outside the classroom, an experience which might have accelerated her interlanguage development, proved to be salient for non-linguistic reasons. Whether or not this affective interference

limited her linguistic development is not discussed by Talburt and Stewart; however, the title of the paper, 'What's the subject of study abroad? race, gender, and "living the culture"', along with the focus on issues of race and identity, lead us to question the notion that a second language context is necessarily conducive to linguistic development as well as the view that language is primarily, if not exclusively, about such linguistic development (there is more on this in Chapter 4). In other words, just as the classroom part of the second language context can vary in terms of factors such as teacher preparation, materials, class size and intensity, so too can the part outside the classroom. This outside-the-classroom part is the be-all for the third context I explore here, the naturalistic context. First, however, I should mention a relatively forgotten context in mainstream SLA.

Somewhere in between the foreign and second language contexts are what Ellis terms 'official language contexts' (Ellis 1994a), that is, contexts where a language which is not the L1 of all members of a community is nonetheless chosen by a government as the official language of one and all. Such contexts are typically ex-colonial in nature, where a newly independent country either adopts the former colonial language as the official language (most commonly in former European colonies, English, French or Portuguese) or chooses as the official language a language common to many of the citizens of the new country, as is the case of Hindi in India and Bahasa in Indonesia.[3] As Ellis (1994a) and Long (1998) note in general discussions of SLA and as authors from official language contexts, such as (Kachru 1994), Sridhar and Sridhar (1986) and Sridhar (1994), have lamented in more specific reference to such contexts, little has been published in mainstream SLA that deals specifically with this context. Interestingly, it is in autobiographical accounts such as Ngũgĩ wa Thiong'o's (1986) *Decolonising the Mind: The Politics of Language in African Literature* and the work of scholars such as Edward Said (e.g. 1994), where we find the most thought-provoking accounts of language acquisition in such contexts. However, Canagarajah (1999) is a recent academic text which provides a compelling account of English language teaching, and learning in the postcolonial context of Sri Lanka.

3.3.3 The naturalistic context

The naturalistic, uninstructed second language acquisition context is, in a sense, the opposite of the foreign language context for the dual reason that it involves no formal instruction and the learning of a language spoken in the surrounding community. In this case, the learner makes her/his way through a variety of interactions necessary to day-to-day life and must rely on her/his background knowledge, learning strategies and intuitions to get by. This is the situation of the millions of refugees, migrants and immigrants around the world who find themselves immersed in a new language context and simply must get on with their lives. Well-known early SLA documentations of learners in such contexts include Schumann's (1978) study of Alberto (based on a larger study by Cazden, Cancino, Rosansky and Schumann 1975) and Schmidt's (1983) study of Wes.

Schumann was concerned with how a Costa Rican immigrant to the US, Alberto, manifested a lack of morphological development in English. Making the case for what he termed the 'Acculturation Model', he posited that this lack of development was due to a long list of factors falling under two headings: social distance, that is the extent to which Alberto formed part of a group – low-income Spanish-speaking immigrants – which was relatively self-contained and isolated from the host English-speaking community, and psychological distance, that is the extent to which Alberto was not motivated to integrate with the host community and was living a personal situation of high anxiety and culture shock.

Schmidt's study of Wes has been taken by many commentators (e.g. Larsen-Freeman and Long 1991 and Ellis 1994a) as a refutation of Schumann's theory about social and psychological distance (see also Stauble 1978, 1984). For two years, Schmidt followed the linguistic development of Wes, a Japanese photographer living in Hawaii. He found that Wes, like Alberto, manifested little morphological development during this period of time and managed to carry out his day-to-day affairs using a repertoire of formulaic utterances. However, unlike Alberto, Wes did not experience excessive social and psychological distance, appearing, on the contrary, to experience high social inclusion in the host community and low anxiety.

Whatever its shortcomings, Schumann's model is generally considered to be unique in SLA as it is one of the few attempts, along with Giles and associates' (e.g. Giles and Coupland 1991) Inter-group Model and Gardner's (1985) Socio-educational Model, to take social context and affective factors in naturalistic settings into account and to make the strong claim that these social and affective factors are causative of SLA. However, Schumann's model has largely disappeared from the SLA research landscape as Schumann has moved to an interest in the connections between affective factors and neurobiology (Schumann 1997), and most researchers in SLA, particularly those who subscribe to the IIO model, look to interaction and cognition as the causes of SLA, relegating social and affective factors to sidelines. Nevertheless, Bonny Norton (2000) has recently resuscitated the Acculturation Model as one of the few attempts in SLA to take a more socially motivated view of SLA, before taking Schumann to task for what she sees as his tendency to essentialise concepts such as group boundaries and motivation and to attribute to Alberto an individual stance of unwillingness to integrate with the host community. For Norton, Alberto's story might more fruitfully be viewed as that of an individual who is continually positioned and constructed as inferior in his day-to-day interactions in the host community and who does the best he can to negotiate an identity in such circumstances.

Closer to Norton's position is more recent work published by Bremer et al. (1996), based on data originally collected in the mid-1980s as part of the European Science Foundation (ESF) Project in Second Language Acquisition (see Perdue 1993a, 1993b, for a thorough survey). Bremer et al. study the acquisition of four different languages – English, French, German and Dutch – in the UK, France, Germany and the Netherlands by immigrants who were L1 speakers of Italian, Spanish and Arabic. The authors are also concerned with issues such as the social

distance between the learner and L2 speaking interlocutors, but more importantly, they challenge two conditions which are assumed to apply when L2 learners are in naturalistic contexts. The first of these is that naturalist contexts provide learners with more opportunities to be exposed to input. While this was the case in the ESF project in terms of gate-keeping encounters (such as visits to the doctor, service encounters and contacts with government agencies), it was not the case in relation to less bureaucratic and social encounters. Indeed, very often it was found that the informants in the study used anything but the target language in their encounters with friends and relatives. Thus, Santo, an Italian immigrant in England, hardly ever used English among co-workers, friends and relatives, and Berta, a Chilean immigrant in France, had no contact with French speakers and very little with Spanish speakers outside her immediate family.

The second assumption challenged by Bremer et al. is that in gate-keeping encounters negotiation for meaning takes place, whereby all interlocutors involved in an exchange work towards mutual understanding. Bremer et al. found that the onus to guarantee understanding was in most cases on the immigrants who varied considerably in their ability to take such responsibility. Thus if the immigrants did not do the lion's share of the negotiation, little if anything would get done with language.

The third assumption challenged is that in a naturalistic context, the learner will learn the L2 through conversational interaction. What Bremer et al. found was that in many cases learners were being assessed in relation to their competence in the L2 and were not given the space needed to develop such competence. As Norton (2000) argues, they were caught in the Catch 22 situation of needing the language in order to communicate while needing to communicate in order to learn the language, whilst all the time their interlocutors were judging their ability to communicate.

In Norton's view, Bremer et al. do not go far enough in their analysis, crucially failing to debunk an assumption often made about naturalistic settings, which is that 'those who speak regard those who listen as worthy to listen, and that those who listen regard those who speak as worthy to speak' (Norton 2000: 8). Thus, in addition to moving away from the notion that a naturalistic setting provides abundant and useful opportunities for the learner to interact in the L2 and learn through such interaction, as Bremer et al. do, Norton argues that there should be additional interest in how learners develop identities as what Bourdieu (1977) calls 'legitimate speakers', that is how they come to be accepted and fully functioning members of different lifestyle sectors (Giddens 1991) and communities of practice (Lave and Wenger 1991) which they inhabit and engage with. In Norton's study of five immigrant woman in Canada, she did just this. One of the woman, a Polish immigrant named Eva, exemplifies the process of moving from an attributed (by others) status of incompetent foreigner in the workplace to legitimate co-worker who is 'worthy to speak and listen'. Through conversations with Eva and Eva's diary entries, Norton is able to reconstruct the story of how Eva struggled when she took on a job at a restaurant where she was the only employee who was 'not Canadian'. At first, she was marginalised in workplace conversations and even exploited by

her fellow workers who made sure that she did the worst chores. Observing that she tended to do the most onerous work and that she did not talk very much, the restaurant manager assumed that she could not deal with customers and this meant that she continued to be given the most menial of jobs. However, through social contacts with her fellow workers outside the confines of work, she came to be seen in a different light, in particular as someone who did have an interesting life, who knew about Europe and who spoke Italian. Feeling more legitimate as a co-worker and human being, Eva began to lose her self-consciousness about speaking English and eventually engaged in many more interactions in English, both on and off the job. Eventually, she was able to carve out an identity as a fully functioning co-worker who was 'worthy to speak and listen'.

An example of less successful L2 learning is reported by Goldstein (1996, 2001) in her study of twenty-seven Portuguese immigrant women working in a garment factory in Toronto. Goldstein was interested in assumptions made at the time of her study (1988–90) by some authorities in Ontario concerning the importance of immigrants being able to communicate in English, both at work and in the wider community. These assumptions were effectively that 'not being able to communicate in English is a deficiency and that immigrant workers who don't speak English are hampered not only in their work lives, but also in their community and personal lives' (Goldstein 2001: 78). Once she began to collect life histories and accounts of work and community experiences from her informants, Goldstein came to realise that such assumptions were totally unfounded. The women in her study had, in effect, formed their own Portuguese community in the workplace, which meant they did not need to learn how to do their work in English. Indeed, speaking in English at work would alienate an individual from the larger group – or 'family', as the workers called themselves – putting her at risk professionally. So pervasive was Portuguese on the job that Goldstein cites the cases of Spanish and Italian immigrants who learned it in order to be a part of the group. Goldstein describes the situation as follows (ibid.: 84):

> The use of Portuguese functioned as a symbol of solidarity and group member-ship in the 'family'/community on the production floor. Portuguese was asso-ciated with the rights, obligations, and expectations members of that community had of each other at work.

Unlike Eva in Norton's study, these women made conscious decisions not to learn English better, as to do so would have upset their valuable community or 'family' life. However, their choice in the matter was very much shaped by the larger community environment and, indeed, Canadian society in general, what Goldstein calls 'the gendered structure and dynamic of the Portuguese family and the class positions they held within the Canadian political economy' (ibid.: 87). In essence, these women were caught between forces that prevented them from acquiring better English language skills, the cultural capital which would allow them access to greater political and economic capital, that is to more independence and prosperity. Because they were poor, they had to work, and because they worked, they could only attend

English classes in the evening. However, evening classes were not a satisfactory solution because (1) male members of the community often discouraged spouses and daughters from attending classes with men; (2) the women felt unsafe going out at night; (3) the women often had childcare responsibilities; and (4) the women often lacked confidence in themselves as students (owing to the fact than many of them had only had four years of schooling in Portugal before emigrating to Canada). As a result, Goldstein's informants tended to live in a non-English-speaking environment where they felt at home and to which they were confined by virtue of the gendered identities they had developed.

The lesson to be learned from a close examination of naturalistic language-learning case studies is that, first, the actual exposure to the target language is often far less than might be expected because there are a number of variables that together conspire to limit both the quantity and quality of input. From Alberto to Eva to the Portuguese factory workers, immigrants in different contexts find that language learning does not depend exclusively on engagement in conversational interaction with native speakers. Indeed, such contacts are often limiting as regards input and the overall affective climate is so negative, owing above all to pressure to perform and conform, that they are rendered of little use. In addition, as Norton points out, even where immigrants become part of a well defined group, such as workers in a restaurant, there is still a long battle to achieving legitimacy as a group member.[4]

In this section we have examined the three general contexts which have been explored by SLA. I have described and discussed them separately, while showing how none of them is ever tidy enough to merit such separate discussion. Foreign language contexts vary immensely, depending on factors such as the international economic projection of the country, the extent to which learners will ever really have the opportunity to put their knowledge of the target language to use, and sociohistorical factors related to the educational system and attitudes in general about foreignness. In addition, there are the many official language contexts around the world which have not often made it onto the SLA playing field, although they do at least merit some mention in general SLA texts. Second language contexts, often seen as ideal in that they combine formal learning with naturalistic exposure, are equally problematic because contact with the target language can vary considerably. In addition, as we observed in the case of Misheila, such contact can do more harm than good in relation to the learner's identification with the target language as well as her/his attitude towards it. Finally, naturalistic contexts are equally problematic, not least because access varies considerably, and very often it is how the individual learner negotiates and carves out an identity in the target language which ultimately determines relative success or failure.

3.4 DISCUSSION

In SLA in general and the IIO model in particular, the term 'second' is used in a loose fashion to refer to where the language being acquired is situated chronologically in an individual's language acquisition experience (second as 'after first') and to where, in

physical terms, this process is taking place. In this chapter I have attempted to show how these uses of second are problematic because they essentialise knowledge of languages and the contexts where such knowledge is acquired. But what do I propose as a solution to the problematic nature of the term? Rampton (1997b) has suggested that terms like 'other' or 'additional' might be more appropriate and I see these terms as preferable to 'second' if what we seek is a different umbrella term for the different language-learning experiences and contexts currently discussed by SLA researchers.

However, another way to look at this situation is to see the wide variety of lingualisms and contexts cited in this chapter as sufficiently diverse to constitute separate areas of inquiry. Thus, if Winston, the main informant in Bailey's study cited above, begins the study of French in his secondary school in Providence, Rhode Island, and an SLA researcher studies this situation, what can he or she learn from a fellow SLA researcher who is in Barcelona investigating the language development of a 23-year-old Polish immigrant? Let us imagine that the individual in question has the following past and present language experiences: (1) several years of EFL and RFL (Russian) instruction while living in Poland until the age of twenty; (2) one year of naturalistic exposure to Italian while working at a restaurant in Milan prior to coming to Barcelona; (3) once in Barcelona, enrolment in Catalan classes provided by the local government; and (4) naturalistic exposure to (primarily) Spanish in the Barcelona restaurant where he works (Spanish is often spoken to him by Catalan speakers because he is identified as a foreigner). Is his language experience in the same category of cognitive and social experience as Winston's? If so, can we ever hope to elaborate a general theory of SLA which would cover both contexts?

Judging by recent debates in SLA about theory-building, the answer provided by authors such as Long and Gass would surely be 'yes', although they would accept that the two situations outlined here are distinct and quite different from one another. Because their view is that there are linguistic universals (thus making language-processing the same all over); universals of cognition unimpeded by environment and social goings-on (thus making information processing the same all over); and universals of interaction (thus making what they believe to be the key to learning a language – interaction – the same all over), these authors would seek to eliminate the clutter of variability in the learners' experiences and the context, in order to get down to the essentials of SLA. In short, they would marginalise from the field of study the very factors which make the two individuals and their respective contexts interesting.

Coming from a different angle, authors such as Firth and Wagner and Rampton would, like Gass and Long, make the case for keeping these two studies inside SLA. However, they would take this tack because for them the fact that there are such diverse circumstances means that SLA researchers should move from essentialised and simplified constructs and theories to a full embrace of as many sociohistorical and contextual factors as possible. For Firth and Wagner and Rampton, these differences are empirical proof that SLA is not researchable in controlled experiments based on tightly defined constructs such as 'negotiation for meaning' and 'grammatical complexification'.

It seems then that both self-proclaimed SLA insiders (such as Long and Gass)

and relative outsiders (such as Firth and Wagner and Rampton) all agree that it is important to keep a diversity of individuals and contexts together under a general super-ordinate category, SLA. The problems arise when it is time to decide how much of this diversity should be taken on board by researchers. If debates published in major applied linguistics and SLA journals and general textbooks are anything to judge by, it looks as if there is at present a divide between those of a more psycholinguistic and scientistic bent and those of a sociological and epistemologically more open bent. In my view, whether or not there is agreement about the relative importance of the psychological and sociological in the SLA process, surely no one can be very satisfied with the 'second' in SLA: the authors cited at the outset of this chapter because it forces them into counter-intuitive statements such as 'L2 can refer to any language learned *after* learning the L1, regardless of whether it is the second, third, fourth, or fifth language'; the latter because they know in their heart of hearts that the monolingual bias, the compartmentalised view of languages and the oversimplified view of context – all inherent in 'second' as it is currently used in SLA – do not hold up to empirical scrutiny.

So what is the alternative? Above, I cited Rampton's two suggestions, 'additional' and 'other'. Of the two, I would choose 'additional'. To my mind, it avoids the vagueness of 'other' and better captures the notion, implicit in Cook's work, of the ongoing accumulation of linguistic knowledge. At the same time, it works much better than 'second' as reference to the different lingualisms and contexts discussed in this chapter. First, it allows us to get around the implicit reference to a unitary and singular L1, as it is agnostic on this point: 'additional' could apply to any language-learning experience, irrespective of the learner's previous language contact. In addition, unlike 'second', it would allow us to avoid confusion in making reference to the 'foreign', 'second', 'naturalistic' and 'self-instructed' contexts represented in Figure 3.1. Not using the same term for a super-ordinate and a sub-ordinate category, as is currently the case when we use 'second', certainly allows for greater clarity.

Nevertheless, I am all too aware that changing SLA to ALA (additional language acquisition) would be the kind of seismic shift that academic fields seldom, if ever, impose on themselves.[5] Indeed, if we are to judge by the responses which authors such as Firth and Wagner (1997) elicit from IIO researchers such as Long (1997, 1998) and Gass (1998, 2000), then we might well conclude that such a shift will never occur.

NOTES

1. I base this assertion on a review of SLA textbooks as well as published articles in major SLA and applied linguistics journals over the past several years. As I am primarily concerned with the IIO model and SLA as the development of speaking and listening skills in this book, I am not considering the growing literature on ICT-mediated language learning. Surely there is great scope for an exploration of how individuals around the world are learning languages via web surfing and participation in chat rooms.
2. An obvious exception would be studies which purport to be about age and therefore do

provide specific and in-depth discussion of the relationship between age and language learning (e.g. De Keyser 2000).

3. Although, as Merrill Swain (personal communication, May 2002) points out, Canada is also a good example of an 'official language context' with multiple language-learning contexts. There, English and French are both official across Canadian territory; however, in Vancouver, located on the Pacific coast far from French-speaking Quebec, it is generally difficult to find L1 French speakers. This means that in Vancouver, learning French is more a question of learning a *foreign* language (Quadrant 1 in Figure 3.1). On the other hand, a case could be made that in some parts of Toronto, where there is a large Portuguese community, and in some parts of Vancouver, where there is a large Japanese community, learning Portuguese or Japanese is more akin to *second* language learning (Quadrant 2 in Figure 3.1).

4. This is no less true among younger immigrants, as McKay and Wong (1996) so effectively argue in their discussion of a two-year study that monitored, among other things, how adolescent Mandarin-speaking immigrants in California negotiated new identities in the context of the junior high school they were attending.

5. There is a parallel with the term 'Applied Linguistics' about which much ink has been spilt since it first became common currency in the late 1960s. Despite debates about what it means in relation to what applied linguists actually do (e.g. issues 7/1, 8/1 and 9/1 of the *International Journal of Applied Linguistics*; Davies 1999; McCarthy 2001), the name is never changed.

Chapter 4

What does the 'L' in SLA stand for?

4.1 INTRODUCTION: FROM LINGUISTIC COMPETENCE TO COMMUNICATIVE COMPETENCE

Second *language* acquisition refers to all the aspects of language that the language learner needs to master. However, the focus has been on how L2 learners acquire grammatical sub-systems, such as negatives or interrogatives, or grammatical morphemes such as plural {s} or the definite or indefinite articles. Research has tended to ignore other levels of language. A little is known about L2 phonology, but almost nothing about the acquisition of lexis. SLA researchers have only recently turned their attention to how learners acquire the ability to communicate and started to examine how learners use their knowledge to communicate their ideas and intentions (i.e. pragmatic knowledge).

<div style="text-align: right">(Ellis 1985: 5)</div>

In the opening chapter of *Understanding Second Language Acquisition*, Rod Ellis (1985) presents the dominant view in the early 1980s that the language in SLA was primarily about linguistic competence, that is the abstract formal knowledge of syntax, morphology and phonology. Thus, from the early days of SLA, from the 1950s to the late 1970s, researchers showed an almost exclusive interest in morphology, syntax and phonology. Early studies based on Contrastive Analysis, with its base in structuralist linguistics, showed a preoccupation with phonology, morphology, and syntax and, at times, lexis.[1] Later, the Chomskyan revolution, with its emphasis on syntax and morphology, was to serve as a basis for Corder's Error Analysis, Selinker's interlanguage and finally Krashen's acquisition orders. Indeed, for Krashen, the 'language' in SLA seemed to be exclusively a morphological affair.

Almost a decade later, in the introduction to *The Study of Second Language Acquisition*, Ellis (1994a) does not offer such a direct definition of what he means by 'language'; however, he does begin by making clear that the goal of SLA research is to account for how learners acquire not only linguistic competence but also communicative competence. He defines the former term as 'the mental representations of linguistic rules that constitute the speaker-hearer's internal grammar' (Ellis 1994a: 12) and the latter term as the 'knowledge that the speaker-hearer has of what constitutes appropriate as well as correct language behaviour and also of what con-

stitutes effective language behaviour in relation to particular communicative goals' (ibid.: 13). Adding communicative competence to the understating of the language in SLA, Ellis was following a trend in applied linguistics, which first took hold in sociolinguistic circles in the early 1970s, was dominant in language teaching circles by the late 1970s, and finally became firmly ensconced in SLA circles in the 1980s. I refer here to Del Hymes's (1971, 1974) famous assertion that this competence is not just about knowing abstract rules of language as formal system; rather, it includes a knowledge of the rules of speaking. John Lyons sums up the Hymesian shift in applied linguistics as follows:

> The so-called communicative point of view, which has been very influential in applied linguistics in recent years, is the product of many factors. One of these, undoubtedly, was the dissatisfaction with the highly theoretical, idealized, classical Chomskyan notion of linguistic competence as a basis for the very practical business of teaching. Many of the proponents of the communicative approach were attracted by an alternative, broader and, it was claimed more realistic, notion of linguistic competence, for which the term 'communicative competence' had been coined by Del Hymes (1974). This term was employed by Hymes to label the ability to produce situationally acceptable, and more especially socially acceptable, utterances, which, in his view, would normally be held to be part of a native speaker's competence in a particular language.
>
> (Lyons 1996: 24)

A perusal of SLA texts over the past decade reveals that, either implicitly or explicitly, authors agree that language should be seen not only as linguistic competence but also communicative competence. Implicit acceptance of this premise is to be found in texts such as Mitchell and Myles (1998) and Lightbown and Spada (1999) where the authors do not discuss language in an overt manner. Explicit acceptance is to be found in texts such as Gass and Selinker (2001) where the authors begin a section entitled 'The nature of language' in the following way:

> Fundamental to the understanding of the nature of SLA is an understanding of what it is that needs to be learned. A facile answer is that a second language learner needs to learn the 'grammar' of the TL. But what is meant by this? What is language? How can we characterize the knowledge that humans have of language?
>
> (Gass and Selinker 2001: 5–6)

Gass and Selinker then go on to briefly discuss language as 'sound systems', 'syntax', 'morphology and lexicon', 'semantics' and 'pragmatics'. In similar fashion, Sharwood Smith (1994) makes the point that while in early SLA studies (pre-1980), it was grammar (understood to be morphology and syntax) which 'had the lion's share of attention' (Sharwood Smith 1994: 137), in recent years, lexis, phonology and pragmatics have received greater attention. For Sharwood Smith the growth in attention to these aspects of language means that researchers need to be more knowledgeable about more areas understood to inform theories of language. Sharwood Smith concludes that '[a]ny language acquisition theory needs a

theoretical model of language, or indeed, several models of language where no suitable single grand theory of language can be found' (Sharwood Smith 1994: 141).[2]

It seems, then, that no one studying and/or researching SLA at any level is going to deny that the language in SLA is about linguistic competence at its most basic level. However, since the 1980s it has become accepted in most SLA circles that language is also about what Hymes termed communicative competence, the exception being those who work in the Universal Grammar camp.[3] Thus the prize in SLA is not only a knowledge of the rules of formal syntactic, morphological, phonological and lexical systems, it is also a knowledge of the rules of use, that is how to employ the formal systems for communication. But is this view of language sufficiently robust as a representation of what second language learners actually acquire in the variety of contexts discussed in Chapter 3? In my view, it is not and the purpose of this chapter is to explain why I take this view by problematising the 'L' in SLA.

As I point out above, in the period 1966–80, SLA researchers moved from viewing what is acquired in SLA – language – as purely and simply linguistic competence, towards viewing it as what Hymes termed 'communicative competence'. In the shift to viewing communicative competence as part of what is acquired, one might have expected researchers to add to linguistic knowledge how to participate in speech events according to the conventions of the community and indeed to take on Hymes's views on the scope of sociolinguistics. According to Hymes (1971, 1974), sociolinguistics should take a view of language as being social as well as linguistic (covering social problems and language use in addition to the traditional concern in linguistics with the formal features of language), socially realistic (based on data collected from existing speech communities), and socially constituted (beginning with a discussion of social functions before exploring how formal features are organised to serve them). However, SLA researchers have, for the most part, fallen short of taking on the entirety of the sociolinguistics that Hymes envisioned and the result has been a limited view of language. Nowhere has this limited view taken hold more strongly than among researchers following some version of the IIO model and nowhere is it more evident than in two concepts which are absolutely essential to this model: 'task', as what individuals do when engaging in conversation, and 'negotiation for meaning', as how information is exchanged. In this chapter, I aim to discuss these two concepts in detail before showing how they cannot adequately capture the kinds of activities which language learners engage in.

As I make my case, I will criticise the IIO model in its less applied form, that is as an attempt to construct a theory which describes and explains second language learning processes, and in its more applied form, that is as an attempt to offer guidance to teachers about effective pedagogy. I feel justified in mixing these two different orientations for two reasons. First, Long, Gass and others have always made the case for basing classroom language-learning tasks on observed real-world conversational interaction (e.g. Long 1996; Gass 1997, as well as, to a lesser extent, Skehan 1998). Leaving aside momentarily the burning question of what exactly is meant by 'real' (but see below for a discussion), I take this to mean that when these

researchers discuss a task in a formal classroom setting, they are making the case that it is similar to what goes on in unmonitored day-to-day social intercourse. This being the case, a discussion of language in the unmonitored workplace – to make the case that many social factors affect conversational interaction – is relevant to a discussion of a task used in a classroom because those designing the task will have attempted to replicate the real world in doing so. In other words, the real-world orientation of classroom-based tasks means that they are meant to be similar to 'real-world' tasks. A second reason for conflating less and more applied versions of task and negotiation for meaning in my discussion is that in both their less and more applied versions, the terms are meant to represent universals of activity and conversational interaction. This being the case, a conversation taking place in a classroom should be analysable in terms of task and negotiation for meaning in a similar way to how a conversation taking place in an unmonitored context would be analysed.

4.2 THE IIO MODEL: FROM COMMUNICATIVE COMPETENCE TO NEGOTIATION FOR MEANING

The move towards a view of language as communicative competence was the basis for the rise of the IIO model as the dominant theory in SLA today. In particular, researchers adopted the interpretation of communicative competence which saw communication as being fundamentally about conversational interaction. Gass, Mackey and Pica (1998) describe developments in SLA during the 1970s and 1980s, when communication in the form of conversational interaction came to be the centre of attention:

> Until the 1970s, conversational interaction was believed to serve a reinforcing function in SLA, whereby learners could take grammatical features, structures, and rules that had been presented in classroom lessons and other assignments and apply them to spoken discourse itself – often carefully organized and orchestrated by their teachers and textbooks – to showcase particular grammatical items. This common orthodoxy changed in 1975 when Wagner-Gough and Hatch (see also Hatch 1978; Hatch and Wagner-Gough 1976) illustrated how learners' participation in conversational interaction provided them with opportunities to hear and produce the L2 in ways that went beyond its role as simply a form for practice. Their analysis of conversation between learners and interlocutors suggested that L2 syntax might develop out of conversation, rather than simply feed into it.
>
> (Gass, Mackey and Pica 1998: 300)

As time went by, it became evident that IIO researchers were not interested in just any form or aspect of conversational interaction; rather, they adopted a fundamentally instrumental view of conversational interaction where the key was the exchange of information. George Yule has called this type of interaction 'referential communication', which he defines as follows:

Referential communication is the term given to communicative acts, generally spoken, in which some kind of information is exchanged between two speakers. This information exchange is typically dependent on successful acts of reference, whereby entities (human and nonhuman) are identified (by naming or describing), are located or moved relative to other entities (by giving instructions or directions), or are followed through sequences of locations and events (by recounting an incident or a narrative).

(Yule 1997: 1)

Consistent with Lyons (1996), Yule attributes the move to referential communication in SLA to the influence of Hymes's distinction between linguistic competence and communicative competence on SLA researchers. He makes the point that taking on Hymes's framework led to a greater focus on the function of language (albeit almost exclusively the information exchange function), although the structure of language has never disappeared, and above all, a focus on semantics (meaning in words) and pragmatics (meaning in context). He sums up a long list of changes in emphasis which have accompanied the shift from linguistic competence to communicative competence. Thus, there have been shifts:

1. from a focus on linguistic form (primarily morphology and syntax) to a focus on meaning and pragmatic function (reference in context)
2. in evaluative criteria, from grammatical accuracy (getting the right form) to a focus on communicative effectiveness (successfully completing a task)
3. in allegiance, from an interest in grammatical rules to an interest in situational rules (appropriateness)
4. in emphasis, from a focus on abstract competence to a focus on situated performance
5. from examining more mechanical and well defined acquisition stages to examining more organic and less well defined developmental patterns.

Despite nods in the direction of indeterminacy, referential communication is still highly structured and, indeed, institutionalised. A hint of its institutional nature is provided again by Yule:

It is the kind of talk needed for communication when we are not at home among those who know us and recognize what we are likely to mean and how we typically express ourselves. As such, it is the obvious kind of talk required of most of those who are using an L2 to accomplish some transactional goal, whether in education, business, technical communication, or any of the extremely wide range of contexts where a language ... has become a common lingua franca.

(Yule 1997: 14–15)

It seems, then, that when IIO researchers looked in the direction of sociolinguistics for a richer model of language and communication, they did so in a selective and narrow manner. They took from conversational analysis the most basic assumptions about conversation (Sinclair and Coulthard 1975), namely that it

follows a general turn-taking system and that consecutive turns form adjacency pairs whereby speaking turns are linked by a logic of relevance (for example, a question is followed by an answer sequence, a complaint by a denial, an offer by a rejection and so on). They took from the ethnography of speaking a variation on Hymes's 'speech event', that is a focus on stretches of utterances as opposed to single utterances (Hymes 1974). They took from speech act theory (Searle 1969) the basic premise that every utterance can be analysed in terms of the speaker's intention to achieve a particular purpose (its 'illocutionary force'). They took from pragmatics, as conceptualised by Grice, the 'cooperative principle', whereby participants in a conversation can be expected to 'make [their] conversational contribution such as required, at the stage at which it occurs, by the accepted purpose or direction of the talk exchange in which [they] are engaged' (Grice 1975: 45). Finally, from ethnomethodology (Garfinkel 1967), they took the idea of sticking closely to the data collected, eschewing the importation to their analyses of abstract social categories such as social class, gender and ethnicity.

IIO researchers from the late 1970s onwards have shown an interest in the mechanics of conversation and a concern with describing it. They therefore have taken on, to some extent, two of the three tenets of Hymes's model of sociolinguistics briefly outlined in the introduction: 'the social as well as the linguistic' and a 'socially realistic linguistics'. However, they have done so in limited fashion. In relation to 'the social as well as the linguistic', there has been a concern with language use in communicative contexts as well as classroom applications of research; however, there has been little concern with what Hymes calls 'social problems', as researchers have seemed reluctant to be 'social' beyond observations of conversational interaction and recommended pedagogical practice. In relation to a 'socially realistic linguistics', there has been a concern with data from language communities, but this has been with a view to establishing a baseline for subsequent research which has often been language-classroom-oriented and researchers have tended to deny language classrooms the status of 'speech communities'.

Most importantly, IIO researchers have not moved an extra step further to what Hymes calls a 'socially constituted linguistics'. According to Hymes, 'a socially constituted linguistics is concerned with contextual as well as referential meaning, and with language as part of communicative conduct and social action' (Hymes 1974: 196–7). It involves putting linguistics at the service of social functions which 'give … form to the ways in which linguistic features are encountered in actual life' (ibid.: 196). To adopt a socially constituted linguistics in SLA would mean researchers having to show a concern not only with referential communication at the service of information exchange, but also with interactional and interpersonal communication at the service of the social construction of self-identity, group membership, solidarity, support, trust and so on. I have more to say about the benefits of a more socially constituted linguistics for SLA below. First, however, I examine in detail two key terms which form the backbone of the IIO. The first is 'task', a term used to describe what individuals are actually doing when exchanging information, and the second is 'negotiation for meaning', a term used to describe how information is exchanged.

4.3 TASK

The term 'task' became the topic of much discussion in language-teaching circles in the 1980s. An exemplary definition from this time is provided by Michael Breen:

> 'task' is used in a broad sense to refer to any structural language learning endeavour which has a particular objective, appropriate content, a specified working procedure, and a range of outcomes for those who undertake the task. 'Task' is therefore assumed to refer to a range of workplans which have the overall purpose of facilitating language learning – from the simple and brief exercise type to more complex and lengthy activities such as group problem-solving or simulations and decision-making.
>
> (Breen 1987: 23)

Elsewhere and at about the same time, Candlin (1987) and Nunan (1989a) define task in terms of the parameters involved. These include input (what are the data presented to or selected by learners?), roles (what are the rules of participation, cooperation and guidance?), settings (is work to be done individually, in pairs or in groups, and who decides?), actions (what procedures are followed in carrying out the task?), monitoring (how is the process – from input to action – to be monitored and by whom?), outcomes (what are the goals of the task?) and feedback (who evaluates performance and at what stage?). What is interesting about these definitions is that they are based not on SLA research, but on what we might call, for lack of a better term, educational principles.[4] When Breen and Candlin discussed task at this time, they were doing so more with a view to providing an heuristic for the development of tasks in local contexts; they were not, by contrast, concerned with providing a definitive model for how task must be in all places at all times. In addition, Breen, Candlin and Nunan's primary focus was on lessons as social events co-constructed by participants.[5] This position is evident in Breen's (1987) contrasting of 'task-as-workplan' and 'task-in-progress' and Nunan's (1989b) explorations of different teacher and student preferences and expectations about lessons. This attention to lessons as social events also led these authors to propose the carrying-out of needs (and wants) analyses prior to the writing of syllabuses and the ongoing monitoring and negotiating of these syllabuses as they were implemented during lessons. While needs analyses would presumably lead to a preoccupation with work-like activities which learners would purportedly do outside the classroom walls, Breen and Candlin (and to some extent, Nunan) did not reject outright what might be considered more traditional activities such as explicit and contextualised grammar activities. They could not rule these tasks out entirely because in many contexts around the world, they are just as authentic for learners in classroom settings as the simulated service encounters which have become the staples of communicative language teaching.

At roughly the same time as Breen, Candlin and Nunan were discussing task from a more social-educational position, SLA researchers began to use the term in a slightly different manner. These researchers shared with Breen, Candlin and Nunan a belief in needs analysis and negotiated syllabuses; however, they sought a much

more structured and less open approach to task. First, definitions came to exclude traditional classroom activities, which were deemed to have no real-world relevance. This applied in particular to any explicit communication about language as a formal system. As Swain and Lapkin (2001) put it:

> With few exceptions ... definitions of communicative tasks emphasize the importance of a focus on meaning ... An alternative view, however, is that a tasks can still be considered communicative even if learners focus quite explicitly on form. This explicit focus on form comes about as learners attempt to express their intended meaning as accurately and as coherently as they are able.
>
> (Swain and Lapkin 2001: 100)

Elsewhere, Guy Cook (2000), echoing Widdowson (1998c), has the following to say about the presupposition, found in discussions of communicative tasks, that form and meaning can actually be separated:

> The presupposition that there can be presentation of form without meaning seems ... to be wrong. To some extent, we may talk of there being form without meaning in abstract statements of rules, and in paradigmatic tables, but as soon as these are instantiated in sentences, they assume meaning. The relevant question, then, is not whether language examples used in teaching should have meaning, but rather *what kind of* meaning it should be.
>
> (Cook 2000: 166–7; emphasis in the original)

Cook also critiques the obsession with 'real world relevance', exemplified in the following instrumental definition of task put forth by Long:

> In the present context, 'task' has no more or less than its everyday meaning. I define it as a piece of work undertaken for oneself or for others, freely or for some reward. Thus, examples of tasks include painting a fence, dressing a child, filling out a form, buying a pair of shoes, making an airline reservation, borrowing a library book, taking a driving test, typing a letter, weighing a patient, sorting letters, taking a hotel reservation, writing a check, finding a street destination and helping someone across the street. In other words, by 'task' is meant the hundred and one things people *do* in everyday life, at work, at play, and in between. 'Tasks' are the things people will tell you they do if you ask them and they are not applied linguists. (The latter tend to see the world as a series of grammatical patterns or, more recently, notions and functions.)
>
> (Long 1985: 89)

Apart from the fact that many of the tasks listed here are not in any obvious way related to language, those that are, such as making an airline reservation or taking a hotel reservation (but only where these are done face-to-face or by telephone, as opposed to on-line), are prosaic to the point of banality, and indeed, in most cases, would require minimal interaction. However, they are consistent with the view of communication as conversational interaction involving information exchange.

This information exchange, of course, does not take place in a vacuum and SLA

researchers who have operationalised task in their work have elaborated a list of key task conditions. Following in particular Long (1996), Skehan (1998), Ellis (2000), Robinson (2001b), these include: (1) the extent to which the type of task is familiar to the interlocutors; (2) the extent to which the topic and discourse genre are familiar to the interlocutors; (3) the relative complexity of the procedure and information processing required to carry out the task; (4) the relative complexity of the language required to carry out the task; (5) the relative stress level of the task (dependent on factors such as time limits, locus of control over process and the quality of response required); (6) if the task is one-way (requiring one interlocutor to ask for information and the other to provide it) or two-way (requiring both or all interlocutors to provide information); (7) if the task is convergent (where the goal is to agree) or divergent (where the goal is not agreement); (8) if the task is closed (only one possible solution) or open (many possible solutions); (9) if the individuals carrying out the task have had time to plan their interventions in any way or not, and (10) the identity of interlocutors as native speakers or non-native speakers of the language being used to carry out the task. As impressive as this list might seem, it is actually quite limited as it conceptualises these selected characteristics of task as somehow determinant of the behaviour of speakers. It is only if we take the work-like and mechanical view of what we do with talk on a moment-to-moment basis that we can accept this framework. A more nuanced view is explored below.

4.4 NEGOTIATION FOR MEANING

If task is a cover term for conversational interaction as information exchange, then negotiation for meaning is the cover term for the key process involved in carrying out tasks. As the name suggests, the key to the IIO model is interaction and interaction more specifically understood as negotiation for meaning (hereafter NfM).[6] NfM is defined as follows:

> Negotiation for meaning is the process in which, in an effort to communicate, learners and competent speakers provide and interpret signals of their own and their interlocutor's perceived comprehension, thus provoking adjustments to linguistic form, conversational structure, message content, or all three, until an acceptable level of understanding is achieved.
>
> (Long 1996: 418)

> Negotiation between learners and interlocutors takes place during the course of their interaction when either one signals with questions or comments that the other's preceding message has not been successfully conveyed. The other then responds often repeating or modifying the message. The modified version might take the form of a word or phrase extracted or segmented from the original utterance, a paraphrase, or a synonym substitution thereof.
>
> (Pica et al. 1996: 61)

These researchers (and many others) do not anywhere make the bold claim that NfM for meaning is absolutely necessary in order for language acquisition to take

place, and Long, following Durkin (1987), cautions against 'a tendency ... to focus on the associations between grammatical input and development and to ignore or downplay the numerous environmental features that apparently make no difference whatsoever' (Long 1996: 453–4). Nevertheless, they do make moderately strong claims to the effect that NfM 'facilitates acquisition because it connects input, internal learner capacities, particularly selective attention, and output in productive ways' (ibid.: 451–2) and that it 'brings about reformulations, segmentations, and the movement of constituents that can provide learners both lexical and grammatical information about the L2 as well as their own IL [interlanguage] system' (Gass, Mackey and Pica 1998: 302).

Similarly, these researchers do not explicitly say that they are setting out to define communication and one could make the case that what they propose is a particular model of communication which provides opportunities for the learner's interlanguage to develop, and that taking such a stance says nothing about what their view on communication is. Indeed, Gass states fairly clearly that 'the emphasis in input and interaction studies is on the language used and not on the act of communication' (Gass 1998: 84). Nevertheless, I see in their discussions a theory of communication, and I say this for several reasons.

First, as was made clear above, the IIO model is in its origins about a move from linguistic competence as the sole object of acquisition in the SLA to communicative competence, a broader view of language including the ability to engage in conversation. This broader view of language necessitates some theorisation of what is meant by the ability to engage in conversation. Surely a move towards such theorisation is to be found in the identification and itemisation of so-called 'negotiation devices' to which many researchers, most notably Long (1996), have devoted considerable time and energy. These devices include: recasts, repetitions, confirmations, reformulations, paraphrasing, comprehension checks, confirmation checks, clarification requests, and lexical substitutions. Such a list, to my mind, constitutes a theory of how NfM takes place (see the references to conversational repair in the definitions of NfM cited above), and because NfM is considered to be so important to the acquisition process, it stands to reason that learners will need to learn how to do it in order to carry out tasks or will learn how to do it as they carry out tasks, where these, following Long, reflect real-world activity. They are, after all, the 'hundred and one things people *do* in everyday life, at work, at play, and in between' (Long 1985: 89).

4.5 THE CRITIQUE OF LANGUAGE IN SLA

Not surprisingly, the tripartite view of language as a narrow and partial version of communicative competence, task as what people do when speaking to one another and conversational interaction as NfM, has not gone unchallenged or been accepted uncritically (although it must be said that for the most part criticisms have come from what might be considered to be the fringes of SLA and constitute, in Gass's terms, 'challenges from without' (Gass 2000: 60)). Thus, we find the sociolinguist Ben Rampton cautioning that SLA researchers 'run ... the risk of remaining

restrictively preoccupied with the space between the speaker and his grammar, rather than with the relationship between speakers and the world around them' (Rampton 1987: 49); we find discourse specialists Alan Firth and Johannes Wagner challenging the 'predominant view of discourse and communication within second language acquisition (SLA)' which is 'individualistic and mechanistic ...' and 'fails to account in a satisfactory way for interactional and sociolinguistic dimensions of language' (Firth and Wagner 1997: 285); and we find language play specialist Guy Cook questioning the undeclared loyalty of many SLA researchers to the principles of Universal Grammar as they 'separate off the formal language system from its social and psychological uses' (Cook 2000: 175). However, it would be misleading to suggest that there have not been significant criticisms from authors whom we might consider to be mainstream SLA researchers.

For example, Ellen Bialystok (1998) argues that language proficiency is a key concept in SLA in need of clarification and proposes moving beyond formulations that focus on either language as form or language as function to a view that would 'include details of the social and cultural contexts in which language is used' (Bialystok 1998: 503). Elsewhere, Diane Larsen-Freeman (1997) has in recent years shown an interest in complexity theory, an interest which has led her to see language as more dynamic than static, more process-like than product-like, more contingent than predictable and more non-linear than linear. In the sections which follow, I explore critiques of SLA which come from three very different sources. In doing so, I shall be working more on the fringes, like Rampton, Firth and Wagner and Cook, as opposed to from the inside. I shall elaborate a deconstruction of task, with the focus on linguistic competence and NfM, to see if we might conceptualise the language in SLA in a different manner.

At this point, the reader might well ask: what is wrong with the current dominant view of language as linguistic competence, used in the process of NfM while carrying out instrumental tasks? And what do I propose as a substitute? First, I should point out that I agree that at its most basic level, the language in SLA must surely be about linguistic competence, that communication is always about doing things with words (although what 'things' is obviously open to debate) and that conversational inter-action with a view to exchanging information is common (although certainly not the same) across different languages and cultures. I therefore do not envisage the wholesale replacement of this fundamentally instrumental view of language and communication with another, presumably less fundamentally instrumental view. Rather, the point of the critique which follows is to attempt to develop a com-plement to what I think is an overly partial and limited view of language and communication. It should not be taken as a dismissal or rejection of the work of many researchers who have compiled an impressive record of interesting research over the past thirty years; rather, it should be taken as an attempt to further and enrich our understanding of what the language in SLA is about.[7]

4.5.1 A critique of task

As I observed above, task as a cover term for our day-to-day activities is seen by many IIO researchers as exclusively work-oriented and where speaking is involved, this work involves the exchange of information. However, if we examine discussions of language and communication which are more sociolinguistically motivated (or, in any case, which are not parochially SLA in origin and outlook), we immediately see how narrow, confining and partial this view is.

4.5.1.1 Ludic talk

One critical angle comes from researchers who make the case that ludic functions of language and communication are just as important, if not more so, than referential/transactional functions. Two scholars in particular, Cook (2000) and Rampton (1999), coming from different backgrounds, have suggested that there are plenty of counter-examples to the claim that communication is primarily about information exchange, getting things done and work. Cook (2000) elaborates a theory of language play as an essential part of the overall competence that human beings need if they are to take active part in the day-to-day interactions of any culture or community. He writes:

> Language play is ... universally important, both cognitively and socially. Yet, it may appear to the hard-pressed worker as a waste of time. It thus throws into doubt the dichotomy between 'useful' and 'useless' activity. For children acquiring a first language, for example, 'useless' pattern manipulation and the creation of alternative realities seems to promote both mastery of language system and acculturation. This key role of language play in first language acquisition suggests the possibility of a similar role in adult second language learning. Yet for both the first and the second language learner, language play is much more than a potential *means*. As a widespread, highly valued use of language, of social and cognitive importance, it is also an *end*. Knowing a language, and being able to function in communities which use that language, entails being able to understand and produce play with it, making this ability a necessary part of advanced proficiency.
>
> (Cook 2000: 150)

For Cook, there is a contrast between instrumental transactional views of language and language play, where communicative purpose is ludic as opposed to work-like, where meanings are indeterminate as opposed to exact and where formal aspects of language are manipulated for the sake of manipulation as opposed to for the sake of fabricating messages.

Coming from a sociolinguistic background, Rampton (1995, 1999) also makes a case for the importance of ludic language activity in his discussions of 'language crossing'. Language crossing involves 'the use of speech varieties which are not normally thought to belong to the speaker' (Rampton 1999: 335) and how this use is a means by which individuals can play with different identities as realised through

the use of one variety or another. In the British secondary schools where Rampton has carried out his research, he has found Indian youths switching between vernacular English and stylised Indian English,[8] and Afro-Caribbean and White youths making use of words and expressions in Punjabi (sic) which they have picked up from, or been taught by, their Punjabi-speaking Indian friends. In both cases, there is an ongoing exploration of different identities which move either towards social similarity or social difference. Thus, while in some cases, an explicit focus on ethnolinguistic difference 'helps to promote supra-ethnic peer group identity' (327), as when non-Punjabi speaking boys are pushed into producing taboo words and expressions in Punjabi, in other cases they serve to maintain and strengthen peer divisions and difference within a group, as when a Punjabi-speaking girl ignores a non-Punjabi speaking girl who attempts to display insider knowledge about bhangra music.[9]

Rampton sees crossing and ludic uses of language as fairly common in the settings he is exploring, and there is the suggestion, similar to that made by Cook, that a part of being competent in a speech community is knowing how to negotiate one's identity across different game-like activities carried out in different language varieties. Of course, one might argue that the contexts Rampton is discussing are not typical or exemplary, as they are peculiar to multicultural urban Britain. However, if I think of my contacts over the years with two other very different language contexts, I see similar patterns of crossing and ludic activity. In Catalonia, it is common for Catalan speakers to play with the interjection of Spanish-speaking voices (and on some occasions, English-speaking voices) in their day-to-day conversations (see Pujolar 1997, 2000, for examples). And, even in supposedly monolingual settings, one finds different varieties of language being used, such as the adoption of silly voices and foreign accents, and the production of formulaic utterances such as 'Whazzzaaaap!' (from Budweiser beer commercials shown in English-speaking countries such as the US and Britain).

Apart from the marginalisation of ludic functions of language, the view of task as work has also led to a near-total lack of attention to what is variably known as 'casual conversation' (Eggins and Slade 1997) or 'small talk' (e.g. J. Coupland 2000a). 'Casual conversation' is a term used by Eggins and Slade to refer to 'interactions which are not motivated by a clear pragmatic purpose [note that 'pragmatic' here means work-like, referential and transactional information exchange], and which display informality and humour ...' (Eggins and Slade 1997: 20). 'Small talk', according to Coupland, has been viewed in both lay and academic circles as 'a conventionalized and peripheral mode of talk ... [which] seems to subsume "gossip", "chat" and "time-out talk"', that is, 'a range of supposedly minor, informal, unimportant and un-serious modes of talk' (Coupland 2000a: 1). However, neither casual conversation nor small talk should be taken as lacking in any purpose whatsoever or as peripheral; rather, they are a foundation, as Malinowski (1923) long ago pointed out, for 'phatic communion', the basic function of which is the establishment, maintenance and strengthening of social ties of companionship.

One interesting question about casual conversation and small talk is the extent to

which it is generally realised separate from referential/transactional communication. Although one can find examples which clearly seem to be strictly referential/transactional or strictly interactional/phatic, it is probably more accurate to see all communication as containing elements of both. This makes sense if we follow linguists such as Halliday (1978) who see language and communication as multi-layered, containing at the same time an ideational meaning (topic-based meaning), interpersonal (role- and relationship-based meaning) and textual (meaning about message construction). It also makes sense if our intention is to enrich our view of language in SLA as opposed to offering an alternative. As I stated above, I am more interested in the former than the latter as a strategy.

4.5.1.2 Talk at work

Given the work-like nature of tasks, as conceptualised by Long and others, one place where we might find an enriched and more nuanced view of task is in studies of exchanges taking place in the workplace. Holmes (2000) discusses small talk in the workplace (specifically, talk among employees in government offices in New Zealand), offering a helpful heuristic for categorising and analysing such talk along a scale with two extremes. At one extreme there is what she calls 'core business talk', that is 'relevant, focused, often context bound, on-task talk, with a high information content' (Holmes 2000: 36); at the other extreme, there is Malinowski's 'phatic communion', that is, talk which is 'independent of any specific workplace context, which is "atopical" and irrelevant in terms of workplace business, and which has relatively little referential content or information load' (ibid.: 37). In between these two extremes, there are two intermediate points on Holmes's scale. The first is 'work-related talk', that is talk relevant to the business context but not, strictly speaking, relevant to the task at hand. The second is 'social talk', that is talk which is irrelevant to a particular task at work but which is about socialising on the job (as when employees make comments in a lift about their respective workload or how horrible Mondays are). Holmes's continuum looks as follows:

```
-----------•----------------------•----------------------•----------------------•----------
```

Core business talk	Work-related talk	Social talk	Phatic communion

For Holmes, there are occasions when work colleagues are engaged in what can clearly be defined as talk belonging to any of these four categories; however, the norm seems to be a drift backwards and forwards along the continuum. Thus, during a very focused business meeting, there will likely be sequences which are exclusively business talk, but there will also be occasional or even frequent moments of drift from core business talk to work-related talk, from work-related talk to social talk, from social talk to phatic communion, from phatic communion to work-related talk, and so on.

Elsewhere, McCarthy (2000) also discusses workplace talk, but focuses on what are commonly termed 'service encounters', that is exchanges taking place around the provision of services. Examining in detail exchanges taking place at a hairdressing

salon and during driving lessons, McCarthy argues that this talk is genre-specific, that is certain speech acts occur in a certain order which will generally be realised during exchanges. However, he makes the point that researchers need to adopt a 'dynamic' approach to genre which takes into account how 'the same genre can exhibit variation in different speech events' and how 'the same genre may be played out in different ways, depending on the identity and purposes of the speakers ...' (McCarthy 2001: 86). Thus, one can model service encounters but, in doing so, must take into account that individual instances will display dynamism and variability and that the transactionally-oriented aspects of talk will be embedded in and intertwined with relational/interpersonal aspects.

The relevance of this discussion of casual conversation/small talk, and specifically such talk in the workplace, is that there seems to be a growing consensus among researchers working in this area of discourse analysis that communication viewed as work- or task-related is not just about information exchange; rather, there is also an interactional/relational/interpersonal angle to be accounted for. In addition, these researchers borrow from Hallidayan linguistics a view of language as being multi-functional and simultaneously so. Three key questions arise from such discussion: (1) Is all referential/transactional communication *at the same time* interactional/relational/interpersonal? (2) During the ongoing flow of talk, is one aspect of communication focused on to the exclusion of the other, and (3) Is it the case that while talk is generally identifiable as more or less about one aspect or the other, the two are so tightly intertwined that they seem to be simultaneous? In order to address any of these questions, SLA researchers will need to move away from the view that tasks carried out on a day-to-day and even moment-to-moment basis, are only about work-like information exchanges.

As Long (1997, 1998) and Gass (1998, 2000) have argued, a concern with such issues is the responsibility of the sociolinguist who studies language use in different contexts and not the SLA researcher who studies second language acquisition (see Chapter 5 for more in-depth discussion of the distinction between use and acquisition). However, it is IIO researchers themselves who have argued, first, that individuals learn through the carrying-out of tasks involving conversational interaction and, second, that formal classroom tasks should mirror those tasks taking place in naturalistic settings where L2 learners are deemed to have the opportunity to interact with fellow L2 learners and L1 speakers (but see Chapter 3 for a discussion of how this is not always the case). Of course, one could return to the educationally motivated discussion of task cited above (Candlin, Breen and Nunan) and argue that there could be tasks that are strictly pedagogical in nature, effective for learning in formal contexts, which bear little resemblance to 'real-world' tasks. However, if such tasks are still about information transfer, they are missing out the ludic uses of language, documented by Cook and Rampton; if they are solely about a focus on form, they are hardly likely to develop much in the way of the learner's communicative competence in the sense of developing socially constituted linguistic knowledge. Many SLA researchers following the IIO model, therefore, have managed to get themselves in a quandary: they want a conceptualisation of what

people do with language that is grounded in the real world, but they do not seem willing to take on the fact that in the real world, there is play as well as work and that when there is work, there is the co-occurrence of other phenomena, such as phatic communion.

4.5.2 Critique of NfM

The process of communication between human beings is not a case of simple transmission of information. Instead, people who communicate do so from a certain position, having particular objectives in mind (which they may or may not achieve), and construct messages that are necessarily and purposefully ambiguous ... Negotiation of positions between persons who communicate is the essence of communication.

(Valsiner and van der Veer 2000: 390)

If day-to-day speaking tasks are not only about referential/transactional communication, but are also interactional/relational/interpersonal in nature and, as Valsiner and van der Veer suggest, about the 'negotiation of positions', what does this mean for the concept of NfM? In my view, it means that we need to consider that, apart from negotiating for meaning, where meaning refers to ideational messages sent back and forth, we must also consider other types of messages or perhaps, better said, phenomena which are involved and at stake.

4.5.2.1 Negotiation of solidarity and support

Pauline Foster's oft-cited study of interactions taking place among ESL students carrying out tasks at a university in London found that 'uncoached negotiation for meaning is not "alive and well" in the classroom' (Foster 1998: 19). Foster came to this conclusion after observing that the quantity and quality of participation among members of groups varied considerably. Considering why this might be the case, she suggests that students may consciously decide not to negotiate for meaning because they have chosen to adopt a 'wait and see' attitude (thus making interruptions of the kind embodied in NfM inappropriate) or they simply do not take the task seriously enough to be bothered. However, after entering such interesting terrain, Foster moves to suggest a solution in the form of different and better task design (she likes Swain's use of form-focused activities, as explained in Swain 1995), and an in-depth consideration of the interactional/relational/interpersonal functions of communication never materialises.

Taking a more socially informed stance, Foster might more fruitfully have deconstructed the concept of NfM by making better use of Guy Aston's (1986, 1993) work, some of which she does in fact cite (Aston 1986).[10] I say this because, several years after the publication of his work on conversational interaction, Aston epitomises the scholar who presents findings that are truly devastating to common assumptions in a field but who nevertheless is not taken seriously enough by those

who depend on such assumptions for the furtherance of their research agenda. Aston is important because in his two finely conceptualised pieces, he made the point, central to this chapter, that NfM and the view of communication as referential/transactional which sustains it is far too narrow and partial a view of communication if our aim is to understand what happens when language learners interact with one another or so-called 'native speakers'. In his 1986 article 'Trouble-shooting in inter-action with learners: the more the merrier', Aston adopts the term 'trouble-shooting' to refer to what some researchers have called 'non understanding routines' (e.g. Varonis and Gass 1985) and others would see as instances of 'conversational repair' (see Long 1996, for extensive treatment). In the following exchange between a native speaker (N) and a learner (L), Aston makes the point that although a confirmation request has taken place, there is really no repair and the native speaker attempts to move the conversation on:

Relevant transcription conventions:
→ indication of where repairs take place
(.) pause
[] overlapping contributions
= latching to preceding contribution

L: My son doesn't like cold.
→N: (.) Doesn't like?
L: Cold.
N: = Cold.
L: = Yeah.
N: But they don't feel it if you freeze them quickly.

(Aston 1986: 136)

Having examined and analysed numerous such instances of trouble-shooting from a variety of sources, Aston concludes:

By jointly performing a trouble-shooting routine, what outcome is achieved? We have already seen that the routines do not, even where accessibility is at issue, necessarily produce a substantive understanding … It can similarly be argued that where acceptability is at issue, they do not necessarily produce substantive agree-ment. Rather, what they appear to achieve is a formal display of the convergence of participants' worlds. They allow the participants to perform a ritual of under-standing or agreement. Thus, confirmation checks can allow participants to go through the motions of agreeing as to the correctness of a hearer's understanding, comprehension checks as to the understanding of the speaker's contribution. Clarification requests enable agreement to be displayed as to what a speaker said or intended. In all these cases, a display of mutual accessibility is provided. Similarly, trouble-shooting in issues of acceptability allows for a ritual of solidarity, with a display of mutual acceptance.

(Aston 1986: 139)

This excerpt appears near the end of the article and is an indication of where Aston is going with his argument, namely towards a consideration of sociologically-oriented constructs, such as solidarity, support and face, which might serve to broaden and embellish our understanding of interaction beyond the confines of NfM.

In a follow-up to his 1986 paper, Aston contrasts communication at the service of 'a convergence of participants' information states' (Aston 1993: 226) with communication at the service of 'the establishment and maintenance of friendly relationships' (ibid.), what Leech (1983) calls 'comity'. In doing so, Aston presages my discussion (above) about task as being too narrowly referential/transactional in nature and echoes his 1986 critique of NfM. This time, however, Aston takes his arguments further, making a case for two new types of negotiation:

1. Negotiation for solidarity 'involves participants in finding they share attitudes to features of their world in common' (Aston 1993: 231), that is, 'some state or event of which they have common experience' (ibid.: 232). It 'is largely characterized by routines of agreement' (ibid.: 232).
2. Negotiation for support involves one participant 'sympathizing, or feeling for the other' (ibid.: 232), despite not having ever experienced the same state or event. It 'is characterized by routines of affiliation' (ibid.: 233).

Negotiation for solidarity includes instances where we agree with someone's comment about the weather, echo complaints about the poor punctuality of trains, or show appreciation for an ironic comment by smiling or laughing. Such negotiation is successfully carried out not only by producing utterances of agreement or gestures or laughter but also linguistically, via the production of analogous contributions (as when a conversation closer such as 'Nice talking to you' is countered with 'Nice talking to you'). Negotiation for support includes instances when we show sympathy for someone's plight (be it illness, mistreatment by a third party or a lost job opportunity), give someone a compliment on their appearance or behaviour, or laugh at someone's jokes. Aston makes the point that just as referential/transactional discourse is reliant on speakers' holding knowledge and beliefs in common, solidarity and support discourse is reliant, in the former case, on actually having experiences in common and, in the latter case, on personal involvement with the other. Just as negotiation for meaning will fail if knowledge and beliefs are not shared, negotiation for solidarity or support will fail if experiences and affective ties, respectively, are not shared.

The problem for Aston is that SLA has traditionally focused on the NfM and has not taken on negotiation for solidarity or support. Of course, one reason for the omission of these constructs is that they do not form part of the IIO framework, as envisaged by Gass, Long, Pica and other researchers, and therefore they are not 'seen'. However, I can think of two other reasons for this omission, one logistical and practical in nature and the other more about convenience. In relation to the logistical and practical reason, the fact that most SLA research is conducted with individuals who do not share common experiences or who do not have strong affective ties with

one another, means that it is deemed more feasible to concentrate on the more technical (and purportedly universal) information side of communication, leaving social affective factors out of the analysis. In relation to convenience, the exclusion of negotiation for solidarity and support from research makes it easier to describe, code and analyse discourse; by contrast, taking on these angles means having to deal with constructs such as irony, ellipsis and silence, which are not really classifiable as negotiation devices but which nonetheless are all effective conversation strategies when solidarity and support are included in the analysis.

Aston finds instances of negotiation for solidarity in native speaker/non-native speaker dyads, where 'participants can be seen to be making up for their lack of a common culture by using their experience as cultural outsiders as a basic for negotiating solidarity' (Aston 1993: 239). He cites the example of two individuals from different cultural backgrounds manifesting critical and ironic attitudes towards their respective home cultures and thereby establishing a bond of solidarity as individuals disaffiliated from these home cultures. In relation to the negotiation of support, Aston finds instances where non-native speakers may inspire sympathy and a desire to help from native speakers if they manifest linguistic and cultural incompetence in an overt way. Thus, in bookshop encounters, a non-native speaker cannot negotiate the location of a book she is looking for by adjusting the linguistic features of her discourse so that they are more grammatically accurate and socially appropriate; however, she can achieve this goal via the route of displayed and self-effacing helplessness, which triggers the native speaker to actively seek to find her book.

4.5.2.2 Negotiation of face

In a different context, but following Aston's line of reasoning (i.e. that simultaneous with the NfM, there is also the negotiation of social affective phenomena), Jane Davies (2000) discusses the idea of 'negotiation of face'. Face may be simply defined as 'the public self-image of a person, ... that emotional and social sense of self that everyone has and expects everyone else to recognize' (Yule 1996: 60) or 'the negotiated public image, mutually granted each other by participants in a communicative event' (Scollon and Scollon 1995: 35; emphasis in the original removed). As regards its origins, scholars such as Thomas (1995) and Scollon and Scollon (1995) make the point that face is not just the invention of sociologists such as Erving Goffman, writing in English; rather, it has a long history, with similar meaning, in languages such as Mandarin, Japanese and Korean. As borrowed and used in sociolinguistics, face is seen to be of two types: positive and negative. Positive face is 'the need to be accepted, even liked by others, to be treated as a member of the same group, and to know that his or her wants are shared by others' (Yule 1996: 62); negative face is 'the need to be independent, to have freedom of action, and not to be imposed on by others' (Yule 1996: 61). As Scollon and Scollon (1995) point out, both types of face are important and, indeed, are simultaneously negotiated during interaction. Face is also generally part of a larger discussion of politeness (see Brown

and Levinson 1987, for a classic exposition of this topic), defined as 'the means employed to show awareness of another person's face' (Yule 1996: 60) or as 'a strategy for *mitigating* threat to face in verbal interaction' (Cameron 2001: 79). For these authors, speakers are constantly having to monitor the extent to which what they say may or may not constitute a face threatening act (FTA) for their interlocutor. In a situation where face is at stake in some way, the general options available are said to be either avoidance of the FTA or 'doing' the FTA. 'Doing' an FTA may be done indirectly, as when, for example, we mention that we do not have a pen in an attempt to get a friend to lend us one. If the FTA is done directly, on the other hand, it may be done baldly on record, with no mitigation or redressive action taken (for example, we simply say to someone, 'Give me that pen') or with mitigation or redressive action (for example, we say, 'Would you lend me a pen?').

In Davies's study, she organised two-way information exchange tasks with three dyads composed of Mandarin speakers and three dyads composed of Japanese speakers. All participants in the study were ESL students at a university in London. Davies video-recorded the dyads completing the tasks and then interviewed participants individually as she played back the recordings to them. Participants were asked to identify and comment on those parts of the recording which they deemed interesting or problematic. One of Davies's findings was that, particularly in the case of the Japanese speakers, the recorded exchanges seemed more motivated by attempts to balance negative and positive face than by attempts to carry out the transactional goal of completing the task. Davies explains one excerpt from the task and the subsequent discussion with one of the participants as follows:

In the following example, the indicator is J2's suggestion about the order of the pictures. J1 disagrees with J2's suggestions, thereby showing that J2 has misunderstood. The ensuing response of J1 seems to be an attempt to repair this misunderstanding.

Example 5–10
(number) = pause in seconds
(normal font) = description of actions
[] = overlapped speech
underlined = emphasis

J2: ah I'm not sure but I think uhm (0.8) you said cutting the wood and divided some pieces of wood / so between them I think (0.8) peeling the (gesturing peeling) (1.8) skin of wood (gesturing peeling)
J1: uh no no I [mean
J2: no?]
J1: the the (1.3) I think that <u>then</u> we need peel the w-
J2: wood
J1: and yeah more smaller
J2: ah (nodding)

J1 comments in her interview that by 'ah' J2 means that she now understands. J2 has a different version of events:

> J2: I give up ... after process [of] the discussion it could be [I will understand] ... I can't understand what she said so I skip.

Although it is J1's utterance that is ultimately being negotiated, the misunderstanding is face threatening for J2. In this context, the suppliance of 'wood', the exclamation of 'ah' and the gesture of nodding are most readily understood as a display of understanding (Aston 1986); a form of self-repair directed at J2's face needs rather than at her understanding, becomes in effect a repair of face for J2.

(Davies 2000: 74–5)

For Davies, the Japanese participants in this study were constantly walking a fine line between the maintenance of positive and negative face, that is, balancing their personal need to be accepted and treated as a member of a group while maintaining their freedom from imposition from others. Contradicting Varonis and Gass's (1985) claim that 'non-native speakers, being not yet competent in the domain of the target language, would also be more likely to respond to other-repair without embarrassment' (71), Davies found that Japanese speakers monitored the use of repair according to their assumptions about their interlocutor's age, social status and, above all, individual dignity.

4.5.2.3 Negotiation of identity

Ultimately discussions about negotiation for solidarity, support and face boil down to the issue of identity and, indeed, what we might call the 'negotiation of identity'. Identity is a difficult term to define, probably because so much has been written about it in recent years, often in less than clear fashion. Here I shall follow the work of social theorists who see conversational interaction as the enactment of different subjectivities, defined by Chris Weedon as 'the conscious and unconscious thoughts and emotions of the individual, her sense of herself and her ways of understanding her relation in the world' (Weedon 1997: 32). In contrast to humanist/structuralist notions of identity as unified, internally completely coherent and uncontested, and stable over both time (past, present and future) and space (in varying contexts), Weedon proposes 'a subjectivity which is precarious, contradictory and in process, constantly reconstituted in discourse each time we think or speak' (ibid.). Thus individuals embody multiple subjectivities which are in a state of ongoing and constant change and which are managed through thought, speech and other forms of communication such as writing, graphic representation and corporal expression.

Subjectivities as multi-voiced in nature, both draw on and continually re-shape and re-construct what different authors have called the different 'lifestyle sectors' (Giddens 1991), 'communities of practice' (Lave and Wenger 1991), 'discourse communities' (Lemke 1995) and 'Discourses' (Gee 1996). Weedon, following Foucault (1981, 1986, 1988), speaks of 'discursive fields', which she defines as

'competing ways of giving meaning to the world and of organizing social institutions and processes' (Weedon 1997: 34). She cites the example of legal discourse in Britain where there are conflicting voices over what is the proper trial practice as regards procedure, sentencing and modes of punishment. Following Weedon, we come to see any conversational intervention produced by a speaker as the expression of a subject position which originates in a particular discursive field. What is actually said and how it is said may be classified as plausible or reasonable within that particular discursive field. It is, therefore, a particular voice which a particular speaker has adopted momentarily with a view to projecting a particular subjectivity. And the sum total of subjectivities embodied by an individual at a given time constitute her/his individual identity.

Traditionally, in SLA research there has been a tendency to provide particulars about individuals such as their age, gender, educational background and their L1; however, as Firth and Wagner (1997) point out, the only subjectivity worthy of any in-depth discussion in SLA is that of non-native speaker (NNS) in contrast with native speaker (NS) as target identity, or 'defective communicator'. They describe the situation in SLA as follows:

> The identity categorizations NS and NNS are applied exogenously and without regard for their emic relevance. The fact that NS or NNS is only one identity from a multitude of social identities, many of which can be relevant simultaneously, and all of which are motile (father, man, friend, local, guest, opponent, husband, colleague, teacher, teammate, intimate acquaintance, stranger, brother, son, expert, novice, native speaker, uninitiated, joke teller, speaker, caller, overhearer ad infinitum), is, it seems fair to conclude, a nonissue in SLA. For the SLA researcher, only one identity *really matters*, and it matters constantly and in equal measure throughout the duration of the encounter being studied.
>
> (Firth and Wagner 1997: 292; emphasis in the original)

When information about other identities is provided by SLA researchers, more often than not they do not actually do anything with it. Thus, as we observed in Chapter 3, we are often informed about the 'L1' of participants in studies, but this is given as dry fact and not explored as possible subject position adopted by the individual vis à vis the language being learned or the process of learning it. In addition, we are not told anything about what 'L1' actually means. Does it mean that the participant is monolingual and has never had contact with any other language except the one he or she is learning at the time of the research? For example, 'Spanish' might be listed as the L1 of a Peruvian immigrant to the US who grew up speaking Quechua and who therefore might have extremely nuanced positions towards Spanish and Quechua and, indeed, English. Or it might refer to a university student in Britain whose parents are from Andalusia but who grew up in Catalonia speaking both Spanish and Catalan, later studied French in secondary school for six years and, when asked what her L1 is, tells the researcher 'Spanish'. Similarly, we are often given a breakdown of participants by 'gender', but with little or no exploration of how being female is a subject position within a particular discursive field and how this

might be important when it comes to conversational interaction. Indeed, as Susan Ehrlich (1997) points out, the term 'gender' is normally used to signify biological sex and there is nothing about gender as socially constructed in analyses.[11] There are discussions of females being more successful than males or females and males using different learning strategies. The problem with much research is that it does not move beyond the most basic sexual categorisations to consider how female-ness or male-ness is done or enacted; nor does it consider how gender is constructed in different ways as we move across cultural boundaries and discourse fields. Thus, to tell a reader that a dyad of ESL learners is made up of two women whose L1 is Japanese, is of little use unless the researcher is going to explore what it means to be a Japanese woman engaging in a conversation in an L2. I have more to say about presentations of L1 and gender in the next section.

The relevance of this critique of NfM is that when individuals engage in conversational exchanges, be they service encounter tasks, workplace tasks or pedagogical tasks, there is more at stake than simply the successful transference of information from one mind to another. Thus, in such exchanges, while there is surely negotiation for meaning at one level, there is also negotiation of identity in a general sense and specifically the negotiation of solidarity, support and face. All of these 'negotiations for and of ...' refer to different aspects of a larger identity and are, following Weedon, different subject positions that we adopt in our moment-to-moment stream of discourse. Traditionally, the problem in SLA has been a tendency to want to limit the analyses of interaction to linguistic features such as morphology, syntax and phonology at the service of NfM, leaving other negotiations in the margins and dealing with identity only in terms of native speaker and non-native speaker. In order to see how this marginalisation takes place and what I suggest might be done about it, in the next section I deconstruct a recent article based on research which sees language as linguistic, task as what we do with language and NfM as how we engage in conversation.

4.6 SOCIALLY SITUATING AN SLA STUDY

4.6.1 The study

What I propose to do here is analyse and deconstruct an article from a major SLA journal, *Studies in Second Language Acquisition*, explaining how its view of language and communication might be made more complete by exploring many of the aspects of language, task and communication which have been discussed in this chapter. The article chosen, 'How do learners perceive interactional feedback?', was published in 2000. The authors are Alison Mackey, Susan Gass and Kim McDonough. I have chosen to focus on this article and not others for several reasons. First, it is relatively recent, having been published in the past three years. Second, it is classically within what we might call the IIO research paradigm. Third, it is a well written piece which reports on well planned and executed research. Fourth and finally, while the authors make some interesting points about the effects of modified input which advance

debate about this aspect of the IIO model, they also either miss or choose not to focus on some interesting phenomena. Below, I discuss how learner identities beyond 'language learner' might have been fruitfully explored in this study and then focus on two excerpts from the data analysis presented in the article, to make the point that participants were saying much more to the researchers than they were perhaps prepared to hear. First, however, I put the reader in the picture by briefly describing what the study was about.

Mackey, Gass and McDonough (2000) have a general interest in the potential contribution to SLA of interactional feedback provided by a more competent interlocutor to a less competent interlocutor in the course of a conversational interaction. The authors believe that in order to explore this relationship, it is first necessary to examine the extent to which such feedback is actually perceived as such by those to whom it is provided. One source of evidence to this effect is to be found in the exchanges themselves: the researchers examine a stretch of discourse and reach an agreement as to whether or not it contains an example of interactional feedback, and if it does, what type of interactional feedback it is and, more importantly, the effect it has on the linguistic structure of the exchange. Another source of evidence for the perception of interactional feedback as interactional feedback is to be found in post-task accounts of what happened provided by the learner.

In order to explore the issue of the perception of interactional feedback, the researchers video-recorded two groups of language students at a university in the US as they engaged in two-way spot-the-differences tasks. Group one comprised ten ESL students from five different countries and group two comprised seven L1 English speakers learning Italian as a foreign language. Members of group one spoke to an L1 speaker of English and members of group two spoke to what the researchers termed a 'near-native' speaker of Italian. These two interviewers were meant to 'provide interactional feedback wherever it seemed appropriate and in whatever form seemed appropriate during the interaction' (Mackey et al. 2000: 479). This interactional feedback was meant to cover four formal aspects of language: phonological, morphosyntactic, lexical and semantic (that is, the overall meaning of an utterance).

Later, the learners were asked to produce stimulated recalls as they viewed the video-recording of their interactions. The authors define a stimulated recall as an opportunity for learners 'to articulate their thoughts while performing a task or after the task has been completed' (ibid.). During the stimulated recalls, learners were asked to comment on those points in the activity when they were exposed to interactional feedback. In particular, the researchers were interested in to what extent examples that they identified as clear cases of feedback were taken as such by learners, and more precisely if episodes identified as being about morphosyntactic, phonological or lexical feedback, were perceived as such by learners. The researchers cross-checked their categorisations of feedback episodes to control for internal validity and they meticulously analysed the learner perceptions of these episodes to see what kind of uptake percentages were achieved. The researchers found that the most salient type of feedback was lexical in nature and the least was morphosyntactic and phonological, and that this state of affairs applied across both groups.

Table 4.1 Participant biodata (based on Mackey et al. 2000)

Participant	Gender	L1	Years of prior study of English or Italian	Weeks spent in the US or Italy
ESL group				
1	M	Cantonese	14	8
2	F	French	10	8
3	M	French	3	28
4	M	French	6	12
5	F	Japanese	15	16
6	F	Japanese	11	12
7	M	Japanese	8	28
8	M	Japanese	8	28
9	M	Korean	10	28
10	M	Thai	8	12
IFL group				
11	F	English	1.5	6
12	M	English	0.5	0
13	F	English	1.5	0
14	F	English	3	38
15	M	English	2	12
16	M	English	2	8
17	M	English	2	4

Early in the article, in their explanation of the research methodology, Mackey et al. present a table which contains 'participant biodata'. I reproduce this table above.

Under the rubric of bio data, the authors display three easily identifiable subjectivities which these learners bring to the task of learning English (in the case of the first group) and learning Italian (in the case of the second group): gender (column 2), L1 (column 3) and foreign student (column 5). Here I am concerned with the first two of these, as they are perhaps the two most common subject positions presented as variables in SLA studies.

4.6.2 Gender

Under the category 'gender', Mackey et al. list participants' biological sex and proceed to do nothing with this categorisation in the rest of the paper. If they wish to make the point that they are against essentialised notions of F/M differences and that a learner is a learner, probably more conditioned in her/his behaviour by the specific conditions of the task being carried out, then they perhaps should make this clear. Of course, such a stance removes the necessity of providing a 'gender' column in the table. On the other hand, if the authors really do think gender is important and following authors such as Cameron (1997), Ehrlich (1997), Talbot (1998), Sunderland (2000), Pavlenko and Piller (2001) and Block (2002), they subscribe to the view that it is not a birth right but a socially constructed aspect of a larger identity and that it is more a question of doing (rather than being) and is 'done' in different ways at different times (depending on any number of contextual factors such as

interlocutor identity, social setting and topic of conversation), then they need to do more than simply produce 'M' and 'F' in a column in a table. In this particular study, taking on gender as a relevant variable would mean exploring how gendered identities were enacted both in the original conversational exchanges and the subsequent stimulated recall sessions. Some of the questions they might have asked and attempted to answer include:

1. In the case of the ESL learners, are learners exposed to English outside the classroom in different ways based on gender differences?
2. How might such differentiated experiences impact on how participants interact in same-gender and different-gender dyads and groups or how they engage in the meta-communicative task of talking about their performance during the situated recalls?
3. The authors mention in an endnote that 'many' of the IFL participants were from 'Italian heritage families' (Mackey et al. 2000: 495). I not sure what 'many' means when discussing seven participants, but a gender question would be: what is the role of Italian in the lives of these participants and are there differences by gender?
4. During the performance of the task and the subsequent situated recall, were there differences across all participants in performance by gender?

Of course, there are big problems with the suggestion that the researchers take on such questions. While it would mean that the authors explored interpretations of input modifications in a more finely tuned manner, it would also mean doing a different type of research where generalisations would likely be more difficult to make and more individualised case studies would be explored. As I suggested above, it might well be the case that these authors are not interested in taking the latter route because they do not think it is relevant to their research interests. In this case, the researchers are interested in a focus on negotiation devices as determinants of behaviour, as opposed to gender as either an influence on behaviour or a part of identity enacted in the exchanges examined. They limit themselves to the provision of information about biological sex, presumably, to give the reader an idea of how representative their sample is as regards this variable. There is, of course, nothing wrong with doing this and, indeed, the authors would probably be taken to task by readers were they not to provide this information. My point here is that they could flesh out their analysis by taking gender more seriously.

4.6.3 L1

In recent discussions of the concept of L1, Rampton (1995) and Leung, Harris and Rampton (1997) have proposed breaking it down into three more nuanced subcategories of language expertise, language affiliation and language inheritance. Language expertise is defined in simple terms as being about 'how proficient people are in a language' (ibid.: 555); however, it raises questions about what criteria are used for making such assessments and whether or not these criteria would be

accepted by normal users of the language in question. Language affiliation is about 'the attachment or identification [people] feel for a language whether or not they nominally belong to the social group customarily associated with it' (ibid.). Finally, language inheritance is about 'the ways in which individuals can be born into a language tradition that is prominent within a family and community setting whether or not they claim expertise in or affiliation to that language' (ibid.).

In this study, the language expertise question might apply to the ESL participants by asking if the languages listed are the only ones in which these participants are proficient. As we observed above, we are informed somewhat late in the article that 'many' of these individuals were from Italian-speaking backgrounds. This characteristic, not mentioned in the table, is actually related to the data collected and presented as a reason why there was little phonological feedback provided to these participants by their interlocutor: 'their pronunciation in many instances was native-like' (Mackey et al. 2000: 495). We are also told that 'they had little command of Italian syntax or morphology' (ibid.). However, the matter is not taken any further and there is no exploration of how proficient these participants were in other areas of language such as lexis and pragmatics. Equally intriguing is the information we are given about the researcher who acted as the IFL participant's conversation partner in the study. We are informed early on that she was 'near native', but we are not told what this means. The interesting question of how this individual's attributed status as an L1 speaker of English might have affected her interactions with the IFL participants, and even differentially so, depending on whether or not these participants were of Italian background, is mentioned in passing ('they shared an L1 [English] ... which may have impacted comprehension of phonology'), but is not explored in any significant way.

Moving to the question of language affiliation, there is an important question which we might ask the ESL participants: what is each participant's degree of group affiliation with speakers of her/his L1 in the US? For example, is the Cantonese speaker a fully functioning member of a local Cantonese-speaking community? If so, what effect might this have on his conversational interaction, to say nothing of his perceptions of input modification? As regards the IFL participants, we might ask about the language affiliation of the Italian-heritage participants. What are their feelings of attachment or identification with Italian and does this relate to how they interact in Italian? Do any of the other IFL participants have language affiliations beyond 'L1 English speaker'? Once again, the researchers' analysis would be fleshed out if they were to show more interest in such questions.

Language inheritance issues overlap with expertise and affiliation issues. A key question here would be aimed at the Italian-heritage IFL participants and the researchers' assumptions about how much Italian would have been passed on to them through their family ties. The researchers claim for these participants little knowledge of morphology and syntax and few problems with pronunciation because 'they have grown up hearing Italian' (Mackey et al. 2000: 495). What would we find if we unpacked this notion? What is the exact nature of Italian-language inheritance among this group of participants and how does it relate to their behaviour?

Thus far, I have discussed the biodata presented by Mackey et al. about the participants in their study. I have argued that while they classify participants by gender and L1, they do not anywhere in the article bring these to life as subject positions. Of course, as I pointed out above, the researchers might argue that they are not really interested in such questions and that their focus is exclusively on input modification, which means that they must stick closely to the data collected and avoid considering the kinds of factors I am introducing. In principle, there is nothing wrong with taking this position and indeed it certainly makes the researcher's life easier. However, if we examine in detail some of the data which Mackey et al. present in the article we see that they are full of readily identifiable examples of many of the issues I discussed when critiquing NfM. Let us examine two excerpts from the article to see what I mean.

4.6.4 A look at some data

The following excerpt is an example of a phonological feedback stimulated recall collected from one of the ESL students and how it was analysed:

Phonological feedback perceived as phonological
NNS: *There are* [flurs]
NS: *Floors?*
NSS: [fluwχrs] *uh flowers.*

Recall: *I was thinking that my pronounce, pronunciation is very horrible.*

In this interaction episode, the NNS pronounced *flowers* in a nontargetlike way, and the NS requested clarification. The NNS reformulated and produced the targetlike version. When asked to comment on what he was thinking at the time of the feedback, the learner remarked that he was thinking that his pronunciation was not very good. Thus, the phonological feedback was perceived by the learner as being about phonology.

(Mackey et al. 2000: 486)

To my mind, the last line of this analysis is incontestable if we are to relate direct comment about pronunciation by the learner to the construct of phonological feedback, as defined by the researchers. However, I would like to consider the possibility that when the student says 'my ... pronunciation is very horrible', he is doing much more than acknowledging that he had made a pronunciation error and then, after having this signalled to him by his interlocutor, had moved to correct it. He makes a general statement about what he perceives as his inability to make himself understood as a result of his poor pronunciation. He is also moving to save face, not by making his pronunciation better (that would be impossible there and then) but by making it clear to his interlocutor that he is aware that he has this problem. Finally, he is perhaps dealing with his own embarrassment at having to watch himself make a public mistake, and hence feels compelled to engage in self-effacement. In short, the situated recall becomes an occasion for the participant to negotiate

different aspects of his identity (deficient communicator and self-aware) as well as to save face.

The following excerpt is an example of a lexical feedback stimulated recall collected from one of the Italian as foreign language students:

Lexical feedback perceived as lexical
NNS: *C'è una Verdi, uh …*
 'There is a green, uh …'
INT: *Una Verdi?*
 'A green?'
NNS: *Una, no, non lo so la lettera per questa.*
 'Ah, no, I don't know the letter for this.'
INT: *Una qualcosa, una pianta?*
 'A something, a plant?'
NNS: *Sì, sì, sì, una pianta.*
 'Yes, yes, yes, a plant.'

Recall: *What is the word for 'plant'? I was thinking 'plant,' I just don't want to say 'plant,' but then I was thinking 'Gosh, I've seen so many plants. I can't believe in Italy I never had to say, "That's a nice plant."'*

… the IFL learner initially produced a nontargetlike word *Verdi* (actually the plural form of 'green'). As indicated by the stimulated-recall comments of this learner, he perceived the target of the feedback, noting that it concerned a specific lexical item.

(Mackey et al. 2000: 489–90)

Once again, I can see how the researchers, in their search for connections between interactional feedback and student perceptions, might limit themselves to simply acknowledging that this is an example of lexical feedback being recognised as such by the student. However, as was the case with the first except, I can think of other things that might be going on. For example, as we observed in the previous example, there is perhaps a degree of embarrassment as the student takes himself to task for not being able to come up with the word for 'plant'. More importantly, there is reference to having spent time in Italy and this experience seems to make his lapse all the more incomprehensible to him. I would suggest that there is perhaps an investment issue here with the student feeling that as someone who has actually spent time in Italy, he should have known this word. Thus, in this case, we once again see the stimulated recall as an instance of negotiation of identity which the researchers have simply taken as an information exchange about what kind of feedback was provided in the original conversational exchange.

In addition, Mackey et al. do not explore in any detail cases where learners produced what were termed 'no content' and 'unclassifiable' recalls, that is recalls which the researchers felt were not about the four key areas of phonology, morphosyntax, lexis and semantics. The reader is provided with definitions and examples of these recall types:

The no content category was operationalized as instances in which the subject participated verbally in the recall, yet said nothing about the content, as in (10).

(10) No content
 a. Ah, two cups, nothing special.
 b. I don't know. I don't remember.

Coded as unclassifiable were instances in which the learner made comments about specific content, but those comments could not be classified into a particular category, as shown in (11).

(11) Unclassifiable
 a. I'm not good because I made a mistake in front of the camera.
 b. Maybe it's crazy I made her laugh.

<div align="right">(Mackey et al. 2000: 482)</div>

The reader is provided with these glosses and examples but not the original interactions which inspired the recalls. This, of course, makes it difficult to speculate about how the recalls relate to the original performance. Nevertheless, I can see in these recalls a tendency towards face-saving through tactics such as downplaying the importance of the interaction (10a) and showing awareness of shortcomings (11a).

Ultimately, however, not having access to all of the data and not having 'been there' make it difficult to carry out an in-depth analysis which would frame conversational exchanges as more than referential/transactional in nature. Indeed, in the mini-analyses I have just presented, I have perhaps had to infer more than I would like to. In order to be more thorough in the explorations of the questions I have posed here, the researchers would need to collect more in the way of learners' accounts of events. I find it disappointing that Mackey et al. do not even consider such lines of inquiry and do not feel the necessity to provide more background information which might shed light on some of the issues I raise. Granted, they certainly do not rule out such lines of inquiry, but given that they are concerned exclusively with the rigorous analysis of the uptake of interactional feedback as manifested in stimulated recalls, they leave no space to consider the kind of avenues of inquiry which I am suggesting here.

Of course, one might ask what the kind of extended analyses I propose would actually achieve. So what if we know more about what kind of identity issues are behind actions taken by the learners when interacting with each other and during the stimulated recalls? The answer is that while we can document and describe different types of interaction and the relative salience of different types of feedback, this is not a full or complete explanation of why learners produce the language they produce at a given place and time. IIO researchers tend to find the explanations for language production in the negotiation for meaning model. I do not deny the validity of this model which primes the linguistic environment of interaction over all others; rather, I attempt to demonstrate that there are questions relating to the negotiation of identity in general and to specific aspects such as face and gender, which are explanatory of the choices learners make when interacting.

4.7 CONCLUSION

> Whatever else we do in speaking to each other, we make claims about ourselves as
> a person, we make claims about the person of our listeners, we claim how the
> persons are related to each other at the outset of the encounter, we project an
> ongoing monitoring of those multiple relationships, as we close the encounter, we
> make claims about what sort of relationships we expect will hold upon resuming
> our contacts in future social encounters.
>
> (Scollon 1998: 33, cited in Coupland 2000b: 8)

The sociolinguistic view of language and communication put forth by Scollon is
a far cry from some of the definitions of task and negotiation for meaning which have
been discussed in this chapter. But does this mean that it is incommensurable with
transactional views of communication and, as such, a completely different field of
inquiry. In recent years, Gass (1998, 2000) has made much of distinctions between
second language use and second language acquisition, making the point that while
the former is interesting in itself, it is not relevant to the latter. I return to Gass's views
on use and acquisition, as well as the views of authors who disagree with her, in
Chapter 5. I mention this point here because it is exemplary of the way in which SLA
researchers in general, and those who subscribe to the IIO model in particular,
systematically marginalise the social side of communication in their work.

My aim in this chapter has been to challenge such attempts at separating the social
and cognitive and the interactional and transactional. I have described in some detail
how in the late 1970s SLA moved from viewing language exclusively in terms of
linguistic competence to viewing it primarily in terms of communicative com-
petence. I argued, however, that this sociolinguistic shift in the form of an adoption
of Hymesian terminology was partial at best, as researchers adopted a rather
mechanistic and, above all, instrumental view of conversational interaction. This
partial adoption of the Hymesian programme evolved into the development of the
key constructs of task and negotiation for meaning which, importantly, were based
on so-called 'real-world' activity and 'real-world' conversational interaction. How-
ever, if we look around us and examine real-world language use, we see that there is
a lot more going on than just information transfer and the carrying-out of mundane
tasks. Thus, language is not just linguistic competence or linguistic competence +
conversation skills put to use to exchange information, although it is, at least in part,
about these competences. In addition, what is needed is a full adoption of the
Hymesian model and a move to the view that (1) language is about social problems
and language use in addition to the formal features of language; (2) its study is based
on data collected from existing speech communities (and here I include formal
classroom settings in both foreign and second language contexts); and (3) any
discussion of it either begins with or highlights social functions before moving to
explore how formal features are organised to serve to them. The only way for this to
happen is for SLA researchers to acquire and use a bigger and more diverse toolkit,
to use Rampton's (1997a) metaphor. This means opening the door to broader
discussions of language of the type which have been common in sociolinguistics for

years, as well as abandoning the use of standard 'yes, but that's not SLA' statements when challenged about the narrow view of language which has existed until now. The alternative, to maintain the status quo, is to continue to erect walls around the current core of SLA as researchers carry out more and more research based on a partial view of the object of SLA. Surely, given the urgent need for an increasingly better understanding of how languages are acquired, a need which Long has often cited in his work (e.g. 1993, 1998), SLA researchers cannot afford such arrogance (where there is absolute certainty that researchers are on the right track) or complacency (where inertia means continuing as always).

NOTES

1. Indeed, if one examines issues of the journal *Language Learning*, published during the 1960s, one finds that most articles purportedly about language learning were in fact linguistic analyses, more often than not comparing and contrasting this or that syntactic, morphological or phonological feature in two or more languages.
2. However, it should be noted that Sharwood Smith then goes on to make clear his personal emphasis on morphology and syntax in discussions of SLA. Thus his call for more informed researchers means knowing more about phenomena such as markedness and variability and not abandoning a psycholinguistic view (although he does acknowledge social phenomena such as context as being important).
3. However, it should be noted that these researchers do not deny that social factors are important when it comes to what they call performance; they simply are not interested in such matters as they see their task as that of constructing an ideal model of linguistic competence.
4. Bygate, Skehan and Swain (2001a) elaborate a similar distinction between what they call 'pragmatic/pedagogic' and 'research' approaches to task. The former approach is concerned with 'understanding how the behaviour of the teacher can be made more effective and how learners can interact with tasks more effectively' (Bygate et al. 2001a: 4) and the latter approach focuses on 'how tasks may be used as a device to uncover the effective engagement of acquisition processes' (ibid.).
5. Although it should be noted that in work published in the late 1980s, Nunan does incorporate into his discussion of tasks research done under the rubric of the IIO model as well as work on learnability (e.g. Pienemann 1989). On the other hand, Breen and Candlin, despite making references to learning theory and cognition, cite little SLA research to support their arguments.
6. It is interesting how in the IIO literature there has been an evolution in usage from 'negotiation *of* meaning' to 'negotiation *for* meaning'. I read this evolution as an implicit recognition that meaning is not out there, an objective entity to be negotiated; rather, it is the co-construction of interlocutors. Nevertheless, researchers who have been critical of the concept of NfM, such as Foster (1998), continue to use 'negotiation *of* meaning'. And among researchers who accept NfM as a useful construct, there are sometimes rather bizarre double uses, such as when Rhonda Oliver (1998) entitled an article 'Negotiation of meaning in Child Interactions' and then went on to refer exclusively to 'negotiation *for* meaning' in the main body of the article. Here I use exclusively 'negotiation *for* meaning' (NfM).
7. It also should not be taken as a complete critique, in the sense of considering all of the different possible frameworks on language available. Notably missing, given my attention to Sociocultural Theory in Chapter 5, is Vygotsky's (1978, 1986) notion of language as psychological tool. For Vygotsky, language is the psychological tool which mediates all

of our social activity. Not only is it what makes possible the planning, execution and respective review of our social activity, via external speech, but it is also what allows us to represent our world symbolically and to mediate our internal mental activity, via internal speech (also known as 'private speech'). Seeing language in this way leads us to question the individual and cognitive view of language, fundamental to the IIO model, and to propose a more socially sensitive view. However, I have decided that if this is my intention, I can go further with my critique of language in the IIO model if I base it on sociolinguistics research and social theory. This tack allows me to hook up with Firth and Wagner's (1997) critique and to take it further. Adopting the language as psychological tool view would lead me in a different direction. In any case, as I indicated above, I do return to Sociocultural Theory in Chapter 5.

8. Rampton (1995) offers detailed discussion of this term, explaining that it is an exaggerated portrayal of English spoken with stereotypical Indian accent and is usually invoked in conversation as an adult voice directed to a child.

9. Rampton defines bhangra music as 'a form of dance music that originated in the Panjab [sic] … that integrated a range of popular musical influences in its transposition to the West, including elements of hip hop' and which in 1987 (when Rampton was carrying out the research described in *Crossing*), 'was a major youth cultural force in the neighbourhood, disseminated on cassette, local radio and at a variety of both local and national functions (weddings, concerts, discos)' (Rampton 1995: 44).

10. I should point out here that in between the 1986 and 1993 publications, Aston published a book chapter (Aston 1988a) and a book (Aston 1988b) in which he further developed the same ideas. However, here I shall concentrate on the 1986 and 1993 publications as they are the ones best known among applied linguists.

11. Ehrlich echoes a view expressed several years earlier by Penny Eckert (1989) in the context of sociolinguistics. Eckert argues that rather than focus on correlations between biological sex and linguistic features, sociolinguists should focus on language use as constitutive of gendered identities.

Chapter 5

What does the 'A' in SLA stand for?

5.1 INTRODUCTION

> We are also interested in all kinds of learning, whether formal, planned and systematic (as in classroom-based learning), or informal and unstructured (as when a new language is 'picked up' in the community). Some second language researchers have proposed a principled distinction between formal, conscious *learning* and informal, unconscious *acquisition*. This distinction attracted much criticism when argued in a strong form by Stephen Krashen (1981); it still has both its active supporters and its critics (e.g. Zobl 1995; Robinson 1997). We think it is difficult to sustain systematically when surveying SLL [second language learning] research in the broad way proposed here, and unless specially indicated we will be using both terms interchangeably.
>
> (Mitchell and Myles 1998: 2)

This is a good starting-point for a discussion of the A for 'acquisition' in SLA as it touches on several points worthy of discussion. First, it makes reference to the fact that over the years SLA researchers have looked at second, foreign and naturalistic contexts, although as has been noted already in Chapter 3, there has been an imbalance in the amount of attention to each of these contexts. Second, it makes reference to the famous distinction between *acquisition* and *learning* put forth by Stephen Krashen from the mid-1970s onwards. As we observed in Chapter 2, Krashen's ideas were important, not least because he was the first SLA researcher to put together what might be called a theory of SLA. For our purposes in this chapter, he is important because his acquisition/learning distinction in some sense opened the door for cognitive science to enter SLA.[1] To this day, the dominant view of acquisition in SLA is one which borrows directly from this broad area of research, and specifically from what is known as the information processing paradigm (see Lachman et al. 1979; Baars 1986; and Mandler 1985, for historical accounts). While authors ranging from Peter Skehan to Rod Ellis to Susan Gass might disagree about some of the particulars of an IIO-based model of SLA, there is a general consensus about how language is processed, stored and, ultimately, acquired, in short how acquisition is conceptualised.

A third significant aspect of the quote reproduced above is the way in which the authors, moving beyond Krashen's distinction, state that they will use the terms 'learning' and 'acquisition' interchangeably. In doing so, they are doing what the authors of other SLA texts have been doing for years (e.g. Ellis 1985; Larsen-Freeman and Long 1991; Towell and Hawkins 1994; Ellis 1994; Lightbown and Spada 1999). However, we might ask ourselves why and when this conflation first occurred. Interestingly, I have found no explanation in any major SLA text published in recent years of why this is the case, although Deborah Cameron (personal communication, November 2001) suggests to me that the use of acquisition as a cover term might be a carry-over from theoretical linguistics where 'First Language Acquisition' has long been a focus of attention. Whatever the case may be, there is a general adherence to 'acquisition' when talking about the field of inquiry and a great deal of looseness when talking about 'acquisition'. This is not an issue I shall explore here and I mention it here simply to make this point.

In the first two sections of this chapter, I examine how the move from Krashen's view to one more grounded in cognitive psychology took place. However, the story does not end here, as there have, in recent years, been challenges to the individualistic laboratory-based view of mental phenomenon that has pervaded cognitive science and, via its application to SLA research, SLA itself. In cognitive science Ulrich Neisser (1967, 1976, 1987, 1997) has been perhaps the best-known critic of research into the workings of the mind, although an ever-growing group of scholars, such as Rom Harré (e.g. Harré and Gillet 1994) and Derek Edwards (for example, 1997), are attracted to discursive psychology. In SLA, it has once again been Firth and Wagner (1997) who have elaborated the best-known critique, although authors following Sociocultural/Activity Theory have also made their views known. There is, then, a growing number of scholars who subscribe to the view that mental processes are as social as they are individual and external as they are internal, a view quite different from that traditionally envisioned by IIO researchers. I devote considerable space to the constructs put forth under the general banner of Sociocultural/Activity Theory, before exploring how, as some proponents of this approach to SLA have suggested, one might integrate information processing and sociocultural approaches to mental processes to form a new model of acquisition in SLA.

5.2 KRASHEN AND THE ACQUISITION/LEARNING DICHOTOMY

As was noted in Chapter 2, just as there was a notable increase in the amount of research being carried out under the heading of 'SLA' in the mid-1970s, Stephen Krashen appeared with his now famous distinction between 'acquisition' and 'learning' (for early formulations, see Krashen 1976, 1977, 1978). According to Krashen, acquisition is a subconscious process taking place in a naturalistic context where there is a focus on meaningful communication. Acquisition is seen to be akin to the process followed by children in first language acquisition. By contrast, learning is a conscious process, taking place in a formal context (such as a classroom) where

there is a focus on formal aspects of the language (such as grammatical rules). Learning is the process followed by language learners around the world who are attending lessons. The starkness of this distinction is reflected in the following quote from Krashen (1978: 153): 'Language acquisition is a subconscious process. Language learning, on the other hand is a conscious process, and is the result of either a formal language learning situation, or a self-study program.'

The acquisition/learning distinction has become an easy-to-understand dichotomy over the years. It is one that has been popular with teachers, as it resonates with their day-to-day experience of ineffective classroom language teaching. It is also superficially consistent with work in theoretical linguistics on first language acquisition, where acquisition is a cover term for 'getting' and 'having'; knowledge and learning is about conscious and intentional effort.[2] However, in retrospect, it is easy to say that it is far too simple. First, it does not really work for those wishing to contrast naturalistic and formal contexts, as it cannot account for the different types of processing engaged in by language learners in both settings. Clearly, the assumptions that 'naturalistic context = subconscious processing' and 'formal context = conscious processing' do not work when it is easy to imagine both types of processing occurring in both contexts: an individual in a naturalistic context might engage in self-directed study, regularly consulting grammar books and dictionaries, while an individual in a classroom setting might not engage at all with the activities organised by her/his teacher, thus rendering useless attempts to focus attention on formal aspects of the target language.

However, by far the biggest problem with Krashen's acquisition/learning distinction has not been so much his definitions, but his claim that that there is no way for information originally processed and stored as 'learned' ever to be transferred to being stored as 'acquired'. This claim has come to be called the 'non-interface' position and it has been a big reason why today Krashen is more respected for putting input on the research agenda in SLA than he is for providing a workable theory of SLA.

The supposed existence of two general types of information processing, one conscious and the other subconscious, had been common currency in cognitive science for over a decade when Krashen first set out his views on acquisition and learning in the mid-1970s. Indeed, as mentioned in Chapter 2, at the same time as Krashen was putting forth his acquisition/learning distinction, cognitive psychology was abuzz with enthusiasm about a seminal two-part article by Schneider and Shiffren (Schneider and Shiffren 1977; Shiffren and Schneider 1977) on the subject of automatic and controlled processes. The two terms parallel Krashen's acquisition and learning, but Schneider and Shiffren make it clear that for them interface is possible:

Automatic processes do not require attention, though they may attract it if training is appropriate, and they do not use up short-term capacity. They are learned following the earlier use of controlled processing that links the same nodes in sequence ... Controlled processing is a temporary activation of nodes in a

sequence that is not yet learned … Controlled processing is used to facilitate long-term learning of all kinds, including automatic processing.

(Schneider and Shiffren 1977: 51–2)

It was not long before SLA researchers with a strong background in cognitive science, most notably Barry McLaughlin (e.g. 1978), were criticising how Krashen, despite having a psychological veneer to his theories, in fact was out of step with commonly accepted notions in cognitive psychology: most importantly for McLaughlin, he had put forth a distinction which was neither testable nor falsifiable. In his 1987 SLA textbook, McLaughlin sums up the problem with the acquisition/learning distinction as follows:

Krashen has argued that the acquisition-learning distinction is an abstraction that predicts many observable and concrete phenomena. He compared his hypothesis to hypotheses in cognitive psychology that are based on abstractions used to predict measurable phenomena. But the abstractions used in cognitive psychology, as Krashen correctly pointed out, are defined by special experimental conditions. If the acquisition-learning hypothesis is to be tested, one needs to know what experimental conditions are necessary to bring out the differences between these two processes.

(McLaughlin 1987: 22)

Krashen did not seem too bothered with such criticisms and to this day maintains the non-interface position (e.g. Krashen 1994, 1998). However, for most other SLA researchers,[3] there has been general acceptance that SLA is a cognitive process as described by researchers working in cognitive science and a noteworthy tendency to use the terms 'acquisition' and 'learning' interchangeably, in recognition that Krashen's distinction has not proved to be empirically supported. This is no less true of researchers working with IIO models of SLA.

5.3 ACQUISITION AS INFORMATION PROCESSING IN THE IIO FRAMEWORK

In Gass's framework for SLA, as described in Chapter 2, what links together the key elements of input, interaction and output – all surface phenomena – is a series of cognitive acts, illustrated in Figure 5.1. Thus, once input kicks off the entire process, there is an apperception stage, where concepts such as attention, noticing and information parsing are introduced to account for how the mind copes with the massive amount of linguistic input to which it is exposed when an individual is engaging in a conversational interaction. After apperception, at the comprehended input stage, further cognitive processes come into play. In particular, Gass refers to analysis of apperceived input, a process involving the marrying of the new with previous knowledge, the linking of both bottom up/inductive and top down/deductive processing. This process eventually becomes what Gass calls the intake stage, that is the crucial moment when the mind begins to assimilate new

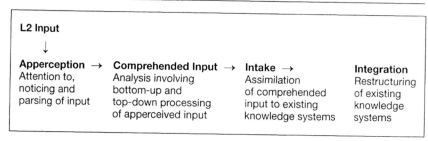

Figure 5.1 Information processing in Gass (1988, 1997)

information into existing knowledge structures that in turn accommodate it. This culminates in integration when the learner's linguistic system has been restructured and newly acquired knowledge becomes intuitive and tacit.

The process of integration, as described by Gass, owes much to the work of McLaughlin who has over the years (e.g. McLaughlin 1987, 1990; McLaughlin and Heredia 1996) developed what has come to be known as the information processing model of SLA. This model is characterised by principles taken directly from information processing work in cognitive science, namely that human beings are active information processors; that the mind is a limited-capacity symbol-processing system; and that complex behaviour is composed of simpler sub-processes which in turn can be isolated and studied in an independent manner. Two such sub-processes in McLaughlin's model are 'automatisation' and 'restructuring'. 'Automatisation' refers to the process described by cognitive scientists such as Schneider and Shiffren (1977) whereby individuals, with time and practice, move from the controlled processing of information held in short-term memory to the automatic processing of information held in long-term memory. Automatic processing of the familiar (or learned) allows the mind to process new information in a controlled manner. Learning thus takes place incrementally as this new controlled processing, again with time and practice, becomes automatic processing. The change that actually takes place as a result of this ongoing process of controlled to automatic processing is called 'restructuring'. In restructuring there is a change to the knowledge system, but this change is not a question of simply adding new knowledge to existing knowledge; rather, it involves a two-way process of assimilation and accommodation, where the former refers to the incorporation of the new and the latter to the destabilisation and eventual reforming of old knowledge.[4]

Researchers following different versions of the IIO model (Long 1996; Gass 1997; Skehan 1998) thus see acquisition as an instance of learning which results from complex intramental processing.[5] In this sense they follow fairly closely developments in cognitive science where the information processing model has been so dominant over the past forty years. However, within cognitive science there has been a long-running debate about the narrowness of the information processing view of learning. Because the views expressed by critics of information processing are relevant to later sections of this chapter, I now briefly rehearse some of them.

5.4 CRITIQUE OF INFORMATION PROCESSING

According to authors such as Ulrich Neisser (1997), Rom Harré (Harré and Gillet 1994) and Derek Edwards (1997), while the advent of the information processing paradigm was hailed as a radical shift in psychology which laid behaviourism to rest (compare Lachman et al. 1979; Baars 1986; Mandler 1985), it has in fact manifested several of the key characteristics of behaviourism over the years. First, it shares with behaviourism a Cartesian mind-body dualism, according to which there are two distinct human life systems: one material (the outer life) and one mental (the inner life). However, the difference between behaviourists and proponents of information processing – and the difference is a major one – is that while the former considered the mental to be out of the reach of researchers and hence unresearchable, the latter see it as central to their task. Nevertheless, dualism, whereby the inner and outer are separate and each can be (and should be) studied independently of the other, has remained unquestioned. Another characteristic shared by both behaviourists and cognitive scientists is the tendency to carry out research in laboratory settings. While it is true that cognitive scientists have preferred human beings over rats in their experiments, they have, according to Baddeley (1997), 'often been excessively timid, … obsessed with the need for experimental control, and … quite unwilling to step out of the laboratory to see if such theories as they have created are indeed applicable to the world outside' (Baddeley 1997: 1). This obsession with experimental control is connected to a third characteristic which behaviourists passed on to cognitive scientists (and which is common to other branches of psychology, such as child development and intelligence), namely, a dominant concern with the aggregate or average human being. Danziger (1990) criticises the pervasive tendency in psychology to research the human mind not as a socio-historically situated individual phenomenon but as a general and quantifiable entity. Thus, cognitive scientists, like their behaviourist predecessors, have shifted to the margins of psychology phenomena such as attitude, motivation, intentionality and emotion. This has allowed them to concentrate exclusively on an idealised psychology of the average human being: observable behaviour for the behaviourists and information processing for cognitive scientists. In the ideal world of cognitive scientists, the human mind is still conceived of as dependent on external stimuli to which it responds. And while cognitive scientists posit mental models stored in an elaborate cognitive architecture inside the minds of individuals (as opposed to the rather rudimentary observable surface models of behaviourist psychology), the adoption of the computer metaphor of input-output does not disguise the fact that there is still a view of mental behaviour as systematic and mechanistic.

Such criticisms, elaborated by the likes of Neisser, Harré and Edwards, have had their effect in cognitive science. Neisser's ecological approach to human cognition (based on the pioneering work of Gibson 1979) has attracted a following over the years, and Harré and Edwards have contributed to the growing literature under the rubric of Discursive Psychology. In SLA critiques of the information processing approach to cognition have been notable by their absence. As in previous discussions,

we must turn to Firth and Wagner for perhaps the best articulated programmatic critique, although as we shall see later in this chapter, the growing amount of work around Sociocultural and Activity Theory amounts to an effective critique of how mental activity is conceptualised in the IIO model.

5.5 FIRTH AND WAGNER (1997)

In their debate-opening piece in the *Modern Language Journal* special issue on the state of SLA, Firth and Wagner (1997) question what they perceive as an individual psycholinguistic bias in the work of many SLA researchers, and they propose in its place a more collective and sociolinguistic view of what language learning entails. In her response to Firth and Wagner, Nanda Poulisse (1997) makes it clear that she does not see what is wrong with defining SLA as a cognitive process and then sticking to a psycholinguistic research paradigm which rules out many of the issues raised by Firth and Wagner. This rather narrow approach to the problem has the advantage of being clear, but it does close down debate rather rapidly. Equally dismissive of Firth and Wagner's stance is Michael Long, who adopts an extreme psycholinguistic stance, defining SLA as follows:

> SLA is a process that (often) takes place in a social setting, of course, but then so do most internal processes – learning, thinking, remembering, sexual arousal, and digestion, for example – and that neither obviates the need for theories of those processes, nor shifts the goal of inquiry to a theory of settings. A theory of memory, for example, deals with such matters as relationships among the frequency and intensity of instances of the phenomena an individual experiences and the subset that are remembered, storage and retrieval of the same, and so on, but not, or not 'centrally', at least, with the social events for example, courtroom testimony or storytelling in a pub, during which memories are put to use.
>
> (Long 1997: 319)

Plausible as this analogy may seem on the surface, it is erroneous for two reasons. First, it puts an involuntary process, digestion, in the same category as cognition, which even the hardest-core computer-based cognitive scientist will acknowledge is at least in part a voluntary one. An individual's mental processing does not just happen outside any intentional control. A second problem is that digestion is affected by the social context in which it takes place. Surely if one is pressured to eat fast or is suffering from a general state of anxiety or depression, then the normally and otherwise automatic processing of masticated food through the digestive tract will be affected.

More interesting for our discussion here is Gabriele Kasper's (1997) response, which is far less dogmatic and opens the door to possible dialogue. Interestingly, Kasper begins on a strong note, seemingly adopting the position that in recent years has become common to many IIO researchers when they are queried about why they dismiss an incorporation of social factors in their theories of SLA, namely that if one

adopts this tack, one is no longer doing SLA research. Indeed, Kasper argues that Firth and Wagner's way would mean dropping acquisition from SLA altogether:

> If the 'A' of 'SLA' is dropped, we are looking at the much wider field of second language studies, which spans as diverse endeavors as intercultural and cross-cultural communication, second language pedagogy, micro – and macro-sociolinguistics with reference to second languages and dialects, societal and individual multilingualism, and SLA … [I]n the final analysis, learning or acquiring anything is about establishing new knowledge structures and making that knowledge available for effective and efficient use. Issues of knowledge representation, processing, and recall have to be central to any discipline that is concerned with learning. A noncognitivist discipline that has learning as its central research object is a contradiction in terms.
>
> (Kasper 1997: 310)

However, just after making this somewhat dismissive comment about Firth and Wagner's discussion of SLA, Kasper does an effective about-face. First, she states that 'there is a whole range of issues in SLA that cognitive theory does not tell us anything about' and that 'one can suspect that the social context in some way influences SLA'. She then goes on to cite a long list of studies which are more ethnographically oriented and show a concern with the social side of learning. In particular, she cites language socialisation theory as an interesting area of inquiry because it has produced studies that 'have shown how linguistic and pragmatic competence, sociocultural knowledge, and learner identity are shaped by novice-expert interaction in various contexts' (Kasper 1997: 311). For Kasper, such research is by nature developmental and has the potential to produce more interesting results than most SLA research as currently conducted because it has as its defining principles the exploration of how culture, cognition and language come together and the inclusion of both psycho-linguistic and sociolinguistic views of language behaviour.[6] It is also consistent with recent attempts to frame acquisition according to theoretical constructs and research falling under the general rubrics of Sociocultural Theory and Activity Theory (e.g. Lantolf and Appel 1994a; Lantolf 2000a, 2000b).

5.6 SOCIOCULTURAL THEORY

> The basic goal of a sociocultural approach to mind is to create an account of human mental processes that recognizes the essential relationship between these processes and the cultural, historical, and institutional settings.
>
> (Wertsch 1991: 6)

> The task of sociocultural analysis is to understand how mental functioning is related to cultural, institutional, and historical context.
>
> (Wertsch 1998: 3)

Thus begin two seminal works by James Wertsch on sociocultural theory, *Voices of the Mind* and *Mind as Action*. Some of the emphases and wording are different: 'goal'

in the first definition becomes 'task' in the second, 'approach' becomes 'analysis', 'create an account' becomes 'understanding', and 'mental processes' become 'mental functioning'. However, the important idea remains in both definitions, namely, that cognitive activity, now framed as mental processes, takes place at the crossroads, of a past (historical perspective) and a present, at the macro-societal level and at the more local institutional level.

Adopting a sociocultural perspective on human development also means taking what Vygotsky termed a 'genetic' approach to the study of mental activity, taking into account changes taking place at four different but interlocking levels. The first level is phylogenesis, which refers to the development of the species (that is human beings) through time. Here we are operating at the level of universals, and authors such as Wertsch (1985, 1991, 1998) and Cole (1996, 1998) allow that one universal about which we can be fairly confident is the capacity of cultural mediation, that is, the ability of human beings to act directly on the world using either material artefacts (such as physical tools) or abstract artefacts (such as language) of their own creation (more on this below). For Cole, Wertsch and others of a sociocultural persuasion, these artefacts are cultural in nature, that is, they are products of the interaction between a particular group of individuals in a particular setting and physical environment. And here we enter the realm of our second level, the sociohistorical. The sociohistorical level is relative and this explains the observation that while all human beings engage in cultural mediation, they have different ways of doing so. One prime differentiating factor across different settings is the existence, or not, of formal schooling. Cole (1998) points out that not all societies have a tradition of formal schooling and among those that do, there are substantial differences, as illustrated by the different ways in which individuals are initiated into societies as adults. The third level of sociocultural change is called ontogenesis. This refers to the individual's development over a lifetime. The child moves from an early novice stage where he or she is completely dependent on other people to subsequent stages where he or she appropriates the mediational means made available by her/his socio-historical environment. The fourth and final level of sociocultural change is called microgenesis, and this refers to changes occurring in mental functioning over the span of weeks, days, hours or even seconds.

As in the case with all forms of sociohistorical development, microgenesis is characterised by several conditions and processes. The first of these is mediation. In sociocultural theory, all forms of higher mental activity are said to be mediated, where mediation refers to devices that intervene in the context of an interaction between human beings and the world of objects, events and behaviour. Such devices can be either physical or symbolic. Physical tools enable individuals, acting with others, to alter and shape their world (the course of events would have been different were it not for humans intervening to impose their will in the pursuance of their own goals). Similarly, there are symbolic tools, or what Vygotsky called 'psychological tools', such as mnemonic devices, diagrams, maps, street signs and, above all, language, which serve as mediators of mental activity.

Another key conceptualisation in sociohistorical development is the dichotomy of

other-regulation/self-regulation. With other-regulation there is appropriate linguistically mediated assistance from a parent or teacher, usually captured in the metaphor of scaffolding. Scaffolding takes place in interactions involving two or more people in which at least one person acts as a mentor and the other(s) as relative novice(s). The individual taking the mentoring role promotes the novice's appropriation of new knowledge by co-constructing it with him or her through shared activity. All of this activity is said to take place in what is known as the Zone of Proximal Development (ZPD), that is, the distance between the actual developmental level as determined by independent problem-solving and the higher level of potential development as determined through problem-solving under the guidance of another human being.

5.7 ACTIVITY THEORY

All of the above phenomena come together under the general rubric of what has come to be known as Activity Theory. Activity Theory is the historical legacy of Vygotsky's contemporary A. N. Leontiev (1978),[7] but the theory has been adopted and refined by more contemporary educationalists such as Wertsch (1985, 1991, 1998), Wells (1999), Mercer (1995, 2000), Engestrom et al. (1999) and by SLA researchers such as Lantolf and Appel (1994a), Donato (2000), Pavlenko and Lantolf (2000) and Lantolf and Pavlenko (2001).

As Lantolf (2000a, 2000b) points out, activity is not to be understood as simply doing things; rather, it is to be seen as something far more complex which encompasses three levels: activity, action and operation. Activity, the term for the first of the three sub-categories, is something of a misnomer, as it actually refers to the general motive or driving force behind actions (the second sub-category) of any kind. Motives are related to underlying needs, which can be biological in nature (the need for food, sex, heat and so on) or socially constructed (the need to feel valued at work or the need to go shopping). However, needs do not become motives for actions until and unless they are directed at a specific object. There is, thus, a progression that looks as follows:

Need → Objective → Motive

At the action level, the concept of goal comes into play. This stage is crucial because, as Wells puts it, '[i]t is only in "action" that an "activity" is translated into reality"' (Wells 1999: 233). In other words, if the previous activity stage, where need, motive and object are crucial, is not canalised into a conscious goal-directed planning, there is no activity. The progression now looks as follows:

Need → Objective → Motive → Goal → Action

The third stage, operation, may be seen as surface behaviour, the actual way in which an action is carried out. It is at this level that the set of concepts outlined above, such as mediation, regulation and scaffolding, comes into play, under the

specific constraints and conditions of the particular setting where the action is being carried out. The final chain of events looks as follows:

Need → Objective → Motive → Goal → Action → Conditions → Operations

One way to look at Activity Theory and the links between motive, action and operations is as follows: motive is about why something is done; action is about what is done; and operation is about how something is done. But how does this chain of events work in practice? In the case of a language learner and the activity of language learning, we begin with the fundamental need to interact and form part of a social group with conspecifics, and the objective, deriving from this need, of achieving full participation in the said social group. This objective creates a motive for action to be taken. Actions depend on goals and, in the case of this language learner, goals would relate to some of the aspects of language and communication discussed in Chapter 4, such as information exchange and identity construction, all of which would contribute to the learner's sense of belonging to (or acceptance by) the group. Actions occur at the meta-cognitive level and would include strategies such as inferring meaning from context, in the case of information exchange, and pre-planning a telephone conversation so as to enhance formal accuracy, in the case of identity construction. Finally, the learner would carry out operations in different ways depending on the conditions of a particular context: inferring meaning in discourse domains familiar to the learner would be carried out more smoothly than in other domains. A telephone conversation might be a challenge to one's sense of competence if an unexpected interlocutor picked up the telephone. Operations are generally considered to be automatised such as when during a conversation a learner automatically infers particular meanings, carries out particular telephoning strategies or automatically nods her/his head whenever the interlocutor seems to be expressing an opinion. However, as Donato and McCormack (1994) point out, this is not a tidy or static package with an invariable progression from deeper motives to conscious goal-directed action to automatised operations; rather, '[r]outinized operations (automatic strategies) can become conscious goal-directed actions if the conditions under which they are carried out change' (Donato and McCormick 1994: 455).

Having considered the basic constructs used in Sociocultural/Activity Theory, it is time to consider the question of what is the result or pay-off of the activity described above. In other words, what is the actual process that results from events at the operational level and in turn allows the move from other to self-regulation and from the intermental to the intramental? In short, what is the Sociocultural/Activity Theory counterpart to 'internalisation' in cognitive science? The term most used for this process is 'appropriation'.

5.8 APPROPRIATION

In general discussions of sociocultural theory in SLA, appropriation has been defined in simple terms, for example, by Mitchell and Myles (1998: 145) as how learners 'eventually take over ... new knowledge or skills into their individual consciousness'.

However, in longer works devoted specifically to sociocultural theory, there are more nuanced views of the concept. Wertsch (1991, 1998), for example, links appropriation to the Russian word 'prisvoit', used by Bakhtin (1981). 'Prisvoit' is defined by Wertsch as 'to bring something into oneself or to make something one's own', or more specifically 'the process ... of taking something that belongs to others and making it one's own' (Wertsch 1998: 53). The reference to 'something that belongs to others' is significant as neither Bakhtin nor Wertsch sees appropriation as an individual, internal process. Indeed, Bakhtin refers to 'the borderline between oneself and the other' (Bakhtin 1981: 293), a notion similar to what social theorists interested in questions of culture and identity (Bhabha 1994) have called a 'third place', and what Wertsch, citing Holquist (1994), refers to as 'living in the middle', that is a hybrid existence that is neither 'other' nor 'self'. Appropriation is thus not just the passing of the external to the internal; it is the meeting of the external and the internal to form a synthesised new state.

However, this borderline synthesis should not be taken as a completely harmonious affair, the achievement of what Rommetveit has termed 'Habermas' promised land of "pure intersubjectivity"' (Rommetveit 1979: 148, cited in Wertsch 1998: 114; emphasis in the original). Drawing on Rommetveit's views and earlier work by Bakhtin (1981), authors such as Lotman (1990) and Wertsch (1998) have criticised the idea that intersubjectivity is somehow the sum of two univocal beings. Instead they propose a multivocal and dialogic function of communication. Wertsch explains:

> In contrast to the univocal function, which tends towards a single, shared, homogeneous perspective comprising subjectivity, the dialogic function tends toward dynamism, heterogeneity, and conflict among voices. Instead of trying to 'receive' meanings that reside in speakers' utterances as envisioned by the 'conduit metaphor' (Reddy 1979), the focus is on how an interlocutor might use texts as thinking devices and respond to them in such a way that new meanings are generated.
>
> (Wertsch 1998: 115)

Nor should the borderline synthesis be seen as temporally fixed or as a once-and-for all event or even as a product. Researchers such as Gordon Wells (1999) argue that appropriation is to be seen more as a transformational ongoing process, involving multiple layers, or what he calls 'cycles':

> Appropriation of cultural artifacts and practices ... involves a continuing three-stage cycle, to which corresponds a triple transformation. First, there is the transformation of the learner – a modification of his or her own mental processes, that changes the ways in which he or she perceives, interprets and represents the world; second there is a transformation of the artifact itself, as its use is assimilated and reconstructed by the learner on the basis of the learner's existing knowledge; finally, in using the artifact to mediate further action, there is a transformation of the situation in which the learner acts which, to a greater or lesser degree, brings

about change in the social practice and in the way in which the artifact is understood and used by other members of the culture.

(Wells 1999: 137)

Elsewhere, Rogoff (1990, 1995) also subscribes to the view of appropriation as involving: (1) the ongoing transformation of the individual's thought, mental processes and behaviour; (2) the artefacts acting as the mediators of the individual's thought, mental processes and behaviour; and (3) the sociocultural context in which the individual's thought, mental processes and behaviour are mediated by artefacts. She rejects clearly drawn dichotomies of group/individual, outside/inside, dependent/independent and social/cognitive, taking a holistic approach to engagement in activity. This means that in her work she focuses on how the three elements in the triad outlined above interact simultaneously and on how the cycle of interaction among the parts never ends. Given her social view of the individual, a key concept for Rogoff is participation, which when combined with the concept of development, produces what Rogoff calls 'participatory appropriation'. She defines participatory appropriation as 'the personal process by which, through engagement in an activity, individuals change and handle a later situation in ways prepared by their own participation in the previous situation (Rogoff 1995: 142). Rogoff adds that '[t]his process is becoming, rather than acquisition' (ibid.).

Rogoff's views on participation have been taken up in recent discussions in education (Sfard 1998) and SLA (Donato 2000; Pavlenko and Lantolf 2000), in the suggestion that the traditional acquisition metaphor is insufficient to account for some aspects of learning and that it should be complemented (but not replaced) by the participation metaphor that would account for these aspects. Sfard explores some of the basic assumptions which have propped up the acquisition metaphor for centuries, citing among others the view of the mind as a container, to be filled with knowledge; the view of knowledge as a commodity, which can be possessed or stored in the mind and transferred to others; and an identification with the conduit metaphor (Reddy 1979), whereby ideas are transmitted from one mind to another. The participation metaphor is presented as a means of dealing with aspects of knowledge and learning that the acquisition metaphor cannot and does not address. First, consistent with sociocultural theory, it socialises the mind and attempts to link the multi-mental (the collective of individual minds), the intermental (between and among minds) and the intramental (internal to one mind) so that mental activity comes to be located in a third place, neither exclusively the 'self' or 'other'. Second, it activates the mind and, more precisely, moves from the view of knowledge as finite and fixed to the view of 'knowing' as ongoing, constant reformulation. As Sfard puts it, '[t]he talk about states has been replaced with attention to activities ... [and] [i]n the image of learning that emerges ... the permanence of *having* gives way to the constant flux of *doing*' (Sfard 1998: 6; emphasis in the original). Third, the participation metaphor contextualises the mind, as 'learning ... is now conceived of as a process of becoming a member of a certain community ... [and acquiring] the ability to communicate in the language of this community and act according to its

particular norms' (ibid.: 6). Participation is thus about becoming a member of a community of practice.

The concept of community of practice is most associated with the work of Jean Lave and Etienne Wenger (see Lave 1988; Lave and Wenger 1991; Wenger 1998). Over the years these authors have outlined a theory of learning which is consistent with sociocultural theory, in that it starts with the assumption that learning is situated 'in the context of our lived experience of participation in the world ... [and] is a fundamentally social phenomenon, reflecting our own deeply social nature as human beings capable of knowing ...' (Wenger 1998: 3). For these authors, the relationship between social participation and communities of practice is essential: the former refers 'not just to local events of engagement in certain activities with certain people, but to a more encompassing process of being active participants in the *practices* of social communities and constructing *identities* in relationship to these communities' (ibid.: 4), while the latter, communities of practice, correspond to the different subject positions we adopt on a moment-to-moment and day-to day basis, and indeed throughout our lifetime, depending on who we are with (examples cited by Wenger include the family, colleagues at work, and social groups at schools). Important, in terms of social participation, are the rules of entry. In a welcoming context, the individual gains entry into a community of practice by means of 'legitimate peripheral participation'. This peripheral participation is achieved via exposure to 'mutual engagement with other members, to their actions and their negotiation of the enterprise, and to their repertoire in use' (Wenger 1998: 100). However, as Wenger points out and Norton has shown in her recent publications (Norton 2000, 2001), '[i]n order to be on an inbound trajectory, newcomers must be granted enough legitimacy to be treated as potential members' (Wenger 1998: 101). Thus, participation must always begin peripherally and if the individual is not deemed legitimate, or in Norton's work 'worthy to speak' (Norton 2000; see Chapter 3 of this book), or if the individual chooses not to participate as a reflective form of resistance (Norton 2001), then it might not begin at all.

5.9 TOWARDS A BROADER CONCEPTUALISATION OF ACQUISITION

The constellation formed by Sociocultural Theory, Activity Theory and variations on the participation metaphor, as well as other related theoretical proposals not discussed explicitly here,[8] has provided the basis for an ever-increasing amount of SLA research in recent years.[9] In the context of this chapter, where we are discussing the 'A' of SLA, the key question about Sociocultural/Activity Theory is whether or not it is possible to integrate it into a bigger, superordinate learning theory which would also encompass existing IIO frameworks such as Gass (1988, 1997). However, before discussing this prospect, there are two important factors to bear in mind. First, if integration to something bigger and broader is to be true integration, it cannot mean that Sociocultural/Activity Theory is positioned as what Thorne refers to as 'an add-on to an otherwise epistemologically divergent approach to SLA' (Thorne 2000:

236). This is because, as Sfard (1998) makes clear, the two metaphors are incommensurable, that is, one is not reducible to the other in terms of underlying theory, concepts and language.[10] Second, integration does not mean that Sociocultural/ Activity Theory absorbs or even replaces the IIO. As Wertsch argues, '[r]ather than seeking the key to individual mental processes in sociocultural setting, or vice versa, ... we should employ a unit of analysis that focuses precisely on how these forces come into dynamic contact' (Wertsch 1998: 179).

The key concept in the attempt to expand on the theory of learning for SLA is the complementarity of views in a broader church. Pavlenko and Lantolf (2000) sum up the general zeitgeist of SLA researchers adopting Sociocultural/Activity Theory as follows:

> We want to make it clear, however, that neither we nor Sfard are prepared to propose the new metaphor [i.e. participation] as a replacement for the acquisition metaphor. Rather it is intended as a complement to the older metaphor, since ... it makes visible aspects of second language learning that the acquisition metaphor leaves hidden.
>
> (Pavlenko and Lantolf 2000: 156)

But is such complementarity possible? Can researchers live with the acquisition metaphor, based as it is in the kind of cognitive science best exemplified by the information processing model discussed above, *and* the participation metaphor, based on socially sensitive models of mental activity embodied in Sociocultural/ Activity Theory, and still do research? Lantolf and Pavlenko certainly seem to believe so, although I cannot find in any of the interesting research that they have published in recent years an instance where they have used the two approaches in a complementary fashion.

In the context of a discussion of task-based research and pedagogy, Ellis (2000) actually does opt for complementarity. He states that what he calls the 'psycholinguistic' tradition of task-based research can provide useful information to educators about how to design pedagogic tasks, while sociocultural theory can provide useful information about the social, cultural and affective environment which task unfolds as activity. As an example of how this might work, he cites work by Samuda (2001) where the author explores how the teacher 'in action' can alter a pre-planned task, thus taking an environmentally sensitive approach to what might otherwise be a cognitively oriented piece of research. Ellis points out that Samuda does not acknowledge the link, but it is one he sees nonetheless. Indeed, following authors such as Swain and Lapkin (1998), he refers to task as a way to 'provide opportunities for learners ...' (Ellis 2000: 211), a statement with echoes of van Lier's (2000) discussion of affordance as a more appropriate concept than input.

A more overt attempt to combine information processing with Sociocultural/ Activity Theory is to be found in the work of Merrill Swain, both individually (Swain 1995, 1997, 2000) and in combination with Sharon Lapkin (Swain and Lapkin 1998, 2001, 2002a, 2002b). Swain, in particular, has incorporated Sociocultural/ Activity Theory into an IIO model of SLA and is in the unique position of being

perhaps the only prominent IIO insider to engage with Sociocultural/Activity Theory in her research. In Swain's work, information processing and the acquisition metaphor figure prominently, but constructs taken from Sociocultural/Activity Theory, such as scaffolding and mediation, are also present. She has reconsidered her well known work on output, calling into question the product-like connotations associated with it, and has added to her analytical framework a more process-like phenomenon which she terms 'collaborative dialogue'. She defines collaborative dialogue as 'dialogue in which speakers are engaged in problem solving and knowledge building' (Swain 2000: 102) and she sees it, in a sense, as a step beyond output. In her earlier research, Swain (1985, 1993) made the case for comprehensible output by arguing that the production of language by learners can be beneficial because it can work as input for individual learners and as a means to consciousness-raising, hypothesis-testing and reflection on language and language activity. More recently, however, Swain (1995, 1997, 2000) examines how output contributes to problem-solving and knowledge-building by two or more individuals. Crucially for Swain, acquisition is still the end-result of such interaction. She sums up her view as follows:

> collaborative dialogue is problem-solving and, hence, knowledge-building dialogue. When participants in an activity make a collaborative effort, their speaking (or writing) mediates this effort. As each participant speaks, their 'saying' becomes 'what they said', providing an object for reflection. Their 'saying' is cognitive activity, and 'what is said' is an outcome of that activity. Through saying and reflecting on what was said, new knowledge is constructed.
>
> (Swain 2000: 113)

In their most recent work, Swain and Lapkin (2002b) have come to see production as a mediator not only of second language learning in general but also of the all-important early process of comprehension. Following Wertsch and Stone (1985), they are interested in the phenomenon whereby language learners first produce appropriate language behaviour without recognising its full significance to fully competent members of the target language culture and then later, via mediated reflection, they develop a better understanding of what they have produced and why it is appropriate. They see their work as fundamentally different from that done by most IIO researchers:

> In this paper, we ask a very specific question: how does language production mediate the process of comprehension? In asking this question, we are moving in a different direction from the research question posed by others, for example Gass (1997) and Long (1996), as to whether conversational moves such as compre-hension checks and confirmation requests make input more comprehensible. Instead, we want here to demonstrate that at least some language learning proceeds from production to comprehension, rather than what is usually argued, from comprehension to production.
>
> (Swain and Lapkin 2002b: 5)

Swain and Lapkin go on to show how Anglophone learners of French in Ontario engaged in such a process. They first showed learners a five-minute video-recorded lesson on pronominal verbs and then asked them to take notes while the instructor read a story to them twice. The learners – some working in pairs, others working individually – were then asked to reconstruct the story. The reconstructed story was given to an 'adult native speaker of French' who reformulated it, correcting inappropriate forms used by the learners. Two days later, the learners were given the corrected version back along with their original stories and asked to talk their way through differences between the two versions. This session was video-recorded and two days later it was shown to the learners, who were asked to comment on the moments when differences were noticed. These stimulated recalls contain interesting instances where the interviewer mediates the process of realisation, that is, when learners finally realise the significance of what they have produced. Thus, there are cases of learners producing, during the writing stage, perfectly appropriate French that they had heard from the instructor but had not really understood. By talking the writing process through with the interviewer, they come to understand and indeed learn, if we are to judge by rewritten stories produced four days after the simulated recall sessions. Swain and Lapkin, however, are cautious. They conclude:

> We make no claim that all learning proceeds from production to comprehension; clearly this is not the case. However, we do wish to claim that one way in which language is acquired is through use: by producing language we can find out what it means, and of what it consists.

(Swain and Lapkin 2002b: 26)

Swain and Lapkin have identified a phenomenon which is much like Krashen's *i + 1* principle in reverse: when individuals are grappling with new knowledge, they very often rise above themselves and, with the help of others, they produce at a level beyond what they are able to explain to interlocutors when asked. In information processing models of cognition, this might be seen as production based on previous subconscious learning (what Krashen calls 'acquisition'); however, from a socio-cultural perspective, it would be viewed as appropriation of the words of others, and then outperforming current competence by operating in collaboration with others (who mediate the process, providing scaffolding) on the edge of the Zone of Proximal Development.

As I pointed out above, Swain is unique in her capacity for synthesis, in both her individual and her collaborative publications with Lapkin. Otherwise, what we have at the moment is an increase in the amount of research being carried out under the general rubric of Sociocultural/Activity Theory to go along with the already substantial amount of work that has been done, and continues to be done, following the IIO model and the acquisition metaphor. Thus, we have researchers who continue to consider themselves SLA researchers, but in actual fact might want to change the acronym to SLP (P for Participation) or to change the 'A' in SLA from Acquisition to Activity, as Lantolf and Pavlenko (2001) suggest (see more on this below).

If we go back to the presentation of Gass's IIO model in Chapter 2, we see that between the input and apperception stages, there is a need to respond to two questions:

1. Why are some aspects of language noticed by the learners and others not?
2. What factors mediate the process of apperception?

As I pointed out in Chapter 2, the answers to these questions are to be found in a filter, which Gass inserts between the input and apperception stages. This filter contains the terms 'frequency', ' prior knowledge' and 'affect', all connected to 'attention', which is necessary if the rest of the apperception to output cycle is to take place. Gass (1997) provides little detailed discussion of the contents of this filter, dispensing with the huge area of 'affect' in just one paragraph (Gass 1997: 17). Gass presumably proceeds in this manner because she considers the contents of the filter peripheral or, in any case, not essential to the process of SLA. However, if Gass and other IIO model researchers were to pause for a moment to focus on the concepts of 'prior knowledge' and 'affect', even to unpack them so as to make clearer what is meant by them, they might find themselves in the realm of what Lantolf and Pavlenko (2001) are talking about in their version of SLA, to which we now turn.

5.10 ACQUISITION AS ACTIVITY (AND AGENCY)

Lantolf and Pavlenko set out to argue that a Sociocultural/Activity perspective allows researchers to do several things that the acquisition metaphor does not allow. Among other things, it allows them to frame learners 'as more than processing devices that convert linguistic input into well-formed (or not so well-formed) outputs' and as individuals with human agency who 'actively engage in constructing the terms and conditions of their own learning' (Lantolf and Pavlenko 2001: 145). Bringing together research from a good number of authors, they develop their Second Language Activity framework. With some poetic licence, I present five of the major tenets of this view of learning and learners:

1. Learners are historically and sociologically situated active agents, not just information processing machines. They are, in short, individuals and not automata, and over a lifetime they build up a historically and sociologically shaped stimulus-appraisal system along the lines of that described by Schumann (1997), which allows them to monitor and evaluate all forms of incoming stimuli according to their everchanging experiential and episodic memory.[11]

2. Learning is about more than the acquisition of linguistic forms; it is about learners actively developing and engaging in ways of mediating themselves and their relationships to others in communities of practice.

3. Learning can be as much about failing to develop as succeeding, and this failure may be in the form of non-participation. Non-participation, however, might be a process of active resistance by the learner, as when learners reflect and decide not to participate; a process of reactive resistance to attempts by

target community members to marginalise the learner; or a passive process of acceptance of marginalisation by target community members.

4. Agency is not an individual phenomenon; rather, it is always co-constructed via interaction with other agents.

5. Learning is part of the ongoing construction of self-identity (Giddens 1991) and the consequent ongoing construction of a personal narrative.

Apart from being an incomplete list of the tenets of Second Language Activity – Lantolf and Pavlenko's discussion is suggestive of many more – this list is also rather stark. Lantolf and Pavlenko in fact provide several examples to illustrate most of these points. What I would like to do is attempt to relate all five of these tenets to the case of one language learner and thus make the point that filtering input at the top of Gass's model is a sociocultural stew which mediates the second language acquisition process and therefore must be taken into account if we are to elaborate a thorough understanding of how learners learn.

The language learner in question, Montse (not her real name), was one of six individuals who participated in a study I carried out several years ago. The aim of the study was to document how learners, via weekly face-to-face interviews, reconstructed and evaluated their lessons. At the time of the study, Montse was a doctor in her late twenties, who was an upper-intermediate student (roughly Cambridge First Certificate exam level) at a large language school in Barcelona. She was attending a semi-intensive general English course that comprised three three-hour lessons per week for one full academic term of ten weeks in length. During this period of time, Montse participated in eight face-to-face interviews, four with me and four with another student who was also participating in the study, but attending a different class.[12] These interviews were open-ended in format and involved conversation about what was being done on a lesson-to-lesson basis and Montse's appraisal of what was done.

A week before the class began, I conducted an introductory interview with Montse with a view to obtaining background information. In this interview, I learned that Montse had grown up in Barcelona as a bilingual speaker of Catalan and Spanish, although she felt much more comfortable in Catalan and used it for the vast majority of her personal and professional activities. More importantly, I learned a great deal about her previous language-learning experiences, none of which had been particularly satisfying. During her life she had studied three foreign languages – German, French and English – and in all three cases, she had bad memories of classes that were too large, and teachers who were boring, uncommitted or incompetent. To make matters worse, where she had managed to find a satisfactory learning environment, for example an interesting, committed and competent teacher, she found that she had to balance her studies with her professional activity as a doctor. The result was that Montse never seemed to have felt unmitigated enjoyment in any of her language-learning experiences and, more importantly, had never really felt comfortable about participating in class. As we shall see in a moment, the experience on which I focused during this study was to be no exception.

Space does not allow for thorough treatment of Montse's case. What I propose to do here, therefore, is to focus on one excerpt from an interview with Montse which will help me to show how the five tenets of agency outlined above come to life and how a language learner 'actively engage[s] in constructing the terms and conditions of [her] ... own learning' (Lantolf and Pavlenko 2001: 145). The interview in question was conducted after eight weeks of class. As was the case with all of Montse's interviews, it was carried out in Catalan; here, however, I present an English translation of the excerpt being examined, from an interview carried out on 4 June 1993.

D = David Block M = Montse

1. D: I think you said something about ... attendance, that a lot of people missed lessons and then another day everyone came ...

2. M: Yes ... Normally on Fridays not many people come, and anyway I missed the lesson last Friday. But if I remember correctly, the [previous] Friday there were three of us and actually, that's not right. It's a little desperate!

3. D: And from your point of view as a student in the class ... Obviously, we go to lessons with a plan, right, that we will do this and that, without knowing if there will be ten people present or three ...

4. M: Right, but in theory you assume that people will come. And you prepare for nine people. And I don't know if it varies a lot if you have prepared for nine and then when you get there, there are only three. It seems to me that in this case you have to do things differently out of necessity.

5. D: And what do you think about this? How has this been handled during this course? I mean, have you noticed that she was going to do one thing but has ended up doing something else?

6. M: I suppose that's what she does. Mind you, I don't really know. I don't know what the lesson plan is for every day but I imagine she must change something. Or maybe not. Maybe everything stays the same, but of course that's not the same thing.

7. D: But what is the difference between a Friday class with three or four students and one ...

8. M: I'd rather have a lesson with five people maximum, but always the same. What I don't understand is that one day there are nine and another day three ... When there are more people, I feel inhibited about speaking, for example. I become passive. That's the way it is, she knows it, she's noticed it.

9. D: But apart from that, what is the difference between a lesson with three or five and a lesson with ten? That is, if you compare a Monday, when ten people have come, and you compare with four, what's the difference in how you feel? Apart from feeling less inhibited ...

10. M: That's right and perhaps ... I don't know, everything seems more stimulating. You maybe learn more things and it's like a private lesson. The thing is that if it is a group of nine, ideally everyone should be there. I don't know why but the people seem more disconnected ... and when you do

exercises, you've done them and someone else hasn't and whether you like it or not, I guess that changes things.

11. D: And how does that work during lessons …
12. M: Right, so she starts to hand out exercises to the people who didn't come and it's like, you know … I don't know. Anyway, I just want to finish.
13. D: Are you tired of English?
14. V: Yes. Anyway, I've just spent four days in London and … I think when I come back here [next year] I'll do 'Basic 1' again.
15. D: Why?
16. M: Because I couldn't understand them.
17. D: Where did you go? To London?
18. M: To London. There was a group of us who went to the gardens and parks. And one place we went to … we had to get some lunch and we couldn't even ask for a sandwich because we couldn't understand what was written on the menu board, which is in itself pretty bad. And when they talked to us, it was like they were speaking Chinese! And, as I know so much English …
19. D: What about the other people who were with you, did they have more or less the same level of English?
20. M: No, no. A lot worse … It was terrible! And of course [the bar staff] didn't really try to understand me, which is what really burns me up. And so … you realise that maybe here they should concentrate more on the practical side and that you go there and the simple things like a bottle of water, I've learned from travelling. They haven't taught me here – not just here, at any other school … They are such silly things that you need when you are there …
21. D: You mean a review of travel English covering
22. M: That's right, the minimal language to make yourself understood. I don't know, in the hotel –
23. D: [You had problems] in the hotel as well –
24. M: No, there the people more or less understood me. But I couldn't understand them! I was especially exasperated when I left [the hotel].
25. D: Tell me about … a conversation …
26. M: I went to buy a theatre ticket and I was able to communicate with that woman, a little Tarzan-like, but we didn't have any problem like the one at lunchtime. It was just impossible! I didn't have any idea what they were saying. And I suppose they were speaking English … I mean not even the menu board, not even a cheese sandwich!
27. D: But what did you say?
28. M: No, I didn't say anything in the end. I saw things they had … I ate what they had, almost pointing, because if not …
29. D: But, for example, what did you say? 'I want a sandwich'?
30. M: We didn't order. Since it was a queue we heard people ordering. Nobody could understand anything so we didn't even try. It's really sad, so much studying …
31. D: Did you feel nervous?

32. M: Nervous, no. More than that, I say it makes you want to throw in the towel. I mean it's like you are at a level where more or less you can understand pretty well, but not really. You go there and …
33. D: Did you tell the teacher about this?
34. M: No, no. No, because I told her I was going and later she didn't ask me anything.
35. D: And what about the other people in the class, they didn't ask you how it had gone either?
36. M: No. Actually, I didn't even tell them. She asked me why I wasn't coming because I almost always come …
37. D: So you missed a lesson.
38. M: Last Friday. But really you learn the most when you go there. That's for sure.
39. D: But do you think you learned anything apart from that you didn't understand anything?
40. M: Yes, yes, in four days you notice silly things, right? Actually, what I plan to do is go there in September to spend three months. And it's like, well, this is the way.
41. D: You're going to London?
42. M: No, no, no. Not to London, because there are too many people … I wrote to different places … one called Sheffield. In the end I'm leaning towards this one.

In this excerpt we see first and foremost that Montse is not just an information processing machine; rather, she is a flesh-and-blood, historically and sociologically situated active agent. And as part of her historical and sociological background, she has developed clear ideas of what for her constitute bad teaching practice and a bad learning environment. Her appraisals of her in-class and outside-class experiences are obviously negative, as the events she recounts run counter to how she would like them to be. However, while she manifests an understanding of why she does not like what she is experiencing, she does not articulate a clear alternative as regards what she might do about it as an agent. Indeed, during the entire ten-week study, she continually judged in a negative manner her teacher's methodology and the lack of an atmosphere conducive to learning, while never really suggesting an alternative to the teacher's action or much in the way of how the atmosphere in her class could have been made better. Her agency therefore was active in identifying problems, but relatively passive when it came to finding solutions. In a sense, a cloud of negativity – in the form of the bad conditions of her learning experiences – seemed to envelop her, and her agency seemed inextricably linked to, and indeed inhibited by, these conditions (see more on the contingent nature of agency below).

We also note in this excerpt that for Montse, learning a language is about more than the acquisition of linguistic forms; it is about how she actively mediates herself and her relationships to others in communities of practice. We can see this in her comments about the community of practice comprising the group of students with

whom she is attending lessons. Particularly in turns 8 and 10 in the excerpt above, Montse expresses clearly that the poor and inconsistent attendance of some of her classmates is a problem because it means that no two lessons are ever the same as regards the people present in them. She expresses her preference for a smaller group of students, but what really seems to bother her is the inconsistency of attendance and how this prevents her from mediating her relationships to others in an effective and satisfactory manner. In a sense, the community of practice comprising her and her classmates is so variable in make-up that she cannot begin to relate to it as such.[13] This point is hammered home in turn 36 when she says that she did not even tell any of her classmates that she was going to London, surely something which would be worthy of comment among members of a better defined and more cohesive community of practice.

In turns 14–32, Montse recounts her experiences with a different community of practice, that of English speakers in London. In this case, she describes episodes in which she could exercise no control over how events unfolded and once again felt frustration at not being able to mediate herself and relationships with others. Nevertheless, after presenting both the classroom and 'there' (that is, a naturalistic context) as instable environments with regard to her relationships with others in communities of practice, Montse ended this part of the interview by saying, 'But really you learn the most when you go there'. Ultimately, the negative experience of this class had made her think that in formal EFL settings she could not actively mediate herself and her relationships to others, but that she might have a chance in an ESL setting.

Also, coming through Montse's words in this excerpt is a sense of failure, and this brings us to the third tenet which might read: for Montse learning is as much about failing as succeeding and this failure may be in the form of non-participation. As we see in turn 20, this non-participation did not occur as an act of resistance on Montse's part; rather it seemed to her to be imposed by her lack of knowledge and ability, which she blamed on teachers who had not taught her practical English and on some of her interlocutors in London, who did not make enough effort to understand her or be understood by her. This other-dependent sense of failure suggests a link to the fourth tenet, namely that Montse's agency was not an individual phenomenon; rather it was always co-constructed via interaction with other agents. This we see in her qualification of the difference between a smaller and larger group of students in turn 8: she is not the same person in these environments, more inhibited and less stimulated in a larger group and presumably less inhibited and more stimulated in a smaller group. Similarly, the agency of Montse as an English speaker in London is obviously dependent on her interlocutor, from understandable hotel employees to incomprehensible bar employees. In short, she is not an incompetent speaker of English on her own, but enacts this identity in the company of others. Still, at the end of the excerpt, she manifests a desire to move towards more positive agency and active participation when she reveals her plans to spend three months in Britain.

Finally, in this excerpt we catch a glimpse of the larger process whereby Montse

was engaged in the ongoing task of identity construction realised through the personal narrative she provided to me during her interviews. Over a period of three months, Montse constructed a story of herself as frustrated language learner and, in a sense, victim of a teacher who was unable to overcome attendance problems or shake Montse's feeling that she was not learning anything. However, as we see at the end of the excerpt above, she opens the door to a new and more positive narrative in the future, as a language learner in Sheffield, a far cry from her classroom in Barcelona. As for why she makes this move, I can only speculate. However, if I go back to our first interview, in which she told me about a long list of negative class-room language-learning experiences, I might easily come to the conclusion that the class she told me so much about in this study was, in effect, the last straw. Despite her negative experience in London, recounted so vividly in this excerpt, Montse had decided that she was better off taking her chances in a naturalistic/second language setting.

5.11 CONCLUSION

With this glimpse of Montse's story, we come to the end of a long discussion of the 'A' in SLA. As we have observed, acquisition has been a contested term, albeit under very different circumstances, over the past thirty years. Krashen's acquisition/learning distinction eventually led to a more refined and certainly more empirically viable view of acquisition in SLA. This view, central to IIO models of SLA, is based on the information processing model, which to this day enjoys a degree of dominance in cognitive science. In SLA circles, the information processing model as the lynchpin of acquisition has apparently seen off the challenge of potential competitors from cognitive science, such as connectionism (but see N. Ellis and Schmidt 1997, 1998). More problematic are criticisms emanating from scholars such as Neisser and Harré to the effect that information processing is not sufficiently contemplative of environmental factors and that a more ecological, context-sensitive approach to cognition is in order. In SLA, approaches to mental activity under the general rubric of Sociocultural/Activity Theory are context-sensitive and this, along with associated metaphors such as participation and communities of practice, has led some scholars to propose a larger superordinate category that could accommodate both traditional individualistic approaches to acquisition and newer sociocultural approaches to participation. This leads us to the question: can SLA stand for both 'Second Language Acquisition' and 'Second Language Activity'? Or, as Gass (1998) and others (Long 1998) have suggested, is this a question of confusing use with acquisition, in short a distraction from the main task of understanding acquisition?

In the previous section I have tried to show how notions associated with Lantolf and Pavlenko's model of SLActivity might fill in the manifestly underdeveloped filter between Input and Apperception in Gass's IIO model. Montse's story is one of input that was never apperceived because so many other phenomena got in the way. I have no doubt that we must understand learning to be more than information processing and acquisition and that the participation metaphor is an attractive and seductive

one. This leaves me in a similar situation to that of the end of Chapter 4. There, I emphasised that no one seems to challenge the notion that language can be viewed as exclusively linguistic in nature (that is, as morphology, syntax, phonology and so on) and that communication is at least in part transactional in nature. These two views are consistent with the allegiance to the information processing model and the acquisition metaphor that is dominant among IIO researchers. Indeed, this is hardly surprising when we see that the same researchers are associated with language as linguistic, communication as negotiation for meaning and learning as acquisition. On the other hand, the view of language and communication as inextricably linked with questions of culture and identity is consistent with the view that learning is about participation and negotiating membership in communities of practice.

In Gass's response (1988) to the Firth and Wagner (1997) article discussed above, she argues that they are interested in second language users, their behaviour and the outcomes of their behaviour, rather than second language learners and their activity. She states her case as follows:

> the goal of my work (and the work of others within the input/interaction framework ...) has never been to understand language use per se ..., but rather to understand what types of interaction might bring about what types of changes in linguistic knowledge ... Nevertheless, it is true that in order to examine these changes, one must consider language use in context. But in some sense this is trivial; the emphasis in input and interaction studies is on the *language* used and not on the act of communication. This may appear to be a small difference, but to misunderstand the emphasis and the research questions ... can result ... in fundamental misinterpretations and naïve criticism. In fact, the result is the proverbial (and not very useful) comparison between apples and oranges.
>
> (Gass 1998: 84)

Gass goes on to present a model that captures how second language use relates to second language acquisition (see Figure 5.2, based on an updated version in Gass 2000). For Gass, there is a superordinate category, 'Second Language Studies', which houses two general subcategories, 'SLA' and 'SL Use'. SLA is dividable into three main areas: 'Universals', 'Transfer' and 'Processing'. SL Use is dividable into four main areas: 'Interaction', 'Speech Acts', 'Communicative Strategies' and 'Variation'. As regards the areas under SLA, Gass believes that 'there is little doubt (or controversy) that the field of SLA encompasses such basic areas' (Gass 2000: 54). On the other hand, she believes that the goal of the IIO model of SLA (and indeed, SLA in general) is to study and discover the cause and effect relations between SL Use categories and SLA, for example, '[t]he extent to which interaction and/or some sort of modified input is relevant in determining grammatical knowledge' (ibid.: 55). Thus, for Gass, authors such as Firth and Wagner have simply got the wrong end of the stick: they misunderstand the fundamental assumptions of SLA and they try to make SLA something that it is not.

It seems that in the use/acquisition debate, an impasse has been reached. On the one hand, authors such as Long and Gass do not seem likely to take on board new

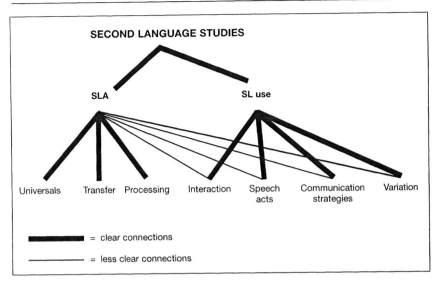

Figure 5.2 A characterisation of research in second language studies
(based on Gass 2000: 54)

proposals. They maintain that there is nothing in the arguments to convince them that many of the contexts discussed by Firth and Wagner are about language acquisition. Gass (1998), for example, seems to think that it is always possible to differentiate acquisition contexts from use contexts: in relation to the former context, she argues that in one of her well known studies with Varonis (Varonis and Gass 1985), participants '*were* learners inasmuch as these individuals were students at the English Language Institute of the University of Michigan, where they were paying rather large sums of money to learn' (Gass 1998: 85; emphasis in the original); in relation to language use contexts, she states that 'we must remember that many of the individuals in a workplace setting, for example, are not learners in the sense that is of interest to researchers in SLA ... [as] they do not evidence change in grammatical systems' (Gass 1998: 84). In response to Gass, Firth and Wagner make the point that 'what constitutes "acquisition" is essentially unclear ... [as] we cannot be sure where "use" ends and "acquisition" begins ... [and] there is surely no easily distinguishable dividing line between psycholinguistics and sociolinguistics' (Firth and Wagner 1998: 91).

I share the concerns raised by Firth and Wagner about clearly differentiating acquisition and use contexts. I cannot accept that just because individuals are enrolled at a language centre and are paying a lot of money for the privilege, they are, *ipso facto*, language learners. To be sure, they might be language learners by social definition or individual intention in the sense that we tend to call people who enrol in courses students or learners, and individuals who take such decisions, it is generally assumed, do so because it is their intention to learn. However, Gass and

others have manifested a lack of interest in matters social or attitudinal, and therefore if they want to make their case on psycholinguistic grounds, then I think they will have to provide more support for their argument: paying tuition fees and then sitting in a room with other putative learners does not make one a learner, psycho-linguistically speaking. Similarly, to exclude from SLA individuals who are not enrolled at language centres but who use the L2 in the workplace, is to fly in the face of empirical evidence and common sense. I cannot imagine that the immigrants in Bremer et al. (1996), Goldstein (1996) or Norton (2000) will ever cease to be second language learners in their lifetimes. Indeed, one of the points made in all three studies is that the state of grace of full L2 proficiency and, perhaps more importantly, complete acceptance by host communities are never going to be fully attained. And if I may cite personal example, no matter what I do in the future, in some sense I will always be a learner of Catalan and Spanish (and indeed other languages of which I have acquired some knowledge) as surely as I will continue to be in contact with these languages for the rest of my life.

So, what is to be done? One solution is to make changes to Gass's Second Language Studies diagram reproduced in figure 5.2, first making the lines between SLA and SL Use bold, and then adding a third subcategory under Second Language Studies (let us call it 'Second Language Activity'), which would include the issues which Lantolf and Pavlenko discuss as 'SLActivity'. Nevertheless, this would not change matters as they stand at present unless IIO researchers take a more dialogic approach in their dealing with those who challenge what seem to be sacred views about what is and what is not acquisition. Judging by exchanges revolving around such matters over the past ten years, I would guess that this is not likely to happen (see Chapter 6 for further discussion about the future). However, on the ground, in the minds of language learners, it is likely to be the case that none of this debate really matters. For it is there that individuals are experiencing language learning in complex webs encompassing language acquisition, language use and language activity. One need only talk to learners like Montse to know this.

NOTES

1. I use the term cognitive science and not cognitive psychology, following authors such as Alan Baddeley. According to Baddeley, cognitive science 'has come to be applied to the study of cognition in the broadest sense', taking in 'a range of disciplines including neurobiology, linguistics and philosophy, as well as Artificial Intelligence and cognitive psychology, all of which contribute to the attempt to understand intelligent behaviour in both its natural and artificial forms' (Baddeley 1997: 271).

2. Krashen's theoretical linguistics pedigree has of course been questioned, most notably by Gregg (1984, 1986). However, if we examine a piece of Chomsky's early writing, we see that there is some connection. For example, in his classic text, *Cartesian Linguistics*, Chomsky (1966) seems to move freely back and forth between 'acquisition' and 'learning' in much the same way as current SLA authors do (see discussion above). In a section entitled 'Acquisition and Use of Language', Chomsky writes the following: 'certain views emerged as to how language is acquired and used ...' (59); '[s]uch universal conditions are not learned ...' (59); 'the speaker of language knows a great deal that he has not

learned' (60); and 'approaching the question of language acquisition ...' (60). However, if we look more closely at what Chomsky is writing, we see that he is using acquisition to refer to the actual 'getting' of the language at some point in time and 'learning' to something which involves some conscious effort or is related to instruction or mentoring of some kind. In this sense, Krashen may be seen to have taken on a part of Chomsky's mantle.

3. The notable exceptions are researchers working within a Universal Grammar framework, such as Jacqueline Schachter (1996) and Lydia White (1996), who see SLA as a process guided and constrained by an innate language faculty rather than general cognitive mechanisms.

4. It is perhaps worth noting here that restructuring is not unidirectional, nor only about progress in learning. Indeed, while restructuring is taking place, there may be a degree of backsliding as the learner reverts to making errors that had previously disappeared from her/his output. As Ellis (1994b) points out, this phenomenon might be attributable to an underlying process of moving from an exemplar-based system of unanalysed chunks of information to a rule-based system of analysed knowledge, which is generative of novel output.

5. This view of acquisition is in general shared by other prominent SLA researchers not always working explicitly within an IIO framework, such as Towell and Hawkins (1994), Van Patten (1996), Johnson (1996) and Ellis (1997).

6. It is interesting to note that through her work on SLA and pragmatics, Kasper has had far more connections to sociolinguistics than Poulisse who has worked in a cognition-dominated universe of communication and learning strategies, or Long who has not ventured far outside the IIO framework in recent years. Ultimately, this biographical particularity goes a long way towards explaining her more temperate attitude towards and her facility in understating and discussing what Firth and Wagner propose. For an update of her position on SLA and pragmatics, see Kasper (2001).

7. However, we should bear in mind that in the work of Leontiev and others after Vygotsky's death, there was some rejection, based on a rather doctrinaire Marxism, of Vygotsky's insistence on culture as the key in mediation as opposed to actual relationships with reality.

8. I refer to, for example, Situated Cognition (e.g. Kirshner and Whitson 1997); Dialogic Inquiry (e.g. Wells 1999) and ecological approaches to cognition (e.g. Neisser 1976, 1987, 1997 in cognitive science; van Lier 2000 in SLA).

9. I refer the reader to collections such as Lantolf and Appel (1994b), Lantolf (2000c), and Hall and Verplaets (2000), as well as publications in applied linguistics journals, in particular the *Modern Language Journal*.

10. A similar point is made by Dunn and Lantolf (1998) with reference to Krashen's *i + 1* and Vygotsky's ZPD, while Kasper states that 'it is abundantly clear that the metaphor of human cognition as a limited capacity information processing device does not mesh with the individual-in-society-in-history that constitutes the object of investigation in socio-cultural theory' (Kasper 2001: 524).

11. Here I exercise some poetic licence by incorporating Schumann's view on the appraisal system to what Lantolf and Pavlenko have to say about historically and sociologically situated agency. I believe that I am justified in doing so because in both cases there is the idea that learners do not come to language-learning experiences as emotionally empty vessels and that their accumulated experiential baggage is drawn on as a resource by active agents engaged in the ongoing task of making sense of their environment.

12. This other student had been a classmate of Montse's in her previous course. Knowing that they were on good terms with one another and that the interview format was familiar to both, I decided to have them interview each other, with a view to simulating a conversation between two students.

13. As Merrill Swain (personal communication, May 2002) suggests, we might even question whether or not a community of practice actually exists in this case. Indeed, it may well be that one of the big problems for Montse (unarticulated, to be sure) is that in her relationship with her classmates there is nothing coherent enough to call a community of practice.

Chapter 6

Some thoughts about the future

6.1 INTRODUCTION

> Of course, one cannot predict with accuracy, but one can think about the trajectory that we are on.
>
> (Gass 2000: 63)

Susan Gass thus commented just prior to speculating about future developments in SLA. In this chapter, I take on board Gass's statement of caution as I move towards the end of this book, where I speculate about the future of the IIO model. First, however, I examine how other authors have approached the task of concluding SLA texts, survey articles and edited collections, in particular the extent to which they have risked making predictions about where SLA is going. My conclusion is that there has certainly not been much in the way of prediction, although there has been a tendency to cite unanswered questions and to suggest what future research might explore. In the latter category, perhaps the most enlightening piece I have read has been Michael Breen's (2001a) conclusion to his edited collection, *Learner Contributions to Language Learning*. To my mind, Breen is right to argue for an expanded agenda for SLA that takes into account not only cognitive and linguistic aspects of SLA, but also what learners, their social environment and interactions between the two bring to the process of SLA. Having discussed Breen's framework in some detail, I move on to argue that SLA researchers should heed his call for greater attention to culture and identity. I cite two areas of research – pragmatics and constructed accounts of language-learning experiences – as areas of SLA where this call has already been taken on. Finally, I conclude with some speculative comments about the future of the IIO model.

6.2 PREDICTION IN SLA TEXTS

For the reader interested in predictions about the future of SLA, reading SLA textbooks can be frustrating. I say this because there is a tendency for authors to avoid ending their books with predictions about where the field is going, opting instead for the coverage of other issues. For example, in Ellis (1994a), the author devotes the final chapter to an excellent and timely discussion of epistemological and

philosophical issues as well as a consideration of the practical applications of SLA research. He makes no detailed prognosis about the future beyond noting that there is a general 'willingness to explore a wide range of issues by means of alternative paradigms and methods' and that '[n]o doubt, over time, the pictures provided by the different sides of the prism will become clearer' (Ellis 1994a: 690). Gass and Selinker (1994/2001) also eschew prediction in favour of dealing with other issues. Their book ends with a comprehensive presentation of Gass's IIO model, which has been the main focus of this book; there is no speculation about the future as the authors limit themselves to calling for more research to test the different aspects of Gass's model. Of course, Ellis and Gass and Selinker can be excused from entering the prediction trade as doing so does not form part of the aims and objectives of their work, which is to document and describe the state of play in SLA, circa 1994 or circa 2001.

Mitchell and Myles (1998) is something of an exception to this general trend in SLA texts. They end their book with a section entitled 'Future directions for SLL research'. Here the authors foresee the continued strength of Chomksyan linguistics in SLA, but they see it balanced by the growing strength of general learning theory (following cognitive science) and sociocultural theory. They believe that some researchers will continue to explore single strands within SLA, while others will endeavour to synthesise and develop hybrid theoretical constructs. In the former category are researchers like Lydia White (e.g. 1996), who are devoted to a Universal Grammar framework and who will likely continue to work exclusively within this framework; in the latter category are researchers like Towell and Hawkins (1994; see Chapter 2 of this book), who combine Universal Grammar and information processing frameworks in their model of SLA. Mitchell and Myles go on to mention recent debate over the ontological and epistemological issues underlying different approaches to SLA – in a nutshell, the rationalist cognitive dominated approach versus the socially sensitive and engaged, postmodern approach – but they refrain from saying which way they think matters will go in the future. Instead, they limit themselves to the suggestion that such debate is likely to continue. Mitchell and Myles close with a discussion of the future relationship between SLA research and language education:

> There is a continuing need for dialogue between the 'practical theories' of classroom educators, and the more decontextualized and abstract ideas deriving from programmes of research. Researchers thus have a continuing responsibility to make their findings and their interpretations of them as intelligible as possible to a wider professional audience, with other preoccupations.
>
> (Mitchell and Myles 1998: 195)

6.3 PREDICTION IN ARTICLES SURVEYING SLA

Journal articles about the state of play in SLA have also tended to be more about the relationship between SLA research and language-teaching practice and less about making predications about future directions in SLA research. A good example is

Lightbown (2000), where the author aims to update her earlier survey article (Lightbown 1985), discussed in Chapter 2, in which she examined the relevance of classroom SLA research to language educators. In both 1985 and 2000, Lightbown rates the applicability to teaching practice of ten general findings in SLA. These findings relate to aspects of SLA such as the role of input, the systematicity of interlanguages, developmental patterns, focus on form and the Critical Period Hypothesis. Her overall conclusion is the same in both cases as she adopts Hatch's (1978) earlier admonition of 'apply with caution'. However, in her 2000 article, Lightbown also argues that the period 1985–2000 produced research which offered further support for the original ten generalisations. This leads her to maintain that '[t]here is no doubt that there is now a rich literature of SLA research which can help shape teachers' expectations for themselves and their students and provide valuable clues to effective pedagogical practice' (Lightbown 2000: 452). The article concludes with a look at the future, but this is a call for more research (specifically, more collaborations where SLA scholars work with practising teachers, a greater diversity of research contexts and more replication studies) rather than a set of predictions about how the field might develop.

Elsewhere, Gass (2000) is somewhat more helpful in terms of making predictions. She ends her article about changing views of language learning with a section entitled 'Reading the tea leaves'. After noting that while it is impossible to predict the future, it is possible to predict trajectories that might be followed (her exact words are reproduced at the beginning of this chapter), Gass goes on to argue that SLA will become more sophisticated as a result of the increased sophistication of data elicitation techniques, which will in turn lead to a 'greater emphasis on what actually is occurring in learners' heads as they process and use language' (ibid.: 63–4). She further argues that there will be an increase in neurobiological approaches to SLA in the form of attempts to explore, for example, which parts of the brain are activated when learners use their first and second languages. However, perhaps aware that this line of research moves SLA away from the interests of most language educators, she also argues that there will be more work on interaction and how it leads to language learning, via tasks. Notably, Gass also cites an increase in interest in learners' perceptions of error correction, in line with her own recent work (see Mackey et al. 2000, discussed in Chapter 4), as having a future in SLA. Finally, Gass suggests a macro goal for the field, namely that SLA should inform understandings of 'the nature of language, the nature of language processing, and how, in general, language is used in a social context' (Gass 2000: 64). She closes by stating that SLA is an 'interdisciplinary field with multiple spokes' and that researchers 'must enter into discussions about the nature of the hub that anchors the spokes' (ibid.).

I find Gass's allusion to interdisciplinarity interesting as it takes me back to Ben Rampton's call for an interdisciplinary applied linguistics discussed in Chapter 1. However, given Gass's views on SLA and her IIO framework, I do wonder if she is truly willing to take on board interdisciplinarity. I have no doubt that Gass is willing to 'enter discussions about the nature of the hub that anchors the spokes'; indeed, she has in effect done so in her exchange with Firth and Wagner. However, if we examine

the thrust of her arguments in that debate, and indeed in the article cited here, we see that she does not seem particularly convinced about tampering with the 'hub' of SLA and therefore not particularly predisposed to working in an interdisciplinary manner. I say this because elsewhere in her 2000 article she makes it clear that that she sees a clear and irreconcilable difference between SL-Acquisition and SL-Use (see Chapter 5). What better way to shut down a move towards interdisciplinarity!

6.4 CONCLUDING CHAPTERS IN EDITED COLLECTIONS

A very different approach to SLA research in the future is to be found in an article by Christopher Candlin (2001). Candlin closes Bygate, Skehan and Swain's edited collection, *Researching Pedagogical Tasks: Second Language Learning, Teaching and Testing*, by posing questions which he sees, not as a 'research agenda', but as 'suggestive of the research, ... which needs to be undertaken if ... guidelines for a task-oriented curriculum ... are to be substantiated and, above all, translated into warranted classroom (inter) action' (Candlin 2001: 241). The questions are organised under three headings: task design, task operationalisation and task evaluation. For example, under the general category of task design and specifically with an interest in the inter-relationship between classroom internal and external worlds, one of Candlin's questions reads as follows: 'How is the "real world" being constructed? In terms of which participants, which roles, which discursive and social relationship?' (ibid.: 239).

Under the general category of task operationalisation, and specifically with an interest in how participants affect task outcomes, one of the questions asked reads: 'If tasks necessarily involve learners in "active participation", how is this participation being defined?' (ibid.: 240). Finally, under the heading of task evaluation, one of Candlin's questions is: 'In relation to the issue of evaluating learner cognition and acquisition, what social factors in terms of learners' backgrounds, schooling, out-of-class socialisation, are being taken into account?' (ibid.: 241).

Whether or not we wish to call Candlin's questions a 'research agenda' or merely 'suggestive of research', they are definitely an attempt to move current research into the future and, as such, they anticipate future developments. And although Candlin is concerned with research into pedagogical tasks, such research also qualifies as SLA research because it explores questions that are relevant to the input/interaction/cognition/output cycle. Among other things, we see in the questions quoted above a concern with issues related to identity beyond that of classroom language learner, participation as a social activity and extra-cognitive aspects of language learning, respectively. In proposing these questions, Candlin is thus extrapolating on the work of the contributors to Bygate et al. (2001b) moving it into what I would call more socially sensitive terrain.

Elsewhere, Michael Breen (2001a) ends his edited collection, *Learner Contributions to Language Learning*, with a call for research agendas that do not eschew traditional interests in SLA as a cognitive and linguistic phenomenon, but do attempt to take on what learners, as sociohistorically situated human beings, bring

to the process. In response to Long's (1997) assertion that 'most current theories of and in SLA' are based on the 'fact' that 'social and affective factors ... are important, but relatively minor in impact ... in both naturalistic and classroom settings' (319), Breen offers the following view:

> It is the case, however, that those 'current theories' prevalent in the last thirty years that have promoted and accounted for language acquisition as primarily the interface between learners' mental processes and the grammatical system of the target language have pursued a research agenda that seeks to account for generalizable patterns of development across all learners. Intervening variables other than cognitive and linguistic that may either enhance or seriously inhibit such development are likely to be positioned as a distraction from this agenda. It may be claimed that a different, complementary and equally valid research purpose is to uncover those variables that are very likely to account for *differences* in the achievements of second language learners. And among such variables will be a range of social and affective factors.
>
> (Breen 2001a: 173, original emphasis)

Breen goes on to provide lists of such variables, in four layers, which interrelate the internal and the external, the individual and the contextual. Figure 6.1 is based on his profile of learner contributions to language learning.

In the first layer of the profile, we find a long list of what Breen calls 'learner attributes, conceptualisations and affects', that is, basically what the individual learner brings to language learning. The list consists of attributes that most researchers would see as given and fixed, that is, innate language acquisition capacity, psycholinguistic processes and disabilities, and others about which there is debate concerning their relative fixedness, that is, aptitude, cognitive style and personality (see Skehan 1998, for a discussion). Age has traditionally been dealt with strictly as a biological variable (e.g. Singleton and Lengyel 1995; Birdsong 1999), but the recent work of sociolinguists such as Nikolas Coupland (2001a) suggests that there may be a case for conceptualising age as socially constructed as well. In this sense, age would join gender as a variable that at one time was treated as biological, but which is now considered by many researchers to be socially constructed (or more precisely, 'sex' refers to the biological, while 'gender' refers to the socially constructed), as suggested by the authors cited in Chapter 4 (e.g. Cameron 1997; Ehrlich 1997; Sunderland 2000; Pavlenko and Piller 2001; Block 2002). Also in the realm of social constructivism are questions of self/social/cultural identity (e.g. Norton 2001), agency (e.g. Lantolf and Pavlenko 2001) and motivation (e.g. Dornyei 2001). Finally, there are several conceptualising variables such as metacognitive knowledge (Wenden 2001), beliefs and attitudes (e.g. Peacock 1999), and the resulting constructions of learner selves and teacher selves (e.g. Ellis 2001; Oxford 2001), the target language and culture (e.g. Kramsch 1998), classroom events (e.g. Block 1998) and so on. In this layer we find just about everything that, metaphorically speaking, is contained *inside* the learner. However, with the exception of the fixed attributes of innate language acquisition capacity, psycholinguistic processes and disabilities, all of

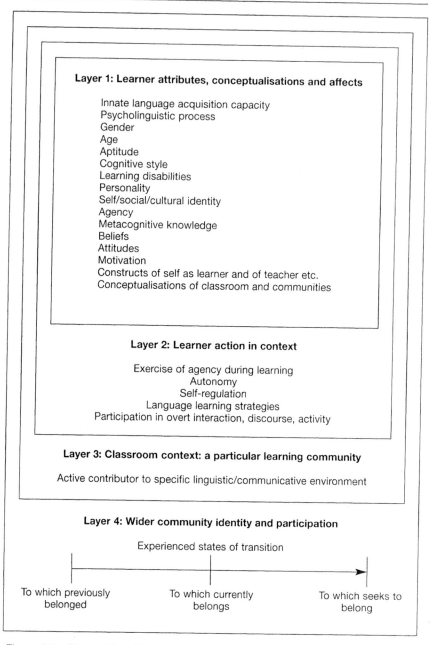

Figure 6.1 The profile of learning contributions to language learning (based on Breen 2001a: 180)

these learner contributions come to life via contact with the remaining three layers, all of which relate at varying points on a micro-macro continuum to context.

At the most micro level is layer 2, what Breen calls 'learner action in context', which relates to the learner's actual engagement with discourse practices and, more specifically, interactions with others. In these interactions, the learner exercises agency via particular language practices and the use of particular strategies and he or she is attributed a degree of autonomy and the ability to self-regulate. Of course, the autonomy and self-regulation in question occur above the level of two individuals exchanging information and they are therefore specific to the communities of practice in which the learner develops these capacities in a language. These communities of practice constitute layer 3 in Breen's diagram. Here, Breen has chosen the classroom as the specific community, but we can, of course, imagine others, even for learners whose main contact with a target language is via formal lessons. For example, the classroom language learner might engage in target language practices outside the classroom via the internet, or he or she might meet with fellow learners or a mentor of some sort (such as a parent), thus finding other, extra-classroom learning communities in which to participate. Whatever the case, within these particular communities of practice, the more socially constituted attributes and conceptualisations of layer 1 are constantly being revised.

The final and macro level of context, layer 4, is that formed by what Breen calls the 'wider community identity and participation'. Here we have the entire sociohistorical background – past, present and aspired – of the learner, that is, the totality of her/his experience of social interaction. It is in this totality of experience that the learner has developed the layer 1 attributes and conceptualisations, and it is only by taking this experience into account that we can make sense of who the individual is and how he or she thinks and acts when learning a language at a given point in time via engagement in particular activities in particular communities of practice. In addition, as Breen notes in his profile, via ongoing participation in communities of practice, the learner is in a constant state of transition. Therefore, we cannot extirpate the learner from the past, present and aspired-to experiential milieu in which he or she has forged an identity and expect to get very far in explaining the process of SLA.

Taking his learner contributions to language-learning profile as a starting point, Breen goes on to suggest that SLA needs to be based on research that attempts to understand different aspects of the puzzle by establishing links across levels. In this sense, he is calling for an SLA research agenda that would take on board the various alternative understandings and interpretations of the second, the language and the acquisition of SLA presented and discussed in Chapters 3–5.

6.5 A CULTURAL TURN FOR SLA RESEARCH?

Thus far, I have discussed the reluctance of authors writing SLA surveys to make predictions about where they think SLA is going, and I have made the point that there is a general tendency to end such discussions with suggestions for further research. Breen (2001a) is certainly no exception to this rule, but because his

questions are couched in a model that effectively links the sociocultural to the cognitive, I have deemed it worthy of discussion in some detail. According to Breen, one of the future challenges for SLA is 'to try to relate a theory or operational definition of culture to the focus of its investigation' (Breen 2001a: 178). It has by now become almost axiomatic to make claims along the lines of 'culture is language', 'language is culture' or 'one cannot separate language from culture'. But, as Breen goes on to point out, 'culture ... is a multidimensional concept that is largely unproblematized in ... our research ...' (ibid.). So what do such claims about the relationship between language and culture actually mean? And more importantly, what do they mean in the context of SLA?

Space does not allow for a detailed discussion of what we mean by culture. And, as has been pointed out by authors such as Kramsch (1993, 1998) and Hinkel (1999), who have dealt with the concept in the context of SLA, the anthropological and sociological literature is full of definitions and even full-length treatments of culture such as Bauman (1973) Geertz (1973) and Williams (1981), and more recently Tomlinson (1999), Eagleton (2000) and Mathews (2000). Definitions provided by two of these authors follow:

> historically transmitted semiotic network constructed by humans and which allows them to develop, communicate and perpetuate their knowledge, beliefs and attitudes about the world.
>
> (Geertz 1973: 89)

> culture can be understood as the order of life in which human beings construct meaning through practices of symbolic representation.
>
> (Tomlinson 1999: 18)

The common thread in both of these definitions, produced twenty-six years apart by an anthropologist and a communications specialist, respectively, is that culture enables individuals to engage in acts of symbolic representation, which of course include language use and communication. Less obvious in these quotes but certainly in line with these authors' views (to say nothing of the views of the majority of anthropologists, sociologists and social theorists today) is that culture stands at the crossroads of structure and agency. This means that while, as Geertz states, culture is a structure that 'allows [human beings] to develop, communicate and perpetuate their knowledge, beliefs and attitudes about the world', and while, as Tomlinson states, culture is 'the order of life in which human beings construct meaning through practices of symbolic representation', culture is, as Geertz states, 'constructed by humans'. In other words, any conceptualisation of culture must be able to account for how structures composed of the world views, behaviours and artefacts of groups or collectives of human beings interrelate with individual agency, which is both determined by and determinant of the structures concerned. Any conceptualisation of culture in the context of SLA will need to relate this structure/agency interaction to ongoing language development. This is indeed a tall order and as we observed above, in Breen's view, culture remains 'largely unproblematized' in SLA. However,

I am aware of two areas of research which already include a cultural perspective and which, I believe, do at least in part achieve this synthesis.

6.6 PRAGMATICS

Pragmatics is defined as the study of communicative action in its sociocultural context. Communicative action includes not only using speech acts (such as apologizing, complaining, complimenting, and requesting), but also engaging in different types of discourse and participating in speech acts of varying length and complexity ... [P]ragmatics ... [is] interpersonal rhetoric – the way speakers and writers accomplish goals as social actors who do not just need to get things done but must attend to their interpersonal relationships with other participants at the same time.

(Kasper and Rose 2001a: 2)

In this way, Gabriele Kasper and Kenneth Rose begin the introduction to *Pragmatics in Language Teaching* (Rose and Kasper 2001a), an edited volume which is part of the general increase in the number of publications devoted to pragmatics in SLA over the past several years. During this time, there have been three survey articles in major applied linguistics journals – Kasper and Schmidt (1996), Bardovi-Harlig (1999) and Kasper (2001) – as well as two collections edited by Bouton (1996, 1999) and a book on researching pragmatics (Kasper and Rose 2001b). The Rose and Kasper collection focuses exclusively on formal language-learning contexts, but the empirical studies presented all share the view that learners will need to accompany any linguistic knowledge (that is, morphology, syntax, phonology and lexis) with a knowledge of sociocultural practices.

Earlier researchers into pragmatics and language use, Geoffrey Leech (1983) and Jenny Thomas (1983), proposed that pragmatics be seen in terms of two types of resources necessary for socioculturally sensitive communication: pragmalinguistics and sociopragmatics. Kasper and Rose define these two resources as follows:

Pragmalinguistics refers to the resources for conveying communicative acts and relational or interpersonal meanings. Such resources include pragmatic strategies like directness and indirectness, routines, and a large range of linguistic forms that can intensify or soften communicative acts.

(Kasper and Rose 2001a: 2)

Sociopragmatics has been described by Leech as (1983, p. 10) as 'the sociological interface of pragmatics', referring to the social perceptions underlying participants' interpretation and performance of communicative action.

(ibid.)

As regards the interrelationship between the two, Bardovi-Harlig states:

pragmalinguistic competence [is] the linguistic competence that allows speakers to carry out the speech acts that their sociopragmatic competence tells them are desirable.

(Bardovi-Harlig 1999: 686)

Following Thomas (1983), Kasper and Rose sum up matters as follows:

> As Thomas (1983) points out, although pragmalinguistics is, in a sense, akin to grammar in that it consists of linguistic forms and their respective functions, sociopragmatics is very much about proper social behavior.
>
> (Kasper and Rose 2001a: 3)

Thus, contained in the study of pragmatics is a distinction between a focus on the formal aspects of language use and a focus on more sociocultural aspects and, I would add, the need to cut across the different layers of Breen's learner contributions profile in order to explore both. How this actually works in practice is perhaps best illustrated by Liddicoat and Crozet's (2001) contribution to Rose and Kasper's collection. Working with Australian learners of French as a foreign language, these authors examine the acquisition of the apparently simple functions of asking and answering questions about weekend activities (for example, 'How was your weekend? Fine'). This aspect of French could, of course, be studied as the development of the morphosyntactic and discourse competence along with the communication strategies necessary for participation in relatively formulaic exchanges. In this case, the researcher would, at best, operate in the realm of layer 2 of Breen's profile. However, as Liddicoat and Crozet (2001) point out, greetings across languages are not equally formulaic and language learners need to enter the realm of sociocultural analysis in order to work out how to make them. In pragmatic terms, researchers interested in such matters need to examine not only the pragmalinguistics of the situation but also the sociopragmatics.

Liddicoat and Crozet examined whether or not their learners would improve after they engaged in awareness-raising activities about the differences between how French speakers and Australian English speakers 'do' the 'How was your weekend?' exchange so common in work and study environments on Monday mornings. Learners were exposed to examples of French speakers and Australian English speakers performing this exchange before engaging in in-depth discussion about differences. In a nutshell, these differences look as follows: while the French version is more an opportunity for information transfer, the strengthening of friendship ties and the projection of an identity as interested individual and animated conversation partner, the Australian version is more a conversation routine, a relation-maintaining formulaic exchange with little informational import and little or no personal revelation.

Liddicoat and Crozet noted that learners exposed to the sociocultural analysis of greetings in both French and English manifested changes in how they dealt with 'How was your weekend?', in general adopting a more topic-based orientation (and therefore a more French orientation) to the question than they had previously. However, the authors also noted how the procedure adopted had raised awareness not only of cultural differences but also of individual agency in the form of some students' reluctance to 'speak like the French'. Liddicoat and Crozet make the point that students were able to develop an 'understanding that learning to speak a foreign language is not a matter of simply adopting foreign norms of behaviour, but about

finding an acceptable accommodation between one's first culture and the target culture' (Liddicoat and Crozet 2001: 137–8).

To my mind, Liddicoat and Crozet's research is exemplary of an approach to a particular aspect of language learning – greetings – which goes beyond Breen's layer 2 – where greetings take place – and involves the learner in a conscious consideration of sociocultural factors which Breen would locate in layer 4, to say nothing of layer 1 phenomena such as agency, beliefs, attitudes and constructions of home and target cultures. Liddicoat and Crozet make very clearly Breen's point about integrating levels in SLA research for the simple reason that to do otherwise is to deal with language learning in a partial and limited manner. More importantly, along with other contributions to Rose and Kasper, their work suggests to me one trajectory that some SLA researchers interested in pragmatics have chosen to follow. It is a trajectory which links more traditional interests in pragmalinguistics with increasingly more informed frameworks for sociopragmatics that include notions of individual agency and the interface of culture and identity.

6.7 LEARNER IDENTITY AND ACCOUNTS OF LANGUAGE LEARNING EXPERIENCES

> We are not going to argue that personal narratives should replace observational/experimental research; rather we believe they bring to the surface aspects of human activity, including SLA, that cannot be captured in the more traditional approach to research.
>
> (Pavlenko and Lantolf 2000: 159)

Over the past decade or so, there has been a notable increase in the amount of research that relies on learners' accounts of their experiences (e.g. Bailey and Nunan 1996; the special issue of *TESOL Quarterly* on language and identity, edited by Norton in 1997; Norton 2000; Pavlenko 2001a). In a sense this interest in personal narrative is not new and it can be linked to a slightly earlier period of SLA research, exemplified by authors such as Schumann and Schumann (1977), Bailey (1983) and Schmidt and Frota (1986) where diaries were kept by applied linguists who were themselves in the process of learning a language. There is also a degree of continuity with researchers who have collected accounts of language learners for a variety of purposes, such as learning strategies (Brown 1985; Abraham and Vann 1987) and perceptions of classroom events (Slimani 1992; Block 1996b). However, the big difference in this more recent research is the fact that it is more informed by social theory than applied linguistics, and that it represents a shift from seeing outcomes of encounters with languages only in linguistic or meta-cognitive terms to seeing them in sociohistorical terms. For example, rather than focus on the acquisition of morphemes, this research examines whether or not learners are able to become fully participating members of the communities of practice they wish to join.

Good examples of a narrative approach to SLA are Bonny Norton's (1995, 1997, 2000, 2001) and Tara Goldstein's (1996, 2001) in-depth longitudinal studies of the

ongoing construction of the social and cultural identities of female immigrants in Canada. As I pointed out in Chapter 3, both Norton and Goldstein observed that exposure to the target language, via interaction with members of target language communities of practice, is often limited by a variety of sociohistorical variables. In Norton's research, these variables included whether or not the learner is considered 'worthy' as a potential conversation partner, or the learner's own disposition to participate. In Goldstein's research, the focus was on how membership in Portuguese-based communities of practice shaped the choice not to participate in English-based communities of practice, and how this non-participation served to guarantee a secure sense of identity at the price of never obtaining fully the cultural capital necessary to gain greater political and economic power in Canadian society.

Elsewhere, Aneta Pavlenko (2001a, 2001b) has examined accounts of language-learning experiences written by the learners themselves and in many cases published as books – what she calls 'language learning memoirs' – as well as accounts produced in interviews that she herself conducted, recorded and later analysed. In her analysis of accounts from these different sources, Pavlenko is particularly interested in how language learners recount their experiences in terms of a journey. The journey begins with the learner's sense of loss of her/his childhood cultural and linguistic identity. This is followed by the struggle to appropriate the voices and ways of the target cultural and language communities, a struggle which usually ends successfully in the accounts cited by Pavlenko. For Pavlenko,

> L2 learning stories, and in particular language learning memoirs, are unique and rich sources of information about the relationship between language and identity in second language learning and socialization. It is possible that only personal narratives can provide a glimpse into areas so private, personal, and intimate that they are rarely – if ever – broached in the study of SLA, and they are at the same time, at the heart and soul of the second language socialization process.
> (Pavlenko 2001b: 167)

In a chapter of their SLA text entitled 'Sociolinguistic perspectives', Mitchell and Myles (1998) present, analyse and critique several different approaches to SLA that are primarily concerned with SLA as a social phenomenon. The work of Goldstein and Pavlenko is not mentioned in this chapter (at least in the case of Pavlenko, this is probably due to the fact that practically none of it had been published when Mitchell and Myles were writing their book). Norton's work, however, is discussed and critiqued, and what the authors say about Norton would certainly apply to Goldstein's and Pavlenko's work as well. Mitchell and Myles describe Norton's work as research that:

> deal[s] with L2 learning in a broad way, embedded in its social context. Indeed, sociolinguists are arguably still mostly preoccupied with the characterization of this context, and in particular, with providing longitudinal accounts of the social processes of L2 interaction ... It frequently involves case studies of individuals or groups of learners; in contrast to most other traditions, great attention is paid

to the personal qualities of the learner. And their own social contribution to the learning context. On the other hand, it is rare to find in sociolinguistic work of his kind, any close attention being paid to the linguistic detail of the learning path being followed (i.e. to the learning *route*).

(Mitchell and Myles 1998: 188–9; emphasis in original)

Thus, for Mitchell and Myles (and I will venture, for many other SLA researchers), the analysis of learners' language-learning stories brings out interesting social issues about SLA, but leaves the linguistic side of SLA completely marginalised. Unlike the pragmatically based SLA research discussed above, where Breen's layer 2, 'learner action in context', was central, this research never really reaches this layer. It starts at layer 4 of Breen's profile, where socially informed notions of the ongoing interaction of culture and identity are covered, and then moves to layer 3, where communities of practice enter the framework. Meanwhile the layer 1 learner attributes and conceptualisations that are deemed socially constructed are also brought to bear on the focus of inquiry. What is missing, however, is engagement with layer 2 aspects such as self-regulation, learning strategies and interaction.

Given that most of my published research is classifiable as the collection and analysis of learner accounts (Block 1996b, 1998, 2000), I am certainly not as bothered as some might be about the partial approach to research represented by Norton and Pavlenko's work. Furthermore, their work is valuable precisely because it addresses the imbalance caused by so many SLA researchers who completely ignore the kinds of issues they explore. However, it would certainly be desirable if someone could do research which combined these contrasting perspectives. Such research would bring together all four of Breen's layers and, in addition, deal with cognitive and linguistic aspects of SLA. To date, I have not found many examples that actually achieve this feat, but two do come to mind.

6.8 TARONE AND LIU'S WORK

Guo-Qiang Liu's research (Tarone and Liu 1995) charts how over a period lasting twenty-six months, a young Chinese boy named Bob (aged five at the start of the study), showed variable discourse-pragmatic, morphosyntactic and lexical development across three different contexts and sets of interlocutors: teachers, the researcher and fellow pupils. He showed the least linguistic development in his interactions with teachers and the most in interactions with the researcher who, importantly, was also a family friend and someone who 'knew how to play and was *interested in* interacting with Bob' (Tarone and Liu 1995: 124; emphasis in the original). In between these two contexts were contacts with fellow pupils. In this research, there are interesting questions arsing about how input was provided by interlocutors and how interactional turn-taking was organised (in short, how the linguistic environment varied across contexts); however, what I find remarkable is one particular phenomenon that the authors mention but do not comment on in great detail. I refer to how Bob adopted very different subject positions depending on his interlocutors.

From the description of the study provided by Tarone and Liu, we find out that with fellow pupils, he was competing and mischievous Bob; with his teachers, he was cooperative and compliant Bob; and with the researcher, he was relaxed and friendly Bob, willing to try out new language in conversation. In effect, it was how Bob negotiated his subject positions in three different communities of practice that perhaps most impacted on the linguistic aspects of his interactions.

In their presentation and discussion of Liu's research, Tarone and Liu manage to synthesise at least three of Breen's four layers. Issues contained in layer 4, specifically the current wider community identity and participation, intervene in the sense that the researcher was friend of Bob's family. More importantly, there is a direct relationship between layer 3, the different communities of practice with which Bob had contact, and layer 2, learner action in context, in the form of Bob's actual interactions with different interlocutors. However, beyond implicit references to the exercise of individual agency in the form of different discourse strategies in different contexts, what is missing in this study is attention to layer 1; in particular, Bob's attitudes and beliefs about his language practices would have been welcome. Finally, the study does not really have much to say in terms of the interrelationship of culture and identity discussed above.

Thus, while Tarone and Liu is a welcome move in the direction of integrating socially oriented and linguistically oriented approaches to SLA, it ultimately does not go far enough in the treatment of the social side. Indeed, the relative importance of social forces in the research seems to have emerged at the end of the research process (the article is based on Liu's PhD research). The authors show an awareness of this in a refreshingly candid endnote in which they admit that they 'can look for a deeper and more detailed analysis of the interaction between social forces and Bob's acquisition of specific grammatical forms in future papers' (Tarone and Liu 1995: 124). However, I should add here that I have only found brief subsequent reference to this study (e.g. Tarone 1997) and therefore can only conclude that such a follow-up has not taken place. Still, Liu's work stands out as a unique demonstration of how social forces can be a determining factor in the linguistic development of a language learner.

6.9 TEUTSCH-DWYER'S WORK

If the establishment of a clear relationship between social factors and linguistic development was more an accident than a result of research design in the case of Tarone and Liu, Marya Teutsch-Dwyer's study of the socially framed linguistic development of Karol, a thirty-eight-year-old Polish man living and working in the US, pursues this inter-connection from start to finish. Via bi-monthly recordings of naturalistic speech, field notes and interviews with Karol, his American girlfriend and co-workers, Teutsch-Dwyer charts the means and devices used by Karol to mark temporality in the production of narratives over a period of fourteen months. Specifically, she focuses on discourse pragmatic devices, such as the positioning of time markers in the overall narrative; lexical means, such as the use of time-marking

adverbials; and morphosyntactic means, such as inflected verbs. Teutsch-Dwyer observes that Karol in fact advanced very little in all three areas and was even using fewer time-marking adverbials at the end of the fourteen-month period.

Karol's limited linguistic progress cannot really be explained by a lack of exposure to the target language, a lack of opportunity to interact with others or a lack of opportunity to speak; indeed, he had abundant access to all three. Rather, the explanation for his linguistic failure is more social in nature, having to do with questions of gendered identity and communities of practice, in particular Karol's struggle for an acceptable male identity in his interactions with others. When he first arrived in the US, Karol lived with his sister and her American husband. At first, his brother-in-law showed an interest in talking to him; however, after a month he had apparently tired of Karol's company and asked him to leave the household. In the workplace, Karol's male boss also slighted him when he told his girlfriend, who was a co-worker, that Karol's English was poor. After finding that he could not really participate as an equal partner in conversations with his American brother-in-law and his male boss, Karol found that it was only with three female co-workers – one of whom was his girlfriend – that he was able to participate fully as a respected interlocutor. According to Teutsch-Dwyer, Karol was an entertaining and engaging storyteller in Polish and he was able to transfer to English this talent, albeit without the linguistic means to be as precise as he could in Polish. His co-workers and girlfriend were happy to listen to him and his girlfriend even came to anticipate his speech to the extent that he was under no pressure to produce more elaborate or accurate language. She also came to take care of Karol's personal business, taking and making telephone calls on his behalf to banks and doctors. Teutsch-Dwyer concludes by suggesting that Karol's 'substantial lack of the grammaticalization process during his language acquisition over a period of fourteen months is closely related to his perceptions of positive acceptance by the social female circles he was a member of and by the sheltered conditions he experienced in his private life' (Teutsch-Dwyer 2001: 192).

In the case of Teutsch-Dwyer, there is a thorough synthesis of Breen's four layers and, in addition, detailed attention to the interrelationship of culture and identity discussed above. The author provides us with a clear picture of how Karol's experiences at layers 4, 3 and 2 interrelate: we are informed that Karol has a wider community identity as a Polish expatriate whose sister lives in the same city; we know that he participates in different communities of practice, such as his homelife, his sister's family and the workplace; and finally, we are able to examine examples of his interactions. In addition, via interviews with Karol, Teutsch-Dwyer was able to obtain insights into Karol's attributes and conceptualisations. Among other things, she was able to glean that he had an outgoing, gregarious personality and strongly-held views about language learning, namely, that the only way to learn a language was to interact with speakers of that language. In terms of the interface between culture and identity, Teutsch-Dwyer does a good job of showing how Karol's behaviour was in some sense formed by his Polish cultural identity (valuing the ability to tell jokes and stories is cited as an example of something eminently Polish)

while his uprooted life in America was leading him to the active formation of third-place identities, the most notable perhaps being his new masculinity as his partner's dependent, both linguistically and socially.

6.10 CONCLUSION

As I indicated in Chapter 1, and I have subsequently maintained throughout this book, those who are most firmly established as SLA researchers have often met suggestions to widen the research agenda of SLA with resistance. One reason in particular, openly expressed by Long (1997, 1998) but held by many in SLA, is that there is general lack of support for the claim that a socially informed SLA would enhance our understanding of how input, interaction, cognition and output combine to bring about language learning. As we observed in Chapter 1, Long has challenged those who would like to see a more interdisciplinary SLA to 'offer ... some evidence that ... a broader view of social context, makes a difference, and a difference not just to the way this or that tiny stretch of discourse is interpretable, but to our understanding of [second language] acquisition' (Long 1998: 92).

In my view, Chapters 3–5 and this chapter, taken together, provide such evidence. In Chapters 3–5, I have drawn heavily on work of sociolinguists and SLA researchers with a more socially informed research agenda, in an attempt to show that social context makes a difference. In Chapter 3, I argued for the importance of a broader understanding of multilingualism as well as of context. In particular, I discussed research findings to the effect that languages do not exist in the head as separate wholes; that the concepts of 'L1' and 'L2' are too often simplified for many SLA experiences; and that opportunities for learners to interact and participate in target languages are not always as abundant and fulfilling as is often assumed. In Chapter 4, the emphasis turned to conceptualisations of language and communication. There, I discussed research findings showing that when individuals interact, there is much more than information transfer going on and that if we wish to be thorough in defining the 'what' of SLA we need to take on board notions such as face-saving and 'negotiation of identity'. In Chapter 5, I focused on alternatives to the acquisition metaphor. Research findings cited suggest that concepts associated with Socio-cultural/Activity Theory, such as appropriation, participation, collaborative dialogue and activity, might serve as complementary frameworks that help us understand the experiences of language learners.

In this chapter, I have examined in detail Breen's (2001a) suggestions about a broader SLA research agenda that takes on board learner contributions to the language-learning process as well as questions of culture and identity. I have also argued that researchers working in the areas of pragmatics and language-learning narratives are already moving in the direction of showing how social factors can impact on language, understood narrowly, as linguistic, and understood broadly, as being wrapped up with culture and identity. This research, along with the small amount of work that has been done under the rubric of language socialisation (see Mitchell and Myles 1998 and Kasper 2001, for discussions) and the ever-increasing

amount of work being done under the general heading of Sociocultural/Activity Theory (as envisaged by Lantolf and Pavlenko (2001), and as exemplified by Montse's experiences in Chapter 5), leads me to some final speculative comments about the future of the IIO model.

My first speculative prediction is that many IIO researchers will carry on as they have until now, ignoring the multiple opportunities around them to do inter-disciplinary research. In this case, the vast majority of researchers guided by the IIO model will continue to work in isolation outside theoretical frameworks, only doing research that draws on already established constructs contained in the model. This research will continue to explore the nature of input, how it is apperceived, comprehended and intaken and, ultimately, its role in SLA. It will also continue to examine the nature and role of interaction, in particular the construct of negotiation for meaning as essential to SLA. It will develop more in-depth understandings of the role of cognition in SLA, elaborating on models of information processing which include constructs such as noticing and integration. Finally, there will be continued interest in the role of learner output, now accepted as essential to SLA. The business-as-usual approach will continue to produce interesting findings and the IIO model will continue to look like a strong candidate for 'best theory around at the moment', in terms of its ability to account for many observed phenomena in SLA.

However, I do foresee an extension to IIO research in the form of an increasing interest among researchers in learners' reflections on their language-learning experiences. As we observed in Chapter 4 when we examined in detail the article by Mackey et al. (2000), IIO researchers are already starting to complement their close-to-the-data analyses of interactions with stimulated recalls. Although I think that these authors have not utilised this form of data collection to its maximum potential (see Davies 2000, discussed in the same chapter), to do so is just a question of asking participants to talk not only about what they think has happened, but also to venture reasons.

At the same time, I also predict that more researchers working within the IIO framework will follow Swain and Lapkin's lead and begin to appropriate frameworks from outside the model. As we observed in Chapter 5, by drawing on work in Sociocultural/Activity Theory, Swain and Lapkin have been able to move their early arguments about the importance of output in SLA from a more individualistic approach, where output becomes input for the individual learners producing it, to a more collective and social one, where output is the focus of work by learners collaborating with one another. Researchers like Swain and Lapkin will progressively find that they have more in common with researchers who have never been part of the IIO in-group, but who have, nevertheless, had interaction at the forefront of their research. I refer to authors contributing to collections such as Lantolf and Appel (1994b), Lantolf (2000c) and Hall and Verplaets (2000). Meanwhile these researchers, who have also been firmly and exclusively situated in the Sociocultural/ Activity Theory camp, will continue to produce publications and progressively, single-author book-length accounts of their research (e.g. Ohta 2001), always a sign that an area of SLA has become prominent. In this research, there will be quite

detailed analyses of interactions and language learning, which an increasing number of IIO researchers will not be able to ignore simply because they are part of a 'different paradigm'.

Above, I discussed recent developments in the study of interlanguage pragmatics as an area which is sensitive to culture and identity issues, as well as the multitude of variables captured in Breen's framework. I made the point that there seems to be an increased interest in this area of SLA in recent years. The question here is the extent to which this research can articulate with work being done in and around the IIO model. As indicated by the existence of pragmalinguistic and sociopragmatic strands, interlanguage pragmatics may be seen as standing at the crossroads of the cognitive and the social. This being the case, it would be particularly important at the input and output extremes of the IIO model where learners come into contact with new language (either in the form of potential input or as their own output). Gass (1997) does not actually rule out the importance of pragmatics at these stages. In reference to Blum-Kulka and Olshtain's (1986) account of a learner of English who was linguistically competent but who nonetheless manifested pragmatically inappropriate behaviour on the telephone, she states that 'it appears that subtleties of pragmatics had not been learned despite ... the fact that all other aspects of language appeared to have been' (Gass 1997: 95). Nevertheless, Gass devotes just three pages to pragmatics and in the remainder of the book sticks to the view that the priority in SLA is to view language in terms of syntax, morphology, phonology and lexis, and that questions of social factors, affect and previous life experience are peripheral to the process. As should be obvious by now, I do not agree with this position, and current interlanguage pragmatics research, such as that done by Liddicoat and Crozet, suggests that a future strand in SLA, with direct relevance to the IIO model, is research into the interface between the pragmalinguistic and the sociopragmatic and the chain of input-interaction-cognition-output.

In the past, IIO researchers might have been forgiven for not seeing any connections between their work and that of researchers who devote their time to the construction of language learners' personal histories. However, in the future, IIO researchers will have to start taking seriously research in which there is an attempt to reconstruct detailed life stories of learners hand-in-hand with an interest in linguistic development over time, as we observed above in the case of Teutsch-Dwyer (2001). It is my speculative prediction that there will be more such research in the future, particularly in naturalistic settings. It would be important, however, if some researchers examined the same social issues of interest to authors like Teutsch-Dwyer in the context of formal foreign language learning. Such research would involve exploring the extent to which macro social constructs such as gender, as well as the trilogy of political, cultural and economic capital, play themselves out at the micro level of the foreign language classroom, and the effect they have on language development, not only in terms of formal aspects but also in terms of issues such as identity and face.

Of course, as Gass reminds us at the outset of this chapter, predicting the future of IIO research with any accuracy is impossible. This being the case, I have limited

myself in this chapter to commenting on what Gass calls 'trajectories that we are on' with a view to speculating about how they might play out in the future. Consistent with the general tone of this book, I have done this by suggesting a more multi-disciplinary and socially informed future for the IIO. Time will tell if I will be deemed to have read current trajectories accurately and if my speculations might one day be considered fairly good predictions. Time will also tell if there really will be a social turn in SLA.

References

Abraham, Roberta and Roberta Vann (1987), 'Strategies of two language learners: a case study', in Anita Wenden and Joan Rubin (eds), *Learner Strategies in Language Learning*, Englewood Cliffs, NJ: Prentice Hall, pp. 85–102.

Allwright, Dick (1988), *Observation in the Language Classroom*, London: Longman.

Anderson, John (1983), *The Architecture of Cognition*, Cambridge, MA: Harvard University Press.

Anderson, John (1995), *Learning and Memory: an Integrated Approach*, New York: John Wiley.

Archibald, John (ed.) (2000), *Second Language Acquisition and Linguistic Theory*, Oxford: Blackwell.

Aston, Guy (1986), 'Trouble-shooting in interaction with learners: the more the merrier', *Applied Linguistics*, 7 (2): 128–43.

Aston, Guy (1988a), 'An applied linguistic approach to the analysis of naturally occurring conversation', in C. Cipolli and E. Rigotti (eds), *Ricerche di semantica testuale*, Brescia: La Scuola, pp. 259–82.

Aston, Guy (1988b), *Learning Comity: An Approach to the Description and Pedagogy of Interactional Speech*, Bologna: Cooperativa Libraria Universitaria Editrice.

Aston, Guy (1993), 'Notes on the interlanguage of comity', in Gabriele Kasper and Shoshana Blum-Kulka (eds), *Interlanguage Pragmatics*, Oxford: Oxford University Press, pp. 224–50.

Baars, Bernard (1986), *The Cognitive Revolution in Psychology*, New York: The Guildford Press.

Baddeley, Alan (1997), *Human Memory*, Mahwah, NJ: Lawrence Erlbaum.

Bailey, Benjamin (2000), 'Language and negotiation of ethnic/racial identity among Dominican Americans', *Language in Society*, 29 (4): 555–82.

Bailey, Kathleen (1983), 'Competitiveness and anxiety in adult second language learning: looking at and through the diary studies', in Herbert Seliger and Michael Long (eds), *Classroom-oriented Research in Second Language Acquisition*, Rowley, MA: Newbury House, pp. 67–103.

Bailey, Kathleen and David Nunan (eds) (1996), *Voices from the Language Classroom*, Cambridge: Cambridge University Press.

Bakhtin, Mikhail (1981), *The Dialogic Imagination: Four Essays*, Austin: University of Texas Press.

Bardovi-Harlig, Kathleen (1999), 'Exploring the interlanguage of interlanguage pragmatics. A research agenda for acquisitional pragmatics', *Language Learning*, 49 (4): 677–713.

Barron, Colin, Nigel Bruce and David Nunan (eds) (2002), *Knowledge and Discourse*, London: Longman.

Bauman, Zygmunt (1973), *Culture as Praxis*, London: Routledge and Kegan Paul.

Beebe, Leslie (ed.) (1988), *Issues in Second Language Acquisition: Multiple Perspectives*, New York: Newbury House.

Belcher, Diane and Ulla Connor (eds) (2001), *Reflections on Multiliterate Lives*, Clevedon: Multilingual Matters.

Beretta, Alan (1991), 'Theory construction in SLA: complementarity and opposition', *Studies in Second Language Acquisition*, 13 (4): 493–511.

Beretta, Alan and Graham Crookes (1993), 'Cognitive and social determinants of discovery in SLA', *Applied Linguistics*, 14 (3): 250–75.

Beretta, Alan, Graham Crookes, Kevin Gregg and Michael Long (1994), 'Comment on van Lier (1994)', *Applied Linguistics*, 15 (3): 347.

Berns, Margie (1990), '"Second" and "foreign" in second language acquisition/foreign language learning: a sociolinguistic perspective', in Bill Van Patten and James F. Lee (eds) (1990), *Second Language Acquisition Foreign – Language Learning*, Clevedon: Multilingual Matters, pp. 3–12.

Bernstein, Basil (1975), *Class, Codes and Control, Volume 3: Towards a Theory of Educational Transmissions*, London: Routledge Kegan Paul.

Bhabha, Homi (1994), *The Location of Culture*, London: Routledge.

Bialystok, Ellen (1998), 'Coming of age in applied linguistics', *Language Learning*, 48 (4): 497–518.

Birdsong, David (ed.) (1999), *Second Language Acquisition and the Critical Period Hypothesis*, Hillsdale, NJ: Lawrence Erlbaum.

Block, David (1996a), 'Not so fast! Some thoughts on theory culling, relativism, accepted findings and the heart and soul of SLA', *Applied Linguistics*, 17 (1): 65–83.

Block, D. (1996b), 'A window on the classroom: classroom events viewed from different angles', in Kathleen Bailey and David Nunan (eds), *Voices from the Language Classroom*, New York: Cambridge University Press, pp. 168–94.

Block, David (1997), 'Publishing patterns and McDonaldization', *IATEFL Newsletter*, 136: 12–15.

Block, David (1998), 'Tale of a language learner', *Language Teaching Research*, 2 (3): 148–76.

Block, David (2000), 'Learners and their meta-pedagogical awareness', *International Journal of Applied Linguistics*, 10 (1): 97–123.

Block, David (2002), 'Language and gender and SLA', in José Santaemilia, Beatriz Gallardo and Julia Sanmartín (eds), *Sexe i Llenguatge*, València: Universitat de València, pp. 49–73.

Bloomfield, Leonard (1933), *Language*, New York: Holt, Rinehart, and Winston.

Blum-Kulka, Shoshana and Olite Olshtain (1986), 'Too many words: length of utterances and pragmatic failure', *Journal of Pragmatics*, 8 (1): 47–61.

Bourdieu, Pierre (1977), *Outline of a Theory of Practice*, Cambridge: Cambridge University Press.

Bouton, Lawrence (ed.) (1996), *Pragmatics and Language Learning*, monograph series vol. 7, Urbana-Champaign: Division of English as an International Language, University of Illinois, Urbana-Champaign.

Bouton, Lawrence (ed.) (1999), *Pragmatics and Language Learning*, monograph series vol. 9, Urbana-Champaign: Division of English as an International Language, University of Illinois, Urbana-Champaign.

Breen, Michael (1987), 'Learner contributions to task design', in Christopher Candlin and Dermot Murphy (eds), *Language Learning Tasks*, Lancaster Working Papers in English Language Education, vol. 7, London: Prentice Hall, pp. 23–46.

Breen, Michael (ed.) (2001a), 'Postscript: new directions for research on learner contributions', in Michael Breen (ed.), *Learner Contributions to Language Learning*, London: Longman, pp. 172–82.

Breen, Michael (ed.) (2001b), *Learner Contributions to Language Learning*, London: Longman.

Bremer, Katharine, Peter Broeder, Celia Roberts, Margaret Simonet and Marie-Thérèse Vasseur (1996), *Achieving Understanding: Discourse in Intercultural Encounters*, London: Longman.

Brown, Cheryl (1985), 'Requests for specific language input: differences between older and younger adult language learners', in Susan Gass and Carolyn Madden (eds), *Input in Second*

Language Acquisition, Rowley, MA: Newbury House.

Brown, H. Douglas (ed.) (1976), *Language Learning, Special Issue No. 4. Papers in Second Language Acquisition*.

Brown, Penelope and Stephen Levinson (1987), *Politeness: Some Universals in Language Use*, Cambridge: Cambridge University Press.

Brown, Roger (1973), *A First Language: The Early Stages*, Cambridge, MA: Harvard University Press.

Brumfit, Christopher (1991), 'Applied linguistics in higher education: riding the storm', *BAAL Newsletter*, 38: 45–9.

Brumfit, Christopher (1997), 'How applied linguistics is the same as any other science', *International Journal of Applied Linguistics*, 7 (1): 86–94.

Bygate, Martin (1999), 'Quality of language and purpose of task: patterns of learners' language on two oral communication tasks', *Language Teaching Research*, 3 (3): 185–214.

Bygate, Martin, Peter Skehan and Merrill Swain (2001a), 'Introduction', in Martin Bygate, Peter Skehan and Merrill Swain (eds), *Researching Pedagogical Tasks: Second Language Learning, Teaching and Testing*, London: Longman, pp. 1–20.

Bygate, Martin, Peter Skehan and Merrill Swain (eds) (2001b), *Researching Pedagogical Tasks: Second Language Learning, Teaching and Testing*, London: Longman.

Byram, Michael and Manuel Tost (eds) (2001), *Social Identity and the European Dimension: Intercultural Competence through Foreign Language Learning*, Strasbourg: Council of Europe.

Cameron, Deborah (1997), 'Theoretical debates in feminist linguistics: questions of sex and gender', in Ruth Wodak (ed.), *Gender and Discourse*, London: Sage, pp. 21–36.

Cameron, Deborah (2001), *Working with Spoken Discourse*, London: Longman.

Campbell, Stuart (1998), *Translation in Second Language Acquisition*, London: Longman.

Canagarajah, Suresh N. (1999), *Resisting Linguistic Imperialism in English Teaching*, Oxford: Oxford University Press.

Candlin, Christopher (1987), 'Towards task based language learning'; and Breen, Michael (1987), 'Learner contributions to task design', in Christopher Candlin and Dermot Murphy (eds), *Language Learning Tasks*, Lancaster Working Papers in English Language Education, vol. 7, London: Prentice Hall, pp. 5–22.

Candlin, Christopher (2001), 'Afterword: taking the curriculum to task', in Martin Bygate, Peter Skehan and Merrill Swain (eds), *Researching Pedagogical Tasks: Second Language Learning, Teaching and Testing*, London: Longman, pp. 229–43.

Catford, John (1998), '*Language Learning* and applied linguistics: a historical sketch', *Language Learning*, 48 (4): 465–96.

Cazden, Courtney, Herlinda Cancino, Ellen Rosansky and John Schumann (1975), *Second Language Acquisition in Children, Adolescents, and Adults, Final Report*, Washington, DC: National Institute of Education.

Cenoz, Jasone (2000), 'Research on multilingual acquisition', in Jasone Cenoz and Ulrike Jessner (eds), *English in Europe: The Acquisition of a Third Language*, Clevedon: Multilingual Matters, pp. 39–53.

Cenoz, Jasone and Ulrike Jessner (eds) (2000), *English in Europe: The Acquisition of a Third Language*, Clevedon: Multilingual Matters.

Chomsky, Noam (1957), *Syntactic Structures*, The Hague: Mouton.

Chomsky, Noam (1959), 'Review of Verbal Behavior by B. F. Skinner', *Language*, 35 (1): 26–58.

Chomsky, Noam (1966), *Cartesian Linguistics*, New York: Harper and Row.

Cohen, Andrew (2001), 'From L1 to L12: the confessions of a sometimes frustrated multi-literate', Diane Belcher and Ulla Connor (eds), *Reflections on Multiliterate Lives*, Clevedon: Multilingual Matters, pp. 79–95.

Cole, Michael (1996), *Cultural Psychology: A Once and Future Discipline*, Cambridge, MA: Berknap Press.

Cole, Michael (1998), 'Cognitive development and formal schooling. The evidence from cross-cultural research', in Dorothy Faulkner, Karen Littlejohn and Martin Woodhead (eds), *Learning Relationships in the Classroom*, London: Routledge, pp. 31–53.

Cook, Guy (2000), *Language Play*, Oxford: Oxford University Press.

Cook, Vivian (1992), 'Evidence for multi-competence', *Language Learning*, 42 (4): 557–91.

Cook, Vivian (1993), *Linguistics and Second Language Acquisition*, Essex: Macmillan.

Cook, Vivian (1996), 'Competence and multi-competence' in Gillian Brown, Kirsten Malmkjaer and John Williams (eds), *Performance and Competence in Second Language Acquisition*, Cambridge: Cambridge University Press, pp. 57–69.

Cook, Vivian (2002), *Portraits of the L2 User*, Clevedon: Multilingual Matters.

Cook, Vivian and Mark Newson (1996), *Chomsky's Universal Grammar: An Introduction*, Oxford: Basil Blackwell.

Corder, S. Pit (1967), 'The significance of learners' errors', *International Review of Applied Linguistics*, 5: 161–9.

Corder, S. Pit (1981), *Error Analysis and Interlanguage*, Oxford: Oxford University Press.

Coupland, Justine (ed.) (2000a), *Small Talk*, London: Longman.

Coupland, Justine (2000b), 'Introduction: sociolinguistic perspectives on small talk', in Justine Coupland (ed.), *Small Talk*, London: Longman, pp. 1–25.

Coupland, Nikolas (2001a), 'Introduction: sociolinguistic theory and social theory', in Nikolas Coupland, Srikant Sarangi and Christopher Candlin (eds), *Sociolinguistics and Social Theory*, London: Longman, pp. 1–26.

Coupland, Nikolas (2001b), 'Age in social and sociolinguistic theory', in Nikolas Coupland, Srikant Sarangi and Christopher Candlin (eds), *Sociolinguistics and Social Theory*, London: Longman, pp. 185–211.

Coupland, Nikolas, Srikant Sarangi and Christopher Candlin (eds) (2001), *Sociolinguistics and Social Theory*, London: Longman.

Crookes, Graham (1992), 'Theory format and SLA theory', *Studies in Second Language Acquisition*, 14 (4): 425–49.

Crystal, David (1998), *Language Play*, Harmondsworth: Penguin.

Cummin, Alistair (ed.) (1998), *50th Jubilee Special Issue of Language Learning*.

Danziger, Kurt (1990), *Constructing the Subject: Historical Origins of Psychological Research*, Cambridge: Cambridge University Press.

Davies, Alan (1999), *An Introduction to Applied Linguistics*, Edinburgh: Edinburgh University Press.

Davies, Alan, Clive Criper and Anthony Howatt (eds) (1984), *Interlanguage*, Edinburgh: Edinburgh University Press.

Davies, Jane (2000), *Social perspectives on negotiation for meaning*, unpublished MA dissertation, Institute of Education, University of London.

Dechert, Hans (ed.) (1990), *Current trends in European Second Language Acquisition Research*, Clevedon: Multilingual Matters.

De Keyser, Robert (2000), 'The robustness of critical effects in second language acquisition', *Studies in Second Language Acquisition*, 22 (4): 499–533.

de Villiers, Jill and Peter de Villiers (1973), 'A cross-sectional study of the development of grammatical morphemes in child speech', *Journal of Psycholinguistic Research*, 1: 299–310.

Donato, Richard (2000), 'Sociocultural contributions to understanding the foreign and second language classroom', in James Lantolf (ed.), *Sociocultural Theory and Second Language Learning*, Oxford: Oxford University Press, pp. 27–50.

Donato, Richard and Dawn McCormick (1994), 'A sociocultural perspective on language learning strategies: the role of mediation', *Modern Language Journal*, 78 (4): 453–64.

Dornyei, Zoltan (2001), *Teaching and Researching Motivation*, London: Longman.

Doughty, Catherine and Michael Long (eds) (forthcoming), *Handbook of Second Language Acquisition*, Oxford: Blackwell.

Dulay, Heidi and Marina Burt (1973), 'Should we teach children syntax?', *Language Learning*,

23 (2): 245–58.

Dulay, Heidi and Marina Burt (1974), 'Natural sequences in child second language acquisition', *Language Learning*, 24 (1): 37–53.

Dulay, Heidi and Marina Burt (1975), 'Creative construction in second language learning and teaching' in Marina Burt and Heidi Dulay (eds), *New Directions in Second Language Learning, Teaching, and Bilingual Education*, Washington, DC: TESOL, pp. 21–32.

Dulay, Heidi, Marina Burt and Stephen Krashen (1982), *Language Two*, New York: Oxford University Press.

Dunn, William and James Lantolf (1998), 'Vygotsky's zone of proximal development and Krashen's i + 1: incommensurable constructs; incommensurable theories', *Language Learning*, 48 (3): 411–42.

Durkin, Kevin (1987), 'Minds and language: social cognition, social interaction and the acquisition of language', *Mind and Language*, 2 (2): 105–40.

Duskova, L. (1969), 'On sources of errors in foreign language learning', *International Review of Applied Linguistics*, 7 (1): 11–36.

Eagleton, Terry (2000), *The Idea of Culture*, Oxford: Blackwell.

Eckert, Penny (1989), 'The whole woman: sex, and gender differences in variation', *Language Variation and Change*, 1 (1): 245–67.

Eckert, Penny (2000), *Linguistic Variation as Social Practice*, Oxford: Blackwell.

Edwards, Derek (1997), *Discourse and Cognition*, London: Sage.

Edwards, John (1994), *Multilingualism*, London: Routledge.

Eggins, Suzanne and Diana Slade (1997), *Analysing Casual Conversation*, London: Cassell.

Ehrlich, Susan (1997), 'Gender as social practice: implications for second language acquisition', *Studies in Second Language Acquisition*, 19 (4): 421–46.

Ellis, Nick and Richard Schmidt (1997), 'Morphology and longer distance dependencies: laboratory research illuminating the A in SLA', *Studies in Second Language Acquisition*, 19, pp. 145–71.

Ellis, Nick and Richard Schmidt (1998), 'Rules or associations in the acquisition of morphology? The frequency by regularity interaction in human and PDP learning of morphosyntax', *Language and Cognitive Processes*, 13, pp. 307–36.

Ellis, Rod (1985), *Understanding Second Language Acquisition*, Oxford: Oxford University Press.

Ellis, Rod (1994a), *The Study of Second Language Acquisition*, Oxford: Oxford University Press.

Ellis, Rod (1994b), 'A theory of instructed second language acquisition', in Nick Ellis (ed.), *Implicit and Explicit Learning of Languages*, London: Academic Press.

Ellis, Rod (1996), *Second Language Acquisition*, Oxford: Oxford University Press.

Ellis, Rod (1997), *SLA Research and Language Teaching*, Oxford: Oxford University Press.

Ellis, Rod (2000), 'Task-based research and language pedagogy', *Language Teaching Research*, 4 (3): 193–220.

Ellis, Rod (2001), 'The metaphorical construction of second language learners', in Michael Breen (ed.), *Learner Contributions to Language Learning*, London: Longman, pp. 65–85.

Ellis, Rod, Helen Basturkmen and Shawn Loewen (2001), 'Preemptive focus on form in the ESL classroom', *TESOL Quarterly*, 35 (3): 407–32.

Engestrom, Yrjo, Reijo Miettinen and Rija-Leena Punamaki (eds) (1999), *Perspectives on Activity Theory*, Cambridge: Cambridge University Press.

Firth, Alan and Johannes Wagner (1997), 'On discourse, communication, and (some) fundamental concepts in SLA research', *Modern Language Journal*, 81 (3): 286–300.

Firth, Alan and Johannes Wagner (1998), 'SLA property: no trespassing!', *Modern Language Journal*, 82 (1): 91–4.

Fisiak, Jacek (ed.) (1981), *Contrastive Linguistics and the Language Teacher*, Oxford: Pergamon.

Foster, Pauline (1998), 'A classroom perspective on the negotiation of meaning', *Applied Linguistics*, 19 (1): 1–23.

Foster, Pauline and Peter Skehan (1999), 'The influence of source of planning and focus of planning on task-based performance', *Language Teaching Research*, 3 (3): 215–47.

Foucault, Michel (1981), *The History of Sexuality. Volume One. An Introduction*, Harmondsworth: Pelican.

Foucault, Michel (1986), *The History of Sexuality. Volume Two. The Use of Pleasure*, Harmondsworth: Viking.

Foucault, Michel (1988), *The History of Sexuality. Volume Three. The Care of the Self*, Harmondsworth: Viking.

Fries, Charles (1945), *Teaching and Learning English as a Foreign Language*, Ann Arbor, MI: University of Michigan Press.

Gardner, Robert (1985), *Social Psychology and Second Language Learning: The Role of Attitude and Motivation*, London: Edward Arnold.

Garfinkel, Harold (1967), *Studies in Ethnomethodology*, Englewood Cliffs, NJ: Prentice Hall.

Gass, Susan (1987), 'The resolution of conflicts among competing systems: a bidirectional perspective', *Applied Psycholinguistics*, 8: 329–50.

Gass, Susan (1988), 'Integrating research areas: a framework for second language studies', *Applied Linguistics*, 9 (2): 198–217.

Gass, Susan (1990), 'Second and foreign language learning: same, different or none of the above', in Bill Van Patten and James F. Lee (eds) (1990), *Second Language Acquisition – Foreign Language Learning*, Clevedon: Multilingual Matters.

Gass, Susan (1993), 'Second language acquisition: past, present, and future', *Second Language Research*, 9/2: 99–117.

Gass, Susan (1997), *Input, Interaction, and the Second Language Learner*, Mahwah, NJ: Lawrence Erlbaum.

Gass, Susan (1998), 'Apples and oranges: or why apples are not oranges and don't need to be. A response to Firth and Wagner', *Modern Language Journal*, 82 (1): 83–90.

Gass, Susan (2000), 'Changing views of language learning', in Hugh Trappes-Lomax (ed.), *Change and Continuity in Applied Linguistics*, Proceedings of the annual meeting of the British Association of Applied Linguistics, 1999, Clevedon: Multilingual Matters, pp. 51–67.

Gass, Susan, Catherine Fleck, Nevin Leder and Ildiko Svetics (1998), 'Ahistoricity revisited: does SLA have a history?', *Studies in Second Language Acquisition*, 20 (3): 407–21.

Gass, Susan, Alison Mackey and Teresa Pica (1998), 'The role of input and interaction in second language acquisition. *Introduction to the special issue*', *Modern Language Journal*, 82 (3): 299–305.

Gass, Susan and Larry Selinker (1994), *Second Language Acquisition: An Introductory Course*, Hillsdale, NJ: Lawrence Erlbaum.

Gass, Susan and Larry Selinker (2001), *Second Language Acquisition: An Introductory Course*, 2nd edn, Mahwah, NJ: Lawrence Erlbaum.

Gass, Susan and Evangeline Varonis (1986), 'Sex differences in NNS/NNS interactions', Richard Day (ed.), *Talking to Learn: Conversation in Second Language Acquisition*, Rowley, MA: Newbury House, pp. 327–51.

Gee, James Paul (1996), *Social Linguistics and Literacies: Ideology in Discourses*, 2nd edn, London: Falmer.

Geertz, Clifford (1973), *The Interpretation of Cultures*, New York: Basic Books.

Gibson, James (1979), *The Ecological Approach to Visual Perception*, Boston, MA: Houghton Mifflin.

Giddens, Anthony (1991), *Modernity and Self-Identity: Self and Society in the Late Modern Age*, Cambridge: Polity.

Giles, Howard and Nikolas Coupland (1991), *Language: Contexts and Consequences*, Pacific Grove, CA: Brook/Cole.

Goldstein, Tara (1996), *Two Languages at Work: Bilingual Life on the Production Floor*, New York: Mouton de Gruyter.

Goldstein, Tara (2001), 'Researching women's language practices in multilingual workplaces', in Aneta Pavlenko, Adrian Blackledge, Ingrid Piller and Mayra Teutsch-Dwyer (eds), *Multilingualism, Second Language Acquisition, and Gender*, New York: Mouton de Gruyter, pp. 77–101.

Gregg, Kevin (1984), 'Krashen's Monitor and Occam's Razor', *Applied Linguistics*, 5 (1): 79–100.

Gregg, Kevin (1986), 'Review of *The Input Hypothesis and its Implications*', *TESOL Quarterly*, 20 (1): 116–22.

Gregg, Kevin (1993), 'Taking explanation seriously; or, let a couple of flowers bloom', *Applied Linguistics*, 14 (3): 276–94.

Gregg, Kevin (2000), 'A theory for every occasion: postmodernism and SLA', *Second Language Research*, 16 (4): 383–99.

Gregg, Kevin, Michael Long, Geoff Jordan and Alan Beretta (1997), 'Rationality and its discontents in SLA', *Applied Linguistics*, 18 (4): 537–58.

Grice, Paul (1975), 'Logic and conversation', in Peter Cole and Jerry Morgan (eds), *Syntax and Semantics, Vol. 3: Speech Acts*, New York: Academic Press, pp. 41–58.

Guiora, Alexander (ed.) (1983), *Language Learning, Special Issue No. 5, An Epistemology for the Language Sciences*.

Hakuta, Kenji and Herlinda Cancino (1977), 'Trends in second-language acquisition research', *Harvard Educational Review*, 47 (3): 294–316.

Hall, Joan Kelly (1997), 'A consideration of SLA as a theory of practice: a response to Firth and Wagner', *Modern Language Journal*, 81 (3): 301–6.

Hall, Joan Kelly and Lorrie Stoops Verplaets (eds) (2000), *Second and Foreign Language Learning Through Classroom Interaction*, Mahwah, NJ: Lawrence Erlbaum.

Halliday, Michael (1978), *Language as a Social Semiotic*, London: Edward Arnold.

Harré, Rom and Grant Gillet (1994), *The Discursive Mind*, London: Sage.

Harris, Roxy (1997), 'Romantic bilingualism: time for a change?', in Constant Leung and Carrie Cable (eds), *English as an Additional Language: Changing Perspectives*, Watford: NALDIC, pp. 14–27.

Harris, Roxy (1999), 'Rethinking the bilingual learner', in Arturo Tosi and Constant Leung (eds), *Rethinking Language Education*, London: CILT, pp. 67–81.

Harris, Roxy, Constant Leung and Ben Rampton (2002), 'Globalization, Diaspora and Language Education in England', in David Block and Deborah Cameron (eds), *Globalization and Language Teaching*, London: Routledge.

Hatch, Evelyn (1978), 'Apply with caution', *Studies in Second Language Acquisition*, 2 (2): 123–43.

Hatch, Evelyn and Judy Wagner-Gough (1976), 'Explaining sequence and variation in second language acquisition', *Language Learning, Special Issue 4*: 39–57.

Haugen, Einar (1953), *The Norwegian Language in America: A Study in Bilingual Behavior*, Philadelphia: University of Pennsylvania Press.

Heller, Monica (1999), *Linguistic Minorities and Modernity: A Sociolinguistic Ethnography*, London: Longman.

Hinkel, Eli (ed.) (1999), *Culture in Second Language Teaching and Learning*, Cambridge: Cambridge University Press.

Holmes, Janet (2000), 'Doing collegiality and keeping control at work: small talk in government departments', in Justine Coupland (ed.), *Small Talk*, London: Longman, pp. 32–61.

Holquist, Michael (1994), 'The reterritorialization of the enthymeme', paper presented at the International Conference on 'Vygotsky and the Human Sciences', Moscow, September 1994.

Howatt, Anthony (1984), *A History of English Language Teaching*, Oxford: Oxford University Press.

Hymes, Del (1971), *On Communicative Competence*, Philadelphia: University of Pennsylvania Press.

Hymes, Dell (1974), *Foundations in Sociolinguistics: An Ethnographic Approach*, Philadelphia: University of Pennsylvania Press.

Johnson, Keith (1996), *Language Teaching & Skill Learning*, Oxford: Basil Blackwell.

Kachru, Yamuna (1994), 'Monolingual bias in SLA research', *TESOL Quarterly*, 28 (4): 795–800.

Kasper, Gabriele (1997), '"A" stands for acquisition: a response to Firth and Wagner', *Modern Language Journal*, 81 (3): 307–12.

Kasper, Gabriele (2001), 'Four perspectives on L2 pragmatic development', *Applied Linguistics*, 22 (4): 502–30.

Kasper, Gabriele and Shoshana Blum-Kulka (eds) (1993), *Interlanguage Pragmatics*, Oxford: Oxford University Press.

Kasper, Gabriele and Kenneth Rose (2001a), 'Pragmatics in language teaching', in Kenneth Rose and Gabriele Kasper (eds), *Pragmatics in Language Teaching*, Cambridge: Cambridge University Press, pp. 1–9.

Kasper, Gabriele and Kenneth Rose (2001b), *Research Methods in Pragmatics*, Mahwah, NJ: Lawrence Erlbaum.

Kasper, Gabriele and Dick Schmidt (1996), 'Developmental issues in interlanguage pragmatics', *Studies in Second Language Acquisition*, 18 (2): 149–69.

Kelly, Louis G. (1969), *Centuries of Language Teaching*, Rowley, MA: Newbury House.

Kirshner, David and James Whitson (eds) (1997), *Situated Cognition: Social, Semiotic, and Psychological Perspectives*, Mahwah, NJ: Lawrence Erlbaum.

Klein, Wilfred (1986), *Second Language Acquisition*, Cambridge: Cambridge University Press.

Klima, Edward and Ursulla Bellugi (1966), 'Syntactic regularities in the speech of children', in John Lyons and Roger Wales (eds), *Psycholinguistic Papers*, Edinburgh: Edinburgh University Press, pp. 183–219.

Kramsch, Claire (1993), *Context and Culture in Language Teaching*, Oxford: Oxford University Press.

Kramsch, Claire (1998), *Language and Culture*, Oxford: Oxford University Press.

Krashen, Stephen (1976), 'Formal and informal linguistic environments in language acquisition and language learning', *TESOL Quarterly*, 10 (2): 157–68.

Krashen, Stephen (1977), 'Some issues relating to the Monitor Model', in H. Douglas Brown, Carlos Yorio and Ruth Crymes (eds), *On TESOL, '77*, Washington, DC: TESOL, pp. 144–58.

Krashen, Stephen (1978), 'The monitor model of adult second language performance', in Marina Burt, Heidi Dulay and Mary Finocchiaro (eds), *Viewpoints on English as a Second Language*, New York: Regents, pp. 152–61.

Krashen, Stephen (1981), *Second Language Acquisition and Second Language Learning*, Oxford: Pergamon.

Krashen, Stephen (1985), *The Input Hypothesis: Issues and Implications*, Harlow: Longman.

Krashen, Stephen (1994), 'The Input Hypothesis and its rivals', in Nick Ellis (ed.), *Implicit and Explicit Learning of Languages*, London: Academic Press, pp. 45–77.

Krashen, Stephen (1998), 'Comprehensible output?', *System*, 26 (2): 175–82.

Labov, William (1970), 'The study of language in its social context', *Studium Generale*, 23: 30–87.

Labov, William (1972), *Sociolinguistic Patterns*, Philadelphia: University of Pennsylvania Press.

Labov, William (1994), *Principles of Linguistic Change, Volume 1: Internal Factors*, Oxford: Blackwell.

Lachman, Roy, Janet Lachman and Earl Butterfield (1979), *Cognitive Psychology and Information Processing*, Hillsdale, NJ: Lawrence Erlbaum.

Lado, Robert (1957), *Linguistics Across Cultures*, Ann Arbor, MI: University of Michigan.

Lantolf, James (1996), 'SLA theory building: letting all the flowers bloom!', *Language Learning*, 46 (4): 713–49.

Lantolf, James (2000a), 'Introducing sociocultural theory', in James Lantolf (ed.), *Sociocultural Theory and Second Language Learning*, Oxford: Oxford University Press, pp. 1–26.

Lantolf, James (2000b), 'Second language learning as mediated process', *Language Teaching*, 33 (2): 79–96.

Lantolf, James (ed.) (2000c), *Sociocultural Theory and Second Language Learning*, Oxford: Oxford University Press.

Lantolf, James and Gabriele Appel (1994a), 'Theoretical framework: an introduction to Vygotskian Perspectives on second language research', in James Lantolf and Gabriele Appel (eds), *Vygotskian Approaches to Second Language Research*, Norwood, NJ: Ablex, pp. 1–32.

Lantolf, James and Gabriele Appel (eds) (1994b), *Vygotskian Approaches to Second Language Research*, Norwood, NJ: Ablex.

Lantolf, James and Aneta Pavlenko (2001), '(S)econd (L)anguage (A)ctivity theory: understanding second language learners as people', in Michael Breen (ed.), *Learner Contributions to Language Learning*, London: Longman, pp. 172–82.

Larsen-Freeman, Diane (1991), 'Second language acquisition research: staking out the territory', *TESOL Quarterly*, 25 (2): 315–50.

Larsen-Freeman, Diane (1997), 'Chaos/Complexity science and second language acquisition', *Applied Linguistics*, 18 (2): 141–65.

Larsen-Freeman, Diane and Michael Long (1991), *An Introduction to Second Language Acquisition Research*, London: Longman.

Lave, Jean (1988), *Cognition in Practice*, Cambridge: Cambridge University Press.

Lave, Jean and Etienne Wenger (1991), *Situated Learning: Legitimate Peripheral Participation*, Cambridge: Cambridge University Press.

Leech, Geoffrey (1983), *The Principles of Pragmatics*, London: Longman.

Legutke, Michael and Howard Thomas (1991), *Process and Experience in the Language Classroom*, London: Longman.

Lemke, Jay (1995), *Textual Politics: Discourse and Social Dynamics*, London: Taylor and Francis.

Lenneberg, Eric (1967), *Biological Foundations of Language*, New York: Wiley and Sons.

Leontiev, A. N. (1978), *Activity, Consciousness and Personality*, Englewood Cliffs, NJ: Prentice Hall.

Leung, Constant (2001), 'English as an additional language: distinctive language focus or diffused curriculum concerns?', *Language and Education*, 15 (1): 33–55.

Leung, Constant, Roxy Harris and Ben Rampton (1997), 'The idealised native speaker, reified ethnicities and classroom realities', *TESOL Quarterly*, 31 (3): 543–60.

Liddicoat, Anthony (1997), 'Interaction, social structure, and second language use: a response to Firth and Wagner', *Modern Language Journal*, 81 (3): 313–17.

Liddicoat, Anthony and Chantal Crozet (2001), 'Acquiring French interactional norms through instruction', in Kenneth Rose and Gabriele Kasper (eds), *Pragmatics in Language Teaching*, Cambridge: Cambridge University Press, pp. 125–44.

Lightbown, Patsy (1984), 'The relationship between theory and method in second-language acquisition research', in Alan Davies, Clive Criper and Anthony Howatt (eds), *Interlanguage*, Edinburgh: Edinburgh University Press, pp. 241–52.

Lightbown, Patsy (1985), 'Great expectations: second-language acquisition research and classroom teaching', *Applied Linguistics*, 6 (2): 173–89.

Lightbown, Patsy (2000), 'Classroom SLA research and classroom teaching', *Applied Linguistics*, 21 (4): 431–62.

Lightbown, Patsy and Nina Spada (1993), *How Languages Are Learned*, Oxford: Oxford University Press.

Lightbown, Patsy and Nina Spada (1999), *How Languages Are Learned*, 2nd edn, Oxford: Oxford University Press.

Long, Michael (1981), 'Input, interaction and second-language acquisition', in Harris Winitz (ed.), *Native Language and Foreign Language Acquisition. Annals of the New York Academy of*

Sciences, 379: 259–78.

Long, Michael (1985), 'Input and second-language acquisition theory', in Susan Gass and Carolyn Madden (eds), *Input in Second Language Acquisition*, Rowley, MA: Newbury House, pp. 377–93.

Long, Michael (1990), 'The least a second language acquisition theory needs to explain', *TESOL Quarterly*, 24 (4): 649–66.

Long, Michael (1993), 'Assessment strategies for SLA theories', *Applied Linguistics*, 14 (3): 225–49.

Long, Michael (1996), 'The role of linguistic environment in second language acquisition', in William Ritchie and Tej Bhatia (eds), *Handbook of Second Language Acquisition*, London: Academic Press.

Long, Michael (1997), 'Construct validity in SLA research: a response to Firth and Wagner', *Modern Language Journal*, 81 (3): 318–23.

Long, Michael (1998), 'SLA: breaking the siege', *University of Hawai'i Working Papers in ESL*, 17 (1): 79–129.

Long, Michael (forthcoming), *Task-based Language Teaching*, Oxford: Blackwell.

Long, Michael, Shunji Inagaki and Lourdes Ortega (1998), 'The role of implicit negative feedback in SLA: models and recasts in Japanese and Spanish', *Modern Language Journal*, 83 (3): 357–71.

Lotman, Yuri (1990), *Universe of the Mind: A Semiotic Theory of Culture*, Bloomington, IN: Indiana University Press.

Lyons, John (1996), 'On competence and performance and related notions', in Gillian Brown, Kirsten Malmkjaer and John Williams (eds), *Performance and Competence in Second Language Acquisition*, Cambridge: Cambridge University Press, pp. 11–32.

McCarthy, Michael (2000), 'Mutually captive audiences: small talk and the genre of close-contact service encounters', in Justine Coupland (ed.), *Small Talk*, London: Longman, pp. 84–109.

McKay, Sandra and Sau-Ling Wong (1996), 'Multiple discourses, multiple identities: investment and agency in second-language learning among Chinese adolescent immigrant students', *Harvard Educational Review*, 66 (3): 577–608.

McLaughlin, Barry (1978), 'The monitor model: some methodological considerations', *Language Learning*, 28 (3): 309–32.

McLaughlin, Barry (1987), *Theories of Second Language Learning*, London: Edward Arnold.

McLaughlin, Barry (1990), 'Restructuring', *Applied Linguistics*, 11 (1): 113–28.

McLaughlin, Barry, Tammi Rossman and Beverly McLeod (1983), 'Second language learning: an information processing perspective', *Language Learning*, 33 (2): 135–58.

McLaughlin, Barry and Roberto Heredia (1996), 'Information processing approaches to research on second language acquisition and use', in William Ritchie and Tej Bhatia (eds), *Handbook of Language Acquisition*, New York: Academic Press, pp. 213–28.

Mackey, Alison (1999), 'Input, interaction, and second language development: an empirical study of question formation in ESL', *Studies in Second Language Acquisition*, 21 (4): 557–87.

Mackey, Alison and Jenefer Philip (1998), 'Conversational interaction and second language development: recasts, responses and red herrings?', *Modern Language Journal*, 82 (3): 338–56.

Mackey, Alison, Susan Gass and Kim McDonough (2000), 'How do learners perceive interactional feedback?', *Studies in Second Language Acquisition*, 22 (4): 471–97.

Malinowski, B. (1923) 'The problem of meaning in primitive languages', in C. K. Ogden and I. A. Richards (eds), *The Meaning of Meaning*, London: Kegan Paul, Trench, Trübner and Co., pp. 296–336.

Mandler, George (1985), *Cognitive Psychology. An Essay in Cognitive Science*, Hillsdale, NJ: Lawrence Erlbaum.

Martinet, A. (1953), 'Preface to Uriel Weinreich *Languages in Contact*', The Hague: Mouton.

Mathews, Gordon (2000), *Global Culture/Individual Identity: Searching for a Home in the Cultural Supermarket*, London: Routledge.

Mercer, Neil (1995), *The Guided Construction of Knowledge*, Clevedon: Multilingual Matters.

Mercer, Neil (2000), *Words and Minds: How We Use Language to Think Together*, London: Routledge.

Meyers-Scotton, Carol (1997), 'Codeswitching', in Florian Coulmas (ed.), *The Handbook of Sociolinguistics*, Oxford: Blackwell, pp. 217–37.

Miller, George (1956), 'The magic number seven, plus or minus two: some limits on our capacity for processing information', *Psychological Review*, 63: 81–97.

Mitchell, Rosalind and Florence Myles (1998), *Second Language Learning Theories*, London: Edward Arnold.

Musumeci, Diane (1997), *An Exploration of the Historical Relationship between Theory and Practice in Second Language Teaching*, New York: McGraw-Hill.

Neisser, Ulrich (1967), *Cognitive Psychology*, New York: Appleton-Century-Crofts.

Neisser, Ulrich (1976), *Cognition and Reality: Principles and Implications of Cognitive Psychology*, San Francisco, CA: Freeman.

Neisser, Ulrich (ed.) (1987), *Concepts and Conceptual Development*, New York: Cambridge University Press.

Neisser, Ulrich (1997), 'The future of cognitive science: an ecological analysis', in David Johnson and Christina Erneling (eds), *The Future of the Cognitive Revolution*, Oxford: Oxford University Press, pp. 247–60.

Nemser, William (1971) 'Approximative systems of foreign language learners', *International Review of Applied Linguistics*, 9: 115–23.

Newmeyer, Frederick and Steven Weinberger (1988), 'The ontogenesis of the field of second language learning research', in Suzanne Flynn and Wayne O'Neil (eds), *Linguistic Theory in Second Language Acquisition*, Dordrecht: Kluwer, pp. 34–45.

Ngũgĩ wa Thiong'o (1986), *Decolonising the Mind: The Politics of Language in African Literature*, London: James Currey.

Norton (Pierce), Bonny (1995), 'Social identity, investment, and language learning', *TESOL Quarterly*, 29 (1): 9–31.

Norton, Bonny (1997), 'Language, identity, and the ownership of English', *TESOL Quarterly*, 31 (3): 409–29.

Norton, Bonny (2000), *Identity in Language Learning: Gender, Ethnicity and Educational Change*, London: Longman.

Norton, Bonny (2001), 'Non-participation, imagined communities and the language class-room', in Michael Breen (ed.), *Learner Contributions to Language Learning*, London: Longman, pp. 159–71.

Nunan, David (1989a), *Designing Tasks for the Communicative Classroom*, Cambridge: Cambridge University Press.

Nunan, David (1989b), 'Hidden agendas: the role of the learner in programme imple-mentation', in Robert Keith Johnson (ed.), *The Second Language Curriculum*, Cambridge: Cambridge University Press, pp. 176–86.

Nunan, David and Clarice Lamb (1996), *The Self-directed Teacher*, Cambridge: Cambridge University Press.

Ohta, Amy (2001), *Second Language Acquisition Processes in the Classroom: Learning Japanese*, Mahwah, NJ: Lawrence Erlbaum.

Oliver, Rhonda (1998), 'Negotiation of meaning in child interactions', *Modern Language Journal*, 82 (3): 372–86.

Ortega, L. (1999), 'Planning and focus on form in L2 oral performance', *Studies in Second Language Acquisition*, 21 (1): 109–45.

Oxford, Rebecca (2001), '"The bleached bones of the story": learners' constructions of language teachers', in Michael Breen (ed.), *Learner Contributions to Language Learning*, London: Longman, pp. 86–111.

Pavlenko, Aneta (2001a), 'Language learning memoirs as gendered genre', *Applied Linguistics*, 22 (2): 213–40.

Pavlenko, Aneta (2001b), '"How am I to become a woman in an American vein?" Transformations of gender performance in second language learning', in Aneta Pavlenko, Adrian Blackledge, Ingrid Piller and Marya Teutsch-Dwyer (eds), *Multilingualism, Second Language Learning, and Gender*, New York: Mouton De Gruyter, pp. 133–74.

Pavlenko, Aneta and James Lantolf (2000), 'Second language learning as participation and the (re)construction of selves', in James Lantolf (ed.), *Sociocultural Theory and Second Language Learning*, Oxford: Oxford University Press, pp. 155–77.

Pavlenko, Aneta and Ingrid Piller (2001), 'New directions in the study of multilingualism, second language learning, and gender', in Aneta Pavlenko, Adrian Blackledge, Ingrid Piller and Marya Teutsch-Dwyer (eds), *Multilingualism, Second Language Learning, and Gender*, New York: Mouton De Gruyter, pp. 17–52.

Pavlenko, Aneta, Adrian Blackledge, Ingrid Piller and Marya Teutsch-Dwyer (eds) (2002), *Multilingualism, Second Language Learning, and Gender*, New York: Mouton De Gruyter.

Peacock, Matthew (1999), 'Beliefs about language learning and their relationship to proficiency', *International Journal of Applied Linguistics*, 9 (2): 247–65.

Pennycook, Alastair (1994), *The Cultural Politics of English as an International Language*, London: Longman.

Pennycook, Alastair (1998), *English and the Discourses of Colonialism*, London: Routledge.

Perdue, Clive (ed.) (1993a), *Adult Language Acquisition: Crosslinguistic Perspectives. Volume 1: Field Methods*, Cambridge: Cambridge University Press.

Perdue, Clive (ed.) (1993b), *Adult Language Acquisition: Crosslinguistic Perspectives. Volume 2: The Results*, Cambridge: Cambridge University Press.

Pica, Teresa (1994), 'Questions from the language classroom: research perspectives', *TESOL Quarterly*, 28 (1): 49–79.

Pica, Teresa (1997), 'Second language teaching and research relationships: a North American view', *Language Teaching Research*, 1 (1): 48–72.

Pica, Teresa, Felicia Lincoln-Porter, Diana Paninos and Julian Linnell (1996), 'Language learners' interaction: how does it address the input, output, and feedback needs of L2 learners?', *TESOL Quarterly*, 30 (1): 59–84.

Pienemann, Manfred (1989), 'Is language teachable?', *Applied Linguistics*, 10 (1): 52–79.

Pienemann, Manfred (1998), *Language Processing and Second Language Development*, Amsterdam: John Benjamins.

Polio, Charlene and Susan Gass (1998), 'The role of interaction in native speaker comprehension of non-native speaker speech', *Modern Language Journal*, 83 (3): 308–19.

Poulisse, Nanda (1997), 'Some words in defense of the psycholinguistic approach: a response to Firth and Wagner', *Modern Language Journal*, 81 (3): 324–8.

Pujol Berché, Mercè and Fermín Sierra Martínez (eds) (1996), *Las lenguas en la Europa Comunitaria II. La adquisición de segundas lenguas y/o de lenguas extranjeras*, Amsterdam: Diálogos Hispánicos.

Pujolar, Joan (1997), 'Masculinities in a multilingual setting', in Sally Johnson and Ulrike Meinhof (eds), *Language and Masculinity*, Oxford: Blackwell, pp. 86–106.

Pujolar, Joan (2000), *Gender, Heteroglossia and Power: An Ethnography of Youth Culture in Barcelona*, Berlin: Mouton de Gruyter.

Rampton, Ben (1987), 'Stylistic variability and not speaking "normal" English: some post-Labovian approaches and their implications for the study of interlanguage', in Rod Ellis (ed.), *Second Language Acquisition in Context*, London: Prentice-Hall International, pp. 47–58.

Rampton, Ben (1995), *Crossing: Language and Ethnicity Among Adolescents*, London: Longman.

Rampton, Ben (1997a), 'Retuning in applied linguistics', *International Journal of Applied Linguistics*, 7 (1): 3–25.

Rampton, Ben (1997b), 'Second language research in late modernity: a response to Firth and Wagner', *Modern Language Journal*, 81 (3): 329–33.

Rampton, Ben (1999), 'Dichotomies, difference, and ritual in second language learning and teaching', *Applied Linguistics* 20 (3): 316–40.

Reddy, Michael (1979), 'The conduit metaphor – a case of frame conflict in our language about language', in Anthony Ortony (ed.), *Metaphor and Thought*, New York: Cambridge University Press, pp. 284–324.

Ritchie, William and Tej Bhatia (1996), 'Second language acquisition: introduction, foundations and overview', in William Ritchie and Tej Bhatia (eds), *Handbook of Language Acquisition*, New York: Academic Press, pp. 1–46.

Ritchie, William and Tej Bhatia (eds) (1996), *Handbook of Language Acquisition*, New York: Academic Press.

Robinson, Peter (1997), 'Individual differences and the fundamental similarity of implicit and explicit adult second language learning', *Language Learning*, 47 (1): 45–99.

Robinson, Peter (2001a), 'Task complexity, task difficulty, and task production: exploring interactions in a componential framework', *Applied Linguistics*, 22 (1): 27–57.

Robinson, Peter (2001b), 'Task complexity, cognitive resources, and syllabus design: a triadic framework for examining task influences on SLA', in Peter Robinson (ed.), *Cognition and Second Language Instruction*, Cambridge: Cambridge University Press, pp. 287–318.

Robinson, Peter (ed.) (2001c), *Cognition and Second Language Instruction*, Cambridge: Cambridge University Press.

Rogoff, Barbara (1990), *Apprenticeship in Thinking, Cognitive Development in Social Context*, Oxford: Oxford University Press.

Rogoff, Barbara (1995), 'Observing sociocultural activity on three planes: participatory appropriation, guided participation, and apprenticeship', in James Wertsch, Pablo del Rio and Amelia Alvarez (eds), *Sociocultural Studies of the Mind*, Cambridge: Cambridge University Press, pp. 139–64.

Romaine, Suzanne (1995), *Bilingualism*, 2nd edn, Oxford: Blackwell.

Romaine, Suzanne (1996), 'Bilingualism', in William Ritchie and Tej Bhatia (eds), *Handbook of Language Acquisition*, New York: Academic Press, pp. 571–604.

Rommetveit, Ragnar (1979), 'On negative rationalism in scholarly studies of verbal communication and dynamic residuals in the construction of human intersubjectivity', in Ragnar Rommetveit and R. M. Blaker (eds), *Studies of Language, Thought, and Verbal Communication*, London: Academic Press, pp. 147–62.

Rose, Kenneth and Gabriele Kasper (eds) (2001), *Pragmatics in Language Teaching*, Cambridge: Cambridge University Press.

Said, Edward (1994), *Culture and Imperialism*, London: Vintage.

Samuda, Virginia (2001), 'Guiding relationships between form and meaning during task performance: the role of the teacher', in Martin Bygate, Peter Skehan and Merrill Swain (eds), *Researching Pedagogical Tasks: Second Language Learning, Teaching and Testing*, London: Longman, pp. 119–40.

Sarangi, Srikant and Malcolm Coulthard (eds) (2000), *Discourse and Social Life*, London: Longman.

Schachter, Jacquelyn (1993), 'Second language acquisition: perceptions and possibilities', *Second Language Research*, 9 (2): 173–87.

Schachter, Jacquelyn (1996), 'Maturation and the issue of Universal Grammar in second language acquisition', in William Ritchie and Tej Bhatia (eds), *Handbook of Language Acquisition*, New York: Academic Press, pp. 159–93.

Schmidt, Richard (1983), 'Interaction, acculturation, the acquisition of communicative competence', in Nessa Wolfson and Elliot Judd (eds), *Sociolinguistics and TESOL*, Rowley, MA: Newbury House, pp. 137–74.

Schmidt, Richard and Sylvia Frota (1986), 'Developing basic conversational ability in a second language: a case study of an adult learner of Portuguese', in Richard Day (ed.),

Talking to Learn: Conversation in Second Language Acquisition, Rowley, MA: Newbury House, pp. 237–322.

Schneider, Walter and Richard Shiffrin (1977), 'Controlled and automatic human information processing: I. Detection, search and attention', *Psychological Review*, 84 (1): 1–66.

Schumann, Francine and John Schumann (1977), 'Diary of a language learner: an introspective study of second language learning', in H. Douglas Brown, Carlos Yorio and Ruth Crymes (eds), *On TESOL, '77*, Washington, DC: TESOL, pp. 41–9.

Schumann, John (1978), *The Pidgenization Process: A Model for Second Language Acquisition*, Rowley, MA: Newbury House.

Schumann, John (1993), 'Some problems with falsification: an illustration from SLA research', *Applied Linguistics*, 14 (3): 328–47.

Schumann, John (1997), *The Neurobiology of Affect in Language, Language Learning*, 48: supplement 1, Oxford: Blackwell.

Scollon, Ron (1998), *Mediated Discourse as Social Interaction: A Study of News Discourse*, London: Addison Wesley Longman.

Scollon, Ron and Suzanne Scollon (1995), *Intercultural Communication: A Discourse Approach*, Oxford: Blackwell.

Searle, John (1969), *Speech Acts*, Cambridge: Cambridge University Press.

Seliger, Herbert (1996), 'Primary language attrition in the context of bilingualism', in William Ritchie and Tej Bhatia (eds), *Handbook of Language Acquisition*, New York: Academic Press, pp. 605–26.

Seliger, Herbert and Robert Vago (1991), *First Language Attrition*, Cambridge: Cambridge University Press.

Selinker, Larry (1972), 'Interlanguage', *International Review of Applied Linguistics*, 10: 209–31.

Selinker, Larry (1992), *Rediscovering Interlanguage*, London: Longman.

Sfard, Anna (1998), 'On two metaphors for learning and the dangers of choosing just one', *Educational Researcher*, 27: 4–13.

Sharwood Smith, Michael (1994), *Second Language Learning: Theoretical Foundations*, London: Longman.

Shiffrin, Richard and Walter Schneider (1977), 'Controlled and automatic human information processing: II. Perceptual learning, automatic attending and a general theory', *Psychological Review*, 84/2: 127–90.

Sierra Martínez, Fermín, Mercè Pujol Berché and Harm den Boer (eds) (1994), *Las lenguas en la Europa Communitaria. La adquisición de segundas lenguas y/o de lenguas extranjeras*, Amsterdam: Diálogos Hispánicos.

Sinclair, John and Malcolm Coulthard (1975), *Towards an Analysis of Discourse*, Oxford: Oxford University Press.

Singleton, David and Zsolt Lengyel (eds) (1995), *The Age Factor in Second Language Acquisition*, Clevedon: Multilingual Matters.

Skehan, Peter (1998), *A Cognitive Approach to Language Learning*, Oxford: Oxford University Press.

Skehan, Peter and Pauline Foster (1999), 'The influence of task structure and processing conditions on narrative retellings', *Language Learning*, 49 (1): 93–120.

Skinner, B. F. (1957), *Verbal Behavior*, New York: Appleton-Century-Crofts.

Slimani, Assia (1992), 'Evaluation of classroom interaction', in Charles Alderson and Alan Beretta (eds), *Evaluating Second Language Acquisition*, Cambridge: Cambridge University Press, pp. 197–220.

Slobin, Dan (1970), 'Universals of grammatical development in children', in Giovanni Flores d'Arcais and Willem Levelt (eds), *Advances in Psycholinguistics*, Amsterdam: North Holland Publishing.

Sridhar, S. N. (1994), 'A reality check for SLA theories', *TESOL Quarterly*, 28 (4): 800–5.

Sridhar, S. N. and K. K. Sridhar (1986), 'Bridging the paradigm gap: second language acquisition theory and indigenized varieties of English', *World Englishes*, 5: 3–14.

Stauble, Anne-Marie (1978), 'Decreolization: a model for second language development', *Language Learning*, 28 (1): 29–54.

Stauble, Anne-Marie (1984), 'A comparison of the Spanish-English and Japanese-English interlanguage continuum', in Roger Andersen (ed.), *Second Languages: a Crosslinguistic Perspective*, Rowley, MA: Newbury House.

Sunderland, Jane (2000), 'Issues of language and gender in second and foreign language education', *Language Teaching*, 33 (4): 203–23.

Swain, Merrill (1985), 'Communicative competence: some roles of comprehensible input and comprehensible output in its development', in Susan Gass and Carolyn Madden (eds), *Input in Second Language Acquisition*, Rowley, MA: Newbury House, pp. 235–53.

Swain, Merrill (1993), 'The output hypothesis: just speaking and writing aren't enough', *Canadian Modern Language Review*, 50: 158–64.

Swain, Merrill (1995), 'Three functions of output in second language learning', in Guy Cook and Barbara Seidlhofer (eds), *Principle and Practice in Applied Linguistics: Studies in Honour of H. G. Widdowson*, Oxford: Oxford University Press, pp. 125–44.

Swain, Merrill (1997), 'Collaborative dialogue: its contributions to second language learning', *Revista Canaria de Estudios Ingleses*, 34: 115–32.

Swain, Merrill (2000), 'The output hypothesis and beyond: mediating acquisition through collaborative dialogue', in James Lantolf (ed.), *Sociocultural Theory and Second Language Learning*, Oxford: Oxford University Press, pp. 97–114.

Swain, Merrill and Sharon Lapkin (1998), 'Interaction and second language learning: two adolescent French immersion students working together', *Modern Language Journal*, 83 (3): 320–37.

Swain, Merrill and Sharon Lapkin (2001), 'Focus on form through collaborative dialogue: exploring task effects', in Martin Bygate, Peter Skehan and Merrill Swain (eds), *Researching Pedagogical Tasks*, London: Longman, pp. 99–118.

Swain, Merrill and Sharon Lapkin (2002a), 'Talking it through: two French immersion learners' response to reformulation', *International Journal of Educational Research*, forthcoming.

Swain, Merrill and Sharon Lapkin (2002b), '"Oh, I get it now!" From production to comprehension in second language learning', manuscript submitted for publication.

Takala, Sauli (1984), 'A review of *Language Two* by Heidi Dulay, Marina Burt and Stephen Krashen', *Language Learning*, 84 (3): 157–74.

Talbot, Mary (1998), *Language and Gender: An Introduction*, Cambridge: Polity.

Talburt, Susan and Melissa Stewart (1999), 'What's the subject of study abroad?: Race, gender, and "living culture"', *Modern Language Journal*, 83 (2): 163–75.

Tarone, Elaine (1997), 'Analyzing IL in natural settings: a sociolinguistic perspective on second-language acquisition', *Culture and Cognition*, 30: 137–49.

Tarone, Elaine and Guo-Qiang Liu (1995), 'Situational context, variation and second language acquisition theory', in Guy Cook and Barbara Seidlhofer (eds), *Principle and Practice in Applied Linguistics*, Oxford: Oxford University Press, pp. 107–24.

Teutsch-Dwyer, Mayra (2001), '(re)constructing masculinity in a new linguistic reality', in Aneta Pavlenko et al. (eds), *Multilingualism, Second Language Acquisition, and Gender*, New York: Mouton de Gruyter, pp. 175–98.

Thomas, Jenny (1983), 'Cross-cultural pragmatic failure', *Applied Linguistics*, 4 (1): 91–112.

Thomas, Jenny (1995), *Meaning in Interaction: An Introduction to Pragmatics*, London: Longman.

Thomas, Margaret (1998), 'Programmatic ahistoricity in second language acquisition theory', *Studies in Second Language Acquisition*, 20(3): 387–405.

Thorne, Steven (2000), 'Second language acquisition theory and the truth(s) about relativity', in James Lantolf (ed.), *Sociocultural Theory and Second Language Learning*, Oxford: Oxford

University Press, pp. 219–43.

Titone, Renzo (1968), *Teaching Foreign Languages: An Historical Sketch*, Washington, DC: Georgetown University Press.

Tomlinson, John (1999), *Globalization and Culture*, Cambridge: Polity.

Towell, Richard and Roger Hawkins (1994), *Approaches to Second Language Acquisition*, Clevedon: Multilingual Matters.

Trudgill, Peter (1983), *On Dialect: Social and Geographical Perspectives*, Oxford: Blackwell.

Umino, Tae (2002), *Foreign Language Learning with Self-instructional Materials: An Exploratory Study*, unpublished PhD thesis, Institute of Education, University of London.

Valsiner, Jaan and René van der Veer (2000), *The Social Mind*, Cambridge: Cambridge University Press.

van Lier, Leo (1994), 'Forks and hope: pursuing understanding in different ways', *Applied Linguistics*, 15 (3): 328–47.

van Lier, Leo (2000), 'From input to affordance: social-interactive learning from an ecological perspective', in James Lantolf (ed.), *Sociocultural Theory and Second Language Learning*, Oxford: Oxford University Press, pp. 245–59.

Van Patten, Bill (1990), 'The acquisition of clitic pronouns in Spanish: two case studies', in Bill Van Patten and James F. Lee (eds), *Second Language Acquisition – Foreign Language Learning*, Clevedon: Multilingual Matters.

Van Patten, Bill (1996), *Input Processing and Grammar Instruction*, Norwood, NJ: Ablex.

Van Patten, Bill and James F. Lee (eds) (1990), *Second Language Acquisition – Foreign Language Learning*, Clevedon: Multilingual Matters.

Varonis, Evangeline and Susan Gass (1985), 'Non-native/non-native conversations: a model for negotiation of meaning', *Applied Linguistics*, 6 (1): 71–90.

Vygotsky, Lev (1978), *Mind in Society*, Cambridge, MA: Harvard University Press.

Vygotsky, Lev (1986), *Thought and Language*, Cambridge, MA: MIT Press.

Wagner-Gough, Judy and Evelyn Hatch (1975), 'The importance of input data in second language acquisition studies', *Language Learning*, 25 (3): 297–308.

Watson, John B. (1919), *Psychology from the Standpoint of a Behaviorist*, Philadelphia: Lippincott.

Weedon, Chris (1997), *Feminist Practice and Poststructuralist Theory*, 2nd edn, Oxford: Blackwell.

Weinreich, Uriel (1953), *Languages in Contact*, The Hague: Mouton.

Wells, Gordon (1999), *Dialogic Inquiry*, Cambridge: Cambridge University Press.

Wenden, Anita (2001), 'Metacognitive knowledge in SLA: the neglected variable', in Michael Breen (ed.), *Learner Contributions to Language Learning*, London: Longman, pp. 44–64.

Wenger, Etienne (1998), *Communities of Practice*, Cambridge: Cambridge University Press.

Wertsch, James (1985), *Vygotsky and the Social Formation of Mind*, Cambridge, MA: Harvard University Press.

Wertsch, James (1991), *Voices of the Mind*, Cambridge, MA: Harvard University Press.

Wertsch, James (1998), *Mind as Action*, Oxford: Oxford University Press.

Wertsch, James and C. Addison Stone (1985), 'The concept of internalisation in Vygotsky's account of the genesis of higher mental functions', in James Wertsch (ed.), *Culture, Communication and Cognition: Vygotskian Perspectives*, Cambridge: Cambridge University Press, pp. 162–79.

White, Lydia (1996), 'Universal grammar and second language acquisition: current and new directions', in William Ritchie and Tej Bhatia (eds), *Handbook of Language Acquisition*, New York: Academic Press, pp. 85–120.

Widdowson, Henry G. (1990), *Aspects of Language Teaching*, Oxford: Oxford University Press.

Widdowson, Henry G. (1998a), 'Retuning, calling the tune, and paying the piper: a reaction to Rampton', *International Journal of Applied Linguistics*, 8 (1): 131–40.

Widdowson, Henry G. (1998b), 'Positions and oppositions: hedgehogs and foxes', *International Journal of Applied Linguistics*, 8 (1): 147–51.

Widdowson, Henry G. (1998c), 'Context, community and authentic language', *TESOL Quarterly*, 32 (4): 705–16.

Williams, Raymond (1981), *Culture*, Glasgow: Fontana.

Yule, George (1996), *Pragmatics*, Oxford: Oxford University Press.

Yule, George (1997), *Referential Communication Tasks*, Mahwah, NJ: Lawrence Erlbaum.

Zobl, Helmut (1995) 'Converging evidence for the "acquisition-learning" distinction', *Applied Linguistics*, 16 (1): 35–56.

Index

Printed in the United States
122027LV00001B/4-18/A

3635 83

9 780878 401444